100%

European
Graphic
Design
Portfolio

PAGE ONE

100% - EUROPEAN GRAPHIC DESIGN PORTFOLIO

Copyright © 2008 SANDU PUBLISHING

Published in Asia in 2008 by
Page One Publishing Pte Ltd
20 Kaki Bukit View
Kaki Bukit Techpark II
Singapore 415956
Tel: (65) 6742-2088
Fax: (65) 6744-2088
enquiries@pageonegroup.com
www.pageonegroup.com

First published in 2008 by Sandu Publishing

sandu 🈯 | 365

Sponsored by: Design 360°-Concept and Design Magazine
(www.360indesign.com)
Consultant: Jean Widmer, Rob Huisman, Marja Seliger, Sergio Calatroni
Editor in Chief: Wang Shaoqiang
Sales Manager: Niu Guanghui (China), Daniela Huang (International)
3rd floor, West Tower, No.10 Ligang Road, Haizhu District,
Guangzhou 510280, China
Tel: (86)-20-8434 4460
Fax: (86)-20-8434 4460
sandu84344460@163.com (Sale)
sandudesign2006@yahoo.com.cn (Contribution)
www.sandu360.com

ISBN 978-981-245-731-8

Printed and bound in China

Preface 004-011

Corporate Identity 013-076

Orientation 077-100

Packaging 101-160

Print&AD 161-256

Illustration 257-314

Poster 315-332

Typography 333-352

Website 353-380

logo 381-400

Preface

Europe is the cradle land of contemporary design at the beginning of the 20th century. From the Arts & Crafts Movement, Art Nouveau Movement, Modernism Movement represented by Bauhaus, to the Neo-modernism at present, Europe has always been the center for modern design movements, representing the unlimited designing creativities. *100%-European Graphic Design* collects the explorative and experimental graphic design in European design area, gathers the top designers in European, and also witnesses the growing of new generation in designing field. Various images are selected and reorganized couples of times in designers' minds, then abstracted into formats and structures which are coherent with the core concept, so as to be reconstructed a refined visual from. That is the European design principle represented by *100%-European Graphic Design Portfolio*: concept under the brilliant surface is the essential part of design.

100%-European Graphic Design Portfolio has gained the support of international organizations such as Wolda, Association of Dutch Designers, Swedish Association of Designers and Association of Professional Graphic Designers in Finland. We express our thanks for those who help us and special thanks to our contributors, such as New Future Graphic (Britain), Dew Gibbons (Britain),

Mark Richardson (Britain), Dragon Rouge (France), Moniteurs (German), Hesse Design (Germany), Khdesign Gmbh (Germany), Büro Uebele (Germany), Rotbraun (Germany), Cacao Design (Italy), Studio Sergio Calatroni Art Room srl (Italy), Ngdesign(Italy), Yonoh (Spain), Studio Dumbar (The Netherlands), Studio Kluif(The Netherlands), Eden Design & Communication (The Netherlands), Lava (The Netherlands), Bard Hole Standal (Norway), Tank Design (Norway), GVA STUDIO (Switzerland), BeetRoot Design Group (Greece), Hreur Lárusson, Katrin Olina (Iceland), Hahmo Design (Finland), Ohlsonsmith (Sweden), Sweden Graphic (Sweden), TURNER DUCKWORTH (Britain & USA), ZUU (Portugal), Laboratorium (Croatia)…

100%-European Graphic Design Portfolio is published in Asia and released internationally. It offers an exchange platform for designers from the world. We will keep on our efforts in the future years, promoting design exchange and strengthening mutual understanding. It is originality that we highlight. Our principle is to interpret life and society through design under different backgrounds of different countries.

Editorial Department of
100%-European Graphic Design Portfolio

I see myself somewhere between the figurative and the abstract. I admire the painting style of Mondrian, whom I discovered as a student in Zurich. As far as graphic design is concerned, Max Bill has always served as my main reference-and, of course, Richard Lohse, Bamett Newman and Ellsworth Kelly.

I try to express myself through my own culture by utilizing geometric forms that, to my mind, are timeless. Graphic design is meant to meet specific demands, yet there is no denying that it is closely linked to its era. In point of fact, graphic design production depends on the taste of the day. Put it this way: The task of graphic designers is to think up the best way to visually communicate an idea. They must also come up with the most easily understandable form of expression. Therefore, they tend to pay heed to both the fashion of their times and the geographic context in which they work.

By comparison with other forms of artistic expression, art is not, at least not necessarily, a greater or nobler spiritual experience than graphic design. It is, however, subjected to less noticeable changes. Graphic designers can be artists without producing art. Painting is a matter of pure invention by painters, while the task of graphic designers is to apply their art to a subject-not that this belittles the theoretical underpinnings of the profession, so well described by Max Bill.

As a graphic designer, I do seek to empty images of any narrative implications. To me, images are meant to transmit information, get to the core of a matter, express a message clearly and render it intelligible and obvious. I do not necessarily aim for a visual consensus, but rather for surprise. Design should lend consistency to an idea. To start out with the semantic content of an image, and go on to garner its cultural and social significance, leads to a more generalized concern with the "ecology of an image."

The realm of communication is currently in full expansion, so that the growing demand for graphic design is entirely warranted. This explains the fad-actually, a rather childish gluttony-for image creators such as we have become. The need for our work is there, so why deny ourselves the pleasure? When I sometimes talk this question over with my son, Jullen, he describes the new generation's appetite for images in any form or shape. The production of images holds a certain fascination, and today the title of "graphic designer" is flattering one. To give you an example, every year we see twelve hundred candidates compete for entry into Ensad (Ecole Nationale superieure dex arts decoratifs), which

can only accept about one hundred. The selection process is pitiless. Young people tend to think it is an easy profession, which is not always true. Quite the contrary, Graphic design studies require boundless curiosity, and a never waning desire to learn. You will be expected to communicate anything under the sun, and you can never know what the next job will involve or what the subject matter will be.

I've noticed that young graphic designers tend to work things out directly by computer. They rush to their keyboard and, eyes riveted to the screen, strike out at the keys almost mechanically. Less consideration is granted nowadays to the art of sketching ideas, formerly the gauge of an artist's talent. Yet, it is the designing phase that takes up the most time and, at that point, computers have nothing much to offer. A graphic designer who has first carefully thought out a concept will have an easier time translating it onto paper. To my mind, resorting to computers for the initial designing of ideas is detrimental to inventiveness: All you get is an overabundance of preexisting images and stylistic effects. Computers are best suited to putting the finishing touches on designs, which requires mastering, above all, production and reproduction techniques. Research and creativity are intrinsic to the power of imagination, one of humanity's most important cultural assets.

The desire to wipe the slate clean of anything old-fashioned instigated an incredible fad for a modernist vision of society and the needs of society. I was familiar with these new ideas, which included functionalism, since they had already made headway In Switzerland. I became one of their strongest defenders and, in fact, applied myself to spreading them in France. Little by little, thanks to all the designers who had joined the French scene from abroad (Switzerland, Great Britain, Italy and Germany), and various major institutions, French design began stealing the spotlight on the European stage.

Clients do not show the same interest in preserving a graphic design project as they might for the restoration of an architectural heritage. Once we have won a competition and the project gets developed as we envisioned it, we have no idea whether or not there will be a contract in the future to keep the project in good shape and even add to it. Often, the work deteriorates over time. It surprises me to see all the relics of the past left to clog up the functioning of certain public institutions: Those responsible for communication do not invest enough in the methodical follow-up necessary to maintain their public image. Indeed, it is only by respecting a graphic design program over the

years that a visual identity can secure a foothold, that it can win instant recognition. Any enterprise, whether public or private, needs to build up its image through a long-term design program. To rely on a short-term program or seitch over to a different agency is to weaken the credibility of that image. The effectiveness of a certain line of design depends basically on considerations of this sort, as much as on a permanent dialogue between the client and the graphic designer. Some of my opinion on design has been mentioned in the exhibition of New York.

I have written a poem about graphic design for this book as follows:

Lier l'objet à la forme, Harmoniser la fonction et l'esprit, Équilibrer la relation et l'illusion… /Par un intermédiaire, par la transformation de l'imaginé en réalité concrète, le graphic design existe et exige. / Sans relâche, l'inspiration traque le genie. Un génie préoccupé par la sensibilité d'un unique souffle créateur, dépositaire de l'idée et de l'intuituion brusque?? ou spontanée. / Le 21e siècle s'écrit à travers la mobilité des techniques de communication, la fluidité du libre échange et la démécanisation des courants de circulation. / Dès lors, le graphic designer s'installe au-delà de sa praxis environnementale et quotidienne, limitée à une gestion typographique et signalétique des espaces. Il se positionne dans une nouvelle dimension en inventant et en développant des champs nouveaux, d'activité électronique et humaine, à l'échelle de la ville. /Aujourd'hui la compétition des villes fait chasse auprès des Architectes et Designer, de génie est l'attraction des grand projet des villes font courir le tourisme. / L'information et la signalétique participent-en surnombre-au bruit urbaine. La multiplicité porte à l'illisibilité, à une codificaation inopérante, a une réglementation désespérée. / Le Graphic Designer doit maîtriser le signe et son organisation, mais il ne peut plus œuvrer seul. Une réflexion pluridisciplinaire s'installe alors dans la modernité d'un contexte où les pouvoirs publics, et les grands industrielles, à l'écoute, deviendrons des partenaires actif.

Jean Widmer

Graphic Designer
Old Professor of the Ecole nationale
supérieure des arts décoratifs

100 % - European Graphic Design Portfolio presents outstanding graphic design from various European countries produced after the 1st of January 2006. The 400 pages include a great deal of pictorial information about current visual communication design, for the contents are carefully selected to cover different areas of graphic design. At the same time, the book challenges the reader to make his or her judgements and to discover which are the trends in typography, illustration techniques and colours and how these trends have been applied within the different fields of graphic design. This gives food for thought on how graphic design has changed since the 1990's, when the term post-modernism was used to describe visual arts and design.

When looking at graphic design produced in the past, during the 20th century, it is fairly easy to distinguish the trends of different decades and also to define some national characteristics. Similarly, when studying the works exhibited in this book, it is possible to find certain features, which connect various artefacts and could be called the characteristic design trends of our time. The following interesting question arises: is it possible to define the origin, the country or continent where a design is produced nowadays? Current visual communication design can be called global, because for example logos, web design and packages are distributed all over the world. Their pictorial messages are recognised and understood in different countries. On the other hand, although graphic design artefacts are intended to convey information or commercial messages, they also carry cultural messages and depict their origin.

Europe is an interesting continent, for it combines several cultures and nations, which are proud of their cultural heritage and want to preserve it. As regards verbal communication, within the European Union there are 27 countries and 23 official languages. Most likely there are also various tones of visual language, in other words, manifold European graphic design. This book invites its readers to discover these characteristics and discuss the questions of time and origin, as well as local and global graphic design.

Marja Seliger

Graphic designer, MA
Board member of Grafia,
Association of Professional Graphic Designers in Finland

The Netherlands boasts a long and rich tradition in graphic design. Not only is the country home to no less than 13 academies that teach the profession (and that's a lot, for such a small country!); the state government also plays an important role as a commissioning client. Just about everything in the Netherlands has been designed at least 10 times over. Our postage stamps, tax forms, waste bins, telephone booths, and as a recent example, the state logo – you name it! This has helped to create a high acceptance level for design in this country. And that, for a discipline that is actually barely a century old here! Graphic design was once just part of the tasks performed by architects and fine artists. It was only around 1900 that something evolved here that one could properly call graphic design. Leafing through this book, I am particularly struck by how the typical character of Dutch design shines through: clear, no-nonsense, and with a touch of humour. It also reminds me of how many highly skilled graphic designers the Netherlands has produced, and how much talent is on offer in the newest generation. Renowned names that come to mind are the typeface designer Gerard Unger, or Anthon Beeke's posters, or those of Piet Zwart. Or such agencies as Dumbar or, still relatively young, Thonik, creating designs with a touch of tongue-in-cheek and a measure of lightness that I don't often encounter in other countries. This book about European Graphic Design is a wonderful initiative that can in turn spawn all sorts of interesting cross-pollinations and especially much inspiration for designers and clients alike. On the grounds of this publication, we can also ponder the question: is there such a thing as European Design? Hard to say for those that are caught up in the midst of it. Yet whenever I look towards Asia or North America, I do think: yes, that is truly typical Asian or American design. So how about European Design? I gladly leave it up to the readers of this book. Who knows, perhaps I'll find out someday too.

Rob Huisman

Director of the Association of Dutch Designers

European Heritage

The graphics European has a tradition thousands of years if we include also written on gravestones of the people Etruscans and Romans. The messages that we have received from these two civilizations are the ancestors of contemporary graphics. Ancient Rome has refined communication and product characters of unsurpassed beauty still used today. The Renaissance has boosted the press and the art of book and the image has spread in Europe and beyond. The Bauhaus has created an earthquake research that has reconditioned the DNA of the graphics world. So testing has become part of the creative process of modern graphics. We are now in 'was man technique. The computer has devastated the landscape expressive graph. The European sedimentazioni dell'espressività were mixed. Now I am suspended. There will be no settlement in graphic language. The European hybrids dell'espressività change in real time, continuously. All this is a sort of mixture of communication that incorporates many different culure.

Sergio Calatroni

Studio Sergio Calatroni Art Room srl

Corporate Identity

Mark Richardson Graphic Design

Title : About Face Aesthetic-Branding and Marketing
Designer : Mark Richardson
Country : Britain

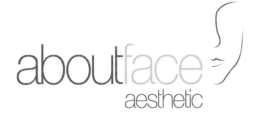

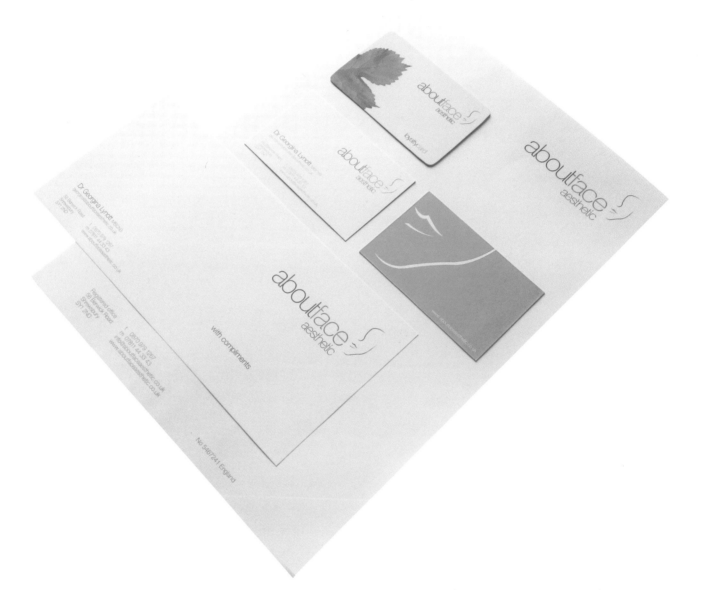

Yonoh

Title : ALDAIA 2007-T-Shirt Design for
Aldaia's Football Club
Design : Alex Selma
Country : Spain

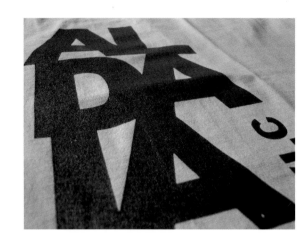

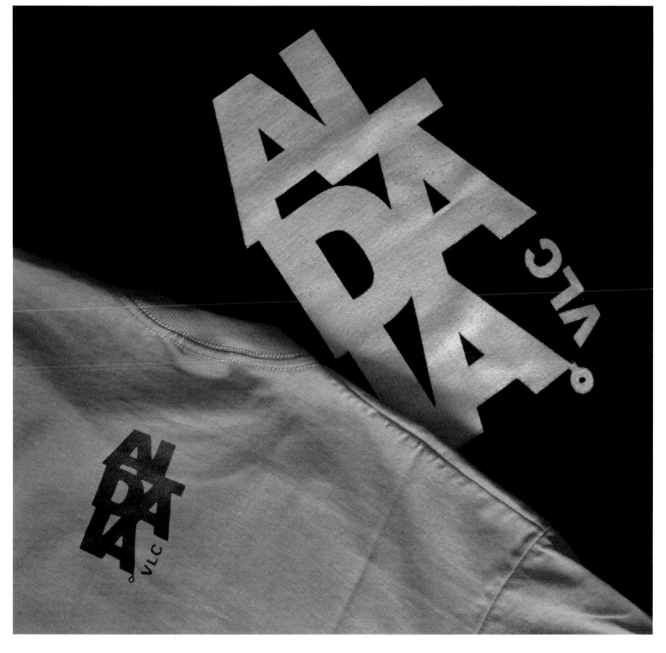

Art

Aids

Art/

Studio Dumbar

Title : Visual Identity Art Aids
Country : The Netherlands

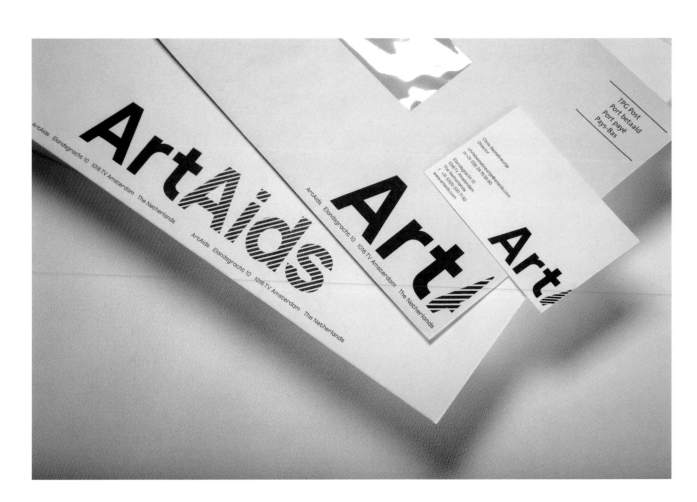

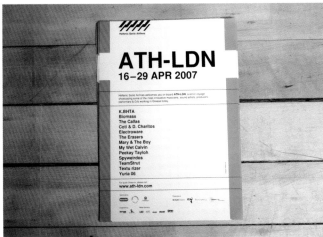

Hellenic Sonic Airlines

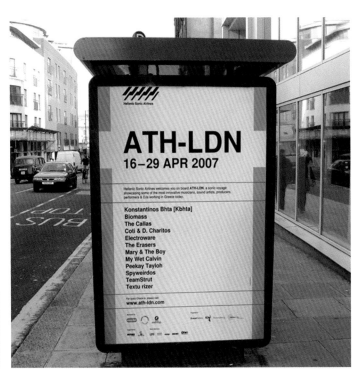

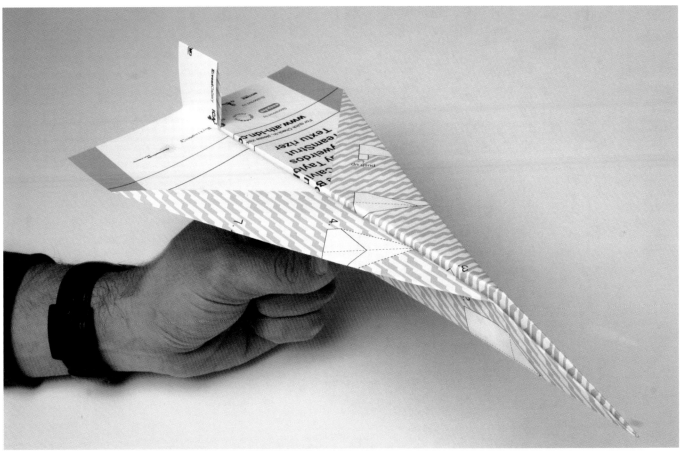

specialising in...

property developments
basement conversions
project management
new build

020 7731 3898
www.bigbuildingcompany.com

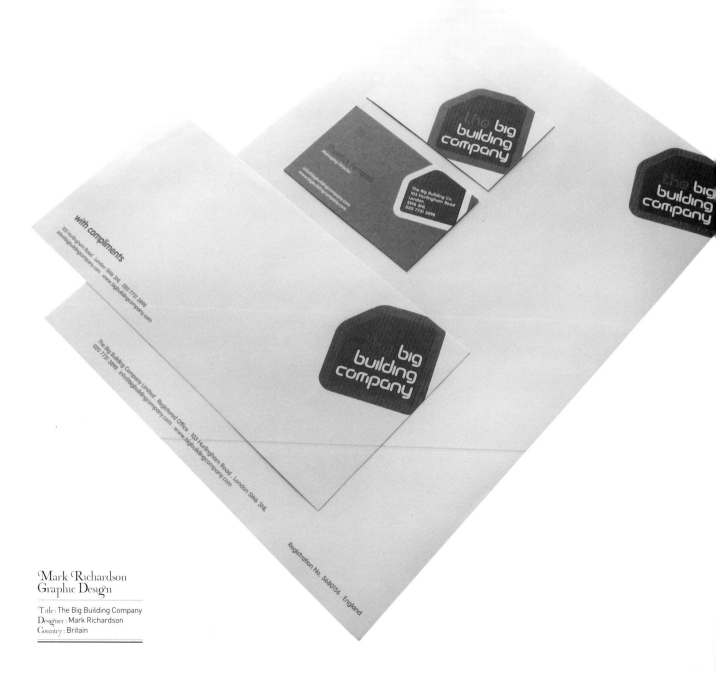

Mark Richardson
Graphic Design

Title : The Big Building Company
Designer : Mark Richardson
Country : Britain

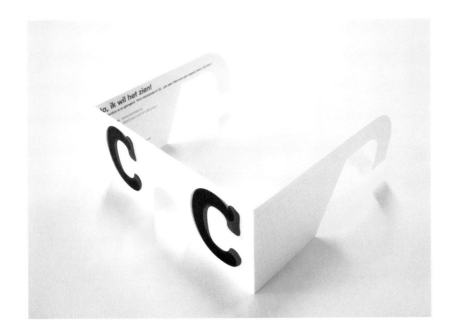

omroep voor kunst en cultuur

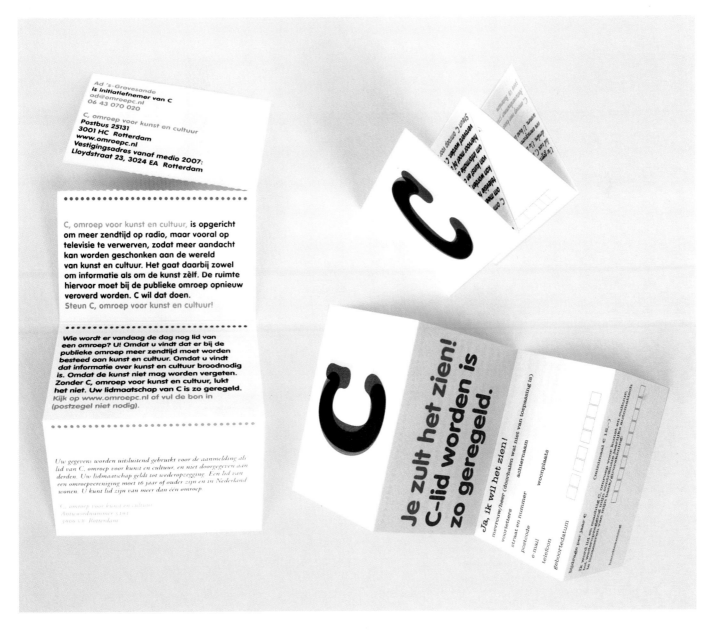

Champalimaud
Foundation

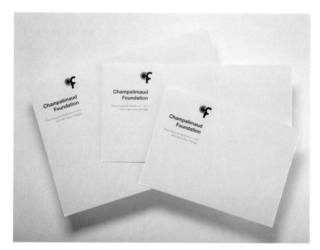

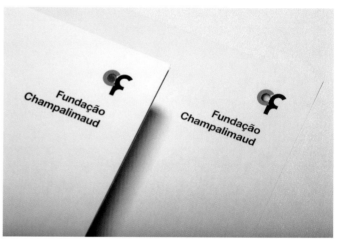

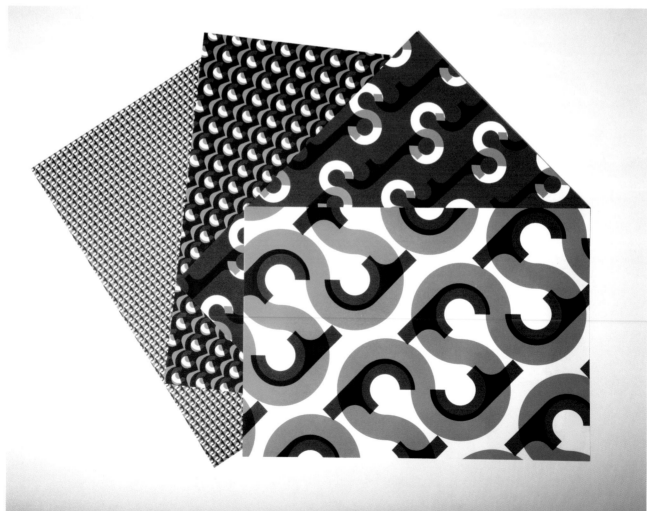

Studio Dumbar

Title : Visual Identity of Champalimaud Foundation
Photography : Dieter Schütte
Country : The Netherlands

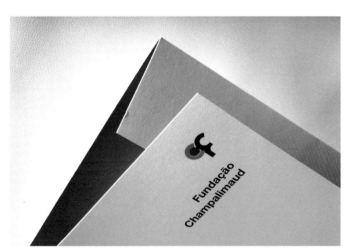

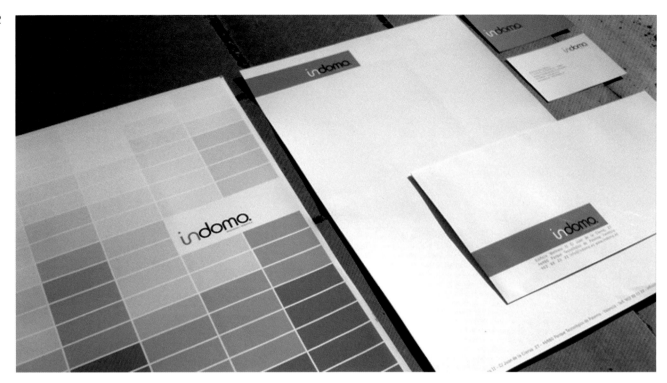

Yonoh

Title : INDOMO 2007
Design : Alex Selma & Clara del Portillo
Country : Spain

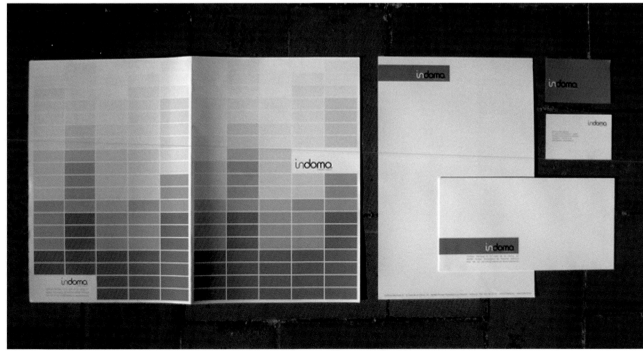

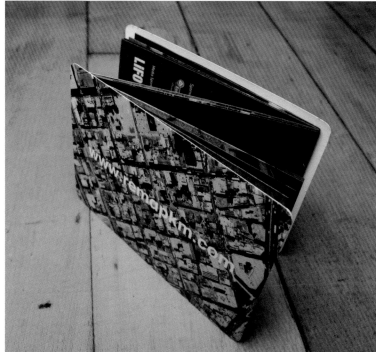

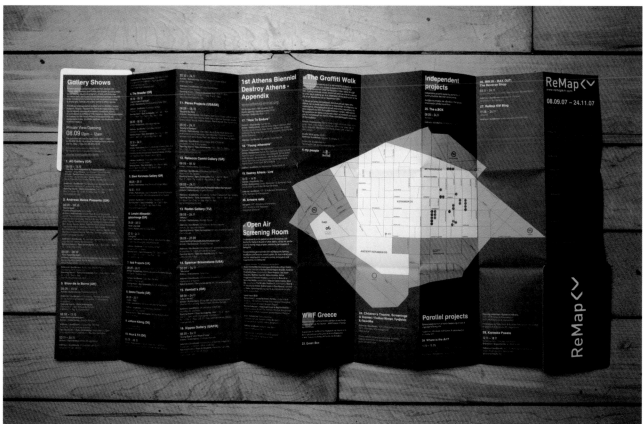

Mark Richardson Graphic Design

Title : OMD Brand Refresh
Country : Britain

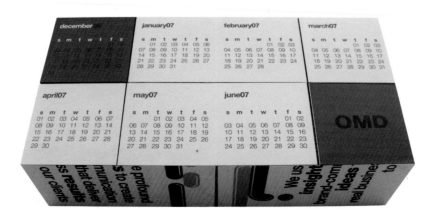

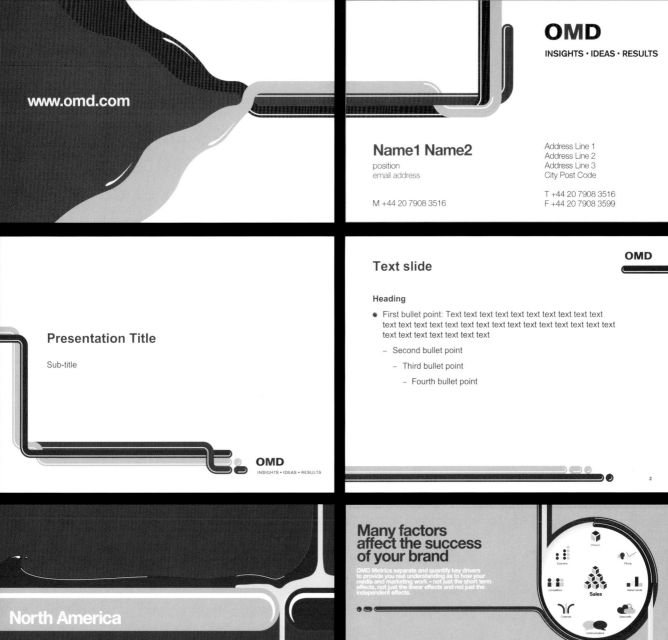

www.omd.com

OMD
INSIGHTS · IDEAS · RESULTS

Name1 Name2
position
email address

M +44 20 7908 3516

Address Line 1
Address Line 2
Address Line 3
City Post Code

T +44 20 7908 3516
F +44 20 7908 3599

Presentation Title

Sub-title

OMD
INSIGHTS · IDEAS · RESULTS

Text slide

OMD

Heading
- First bullet point: Text text
 - Second bullet point
 - Third bullet point
 - Fourth bullet point

2

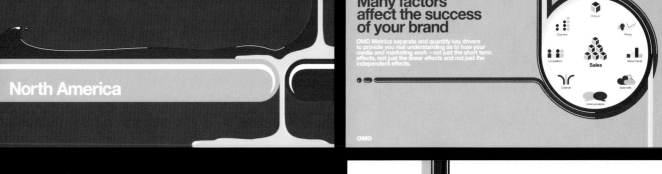

North America

Many factors affect the success of your brand

OMD Metrics separate and quantify key drivers to provide you real understanding as to how your media and marketing work – not just the short term effects, not just the linear effects and not just the independent effects.

Product
Economy
Pricing
Competitors
Sales
Market trends
Channels
Seasonality
Communications

OMD

17

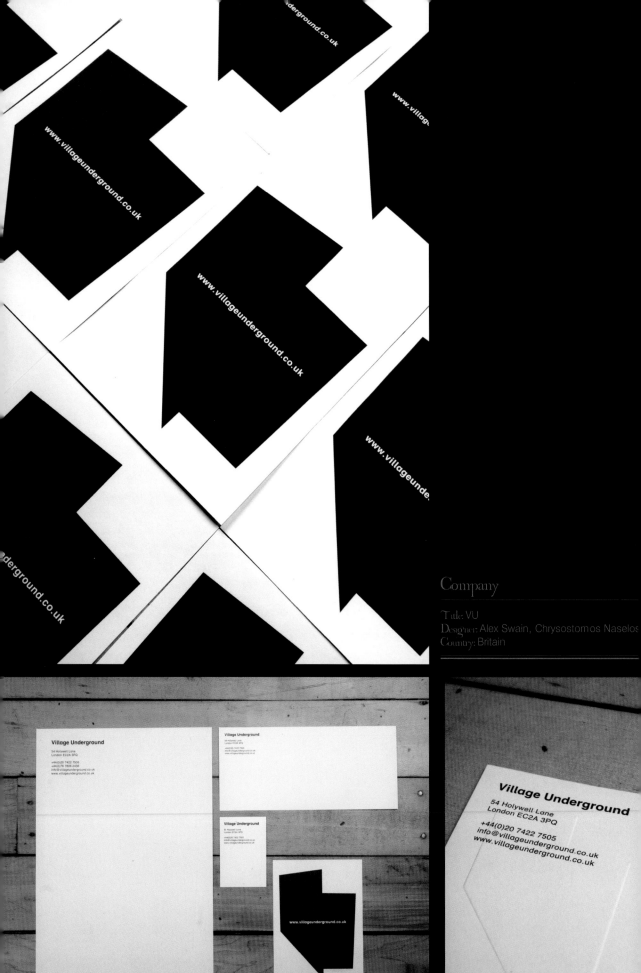

Company

Title: VU
Designer: Alex Swain, Chrysostomos Naselos
Country: Britain

Rotbraun Informationsgestaltung

Title: Deutsch-Polnischer Verein Zwickau E.V.
Design: Nora Bilz, Pia Schneider
Illustration: Nora Bilz, Pia Schneider
Country: Germany

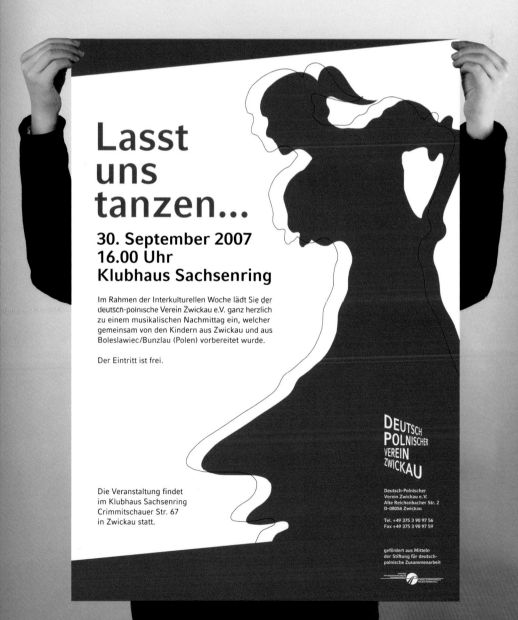

Mark Ronson
and special guests
with the BBC
Concert Orchestra
VERY SPECIAL GUESTS
The Coral

A new music experience

Wednesday 25th October
The Roundhouse, Camden,
London, NW1 8EH

Doors Open 19:30
Tickets £15.00 Adv.
(Subject To Booking Fee)

Wednesday 25th October
The Roundhouse, Camden, London, NW1 8EH

Mark Ronson
and special guests with
The BBC Concert Orchestra
PLUS VERY SPECIAL GUESTS

01234 01234 01234

new music experience. a new music experience

New Future Graphic

Title: BBC Electric Proms
Creative Director: Marcus Walters & Gareth White
Country: UK

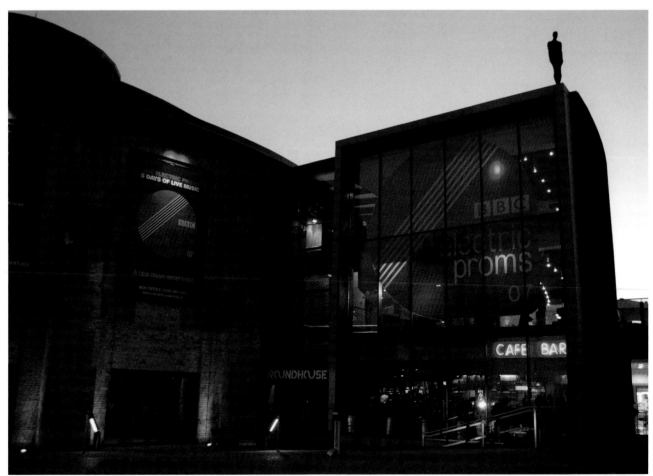

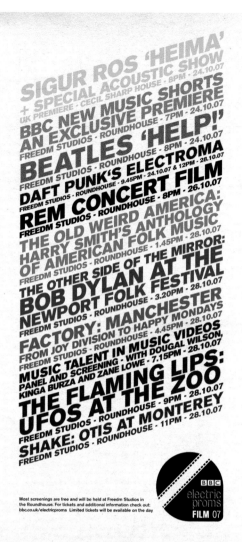

SIGUR ROS 'HEIMA'
+ SPECIAL ACOUSTIC SHOW
UK PREMIERE · CECIL SHARP HOUSE · 8PM · 24.10.07

BBC NEW MUSIC SHORTS
AN EXCLUSIVE PREMIERE
FREEDM STUDIOS · ROUNDHOUSE · 7PM · 24.10.07

BEATLES 'HELP!'
FREEDM STUDIOS · ROUNDHOUSE · 8PM · 24.10.07

DAFT PUNK'S ELECTROMA
FREEDM STUDIOS · ROUNDHOUSE · 9.45PM · 24.10.07 & 12PM · 28.10.07

REM CONCERT FILM
FREEDM STUDIOS · ROUNDHOUSE · 8PM · 26.10.07

THE OLD WEIRD AMERICA:
HARRY SMITH'S ANTHOLOGY
OF AMERICAN FOLK MUSIC
FREEDM STUDIOS · ROUNDHOUSE · 1.45PM · 28.10.07

THE OTHER SIDE OF THE MIRROR:
BOB DYLAN AT THE
NEWPORT FOLK FESTIVAL
FREEDM STUDIOS · ROUNDHOUSE · 3.20PM · 28.10.07

FACTORY: MANCHESTER
FROM JOY DIVISION TO HAPPY MONDAYS
FREEDM STUDIOS · ROUNDHOUSE · 4.45PM · 28.10.07

MUSIC TALENT IN MUSIC VIDEOS,
PANEL AND SCREENING · WITH DOUGAL WILSON,
KINGA BURZA AND ZANE LOWE · 7.15PM · 28.10.07

THE FLAMING LIPS:
UFOS AT THE ZOO
FREEDM STUDIOS · ROUNDHOUSE · 9PM · 28.10.07

SHAKE: OTIS AT MONTEREY
FREEDM STUDIOS · ROUNDHOUSE · 11PM · 28.10.07

Most screenings are free and will be held at Freedm Studios in
the Roundhouse. For tickets and additional information check out:
bbc.co.uk/electricproms Limited tickets will be available on the day

BBC
electric
proms
FILM 07

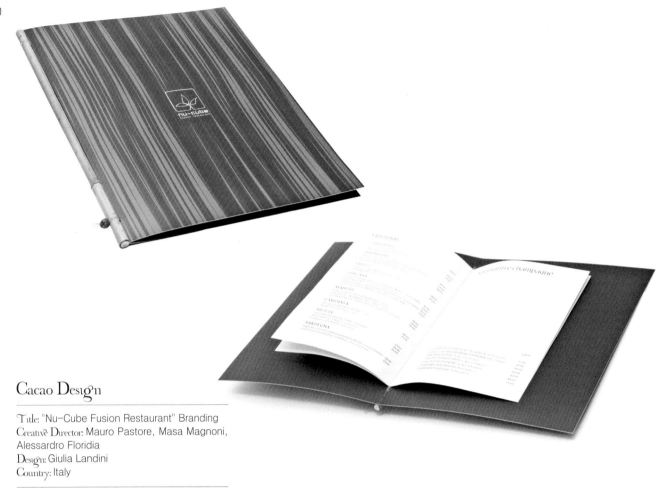

Cacao Design

Title: "Nu-Cube Fusion Restaurant" Branding
Creative Director: Mauro Pastore, Masa Magnoni,
Alessardro Floridia
Design: Giulia Landini
Country: Italy

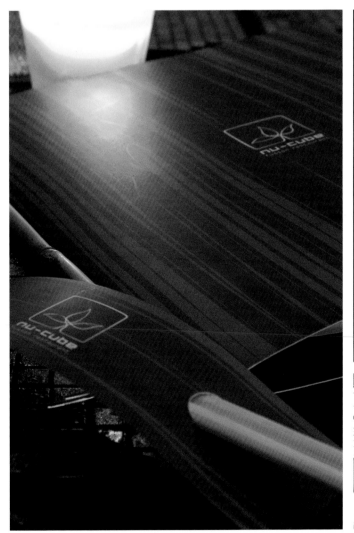

Mitch & Co.

Naroska Design

Title: Mitch & CO
Country: Germany

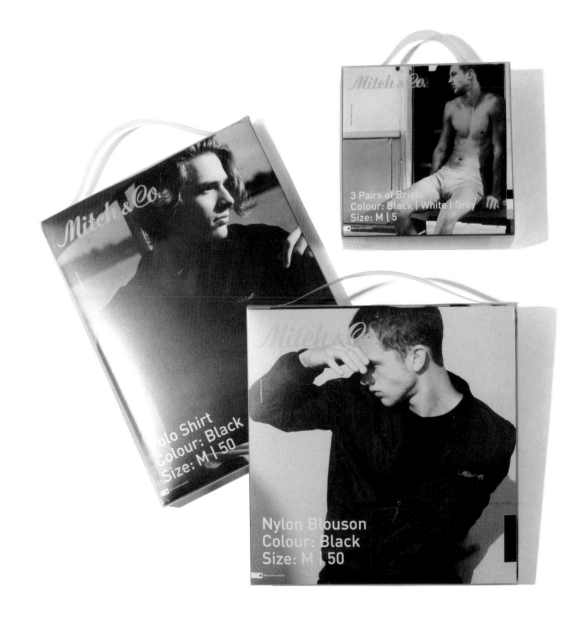

3 Pairs of Briefs
Colour: Black | White | Grey
Size: M | 5

Polo Shirt
Colour: Black
Size: M | 50

Nylon Blouson
Colour: Black
Size: M | 50

Mark Richardson Graphic Design

Title : Promotion of S&M Cafe
Designer : Mark Richardson
Country : Britain

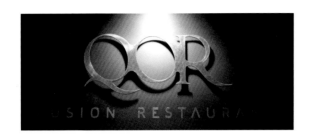

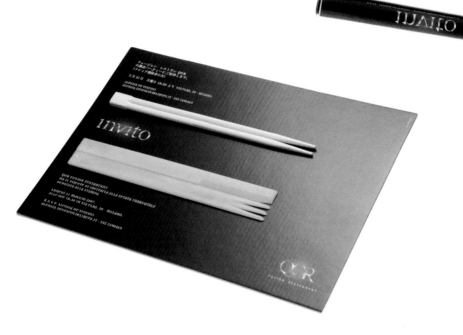

Cacao Design

Title : "Qor Fusion Restaurant" Total Rebranding
Creative Director : Mauro Pastore, Masa Magnoni,
Alessandro Floridia
Design : Giulia Landini
Country : Italy

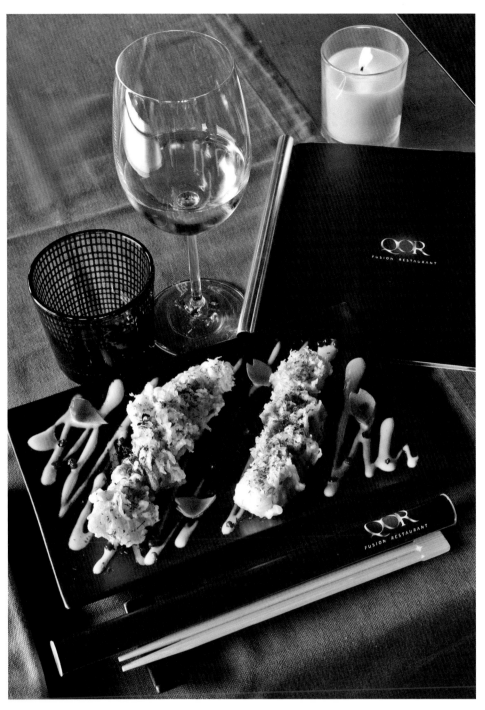

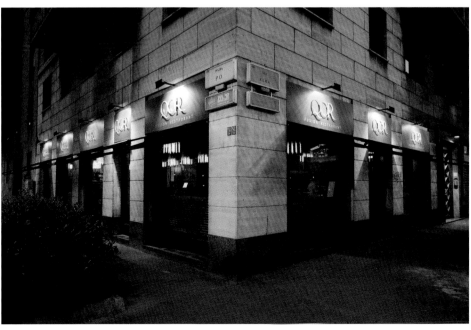

COEN!

Title : Nederlandse Publieke Omroep
Design : Coen van Ham
Country : The Netherlands

visicon

Visicon GmbH

Hardstrasse 219/K2
CH-8005 Zürich

T: + 41 (43) 817 13 43
F: + 41 (43) 817 13 44

www.visicon.ch
info@visicon.ch

13.01.2005

MwSt.-Nr. 568713

Deutsche Bank AG
D-Singen
733634

...ten ein neues Er-
...wendung

visicon

...erschenken? Warum jährlich
...lassen? Und

Visicon GmbH

Hardstrasse 219/K2
CH-8005 Zürich

T + 41 (43) 817 13 43
F + 41 (43) 817 13 44
M + 41 (76) 596 82 63

sebastian.raum@visicon.ch

CH-8005 Zürich

T + 41 (43) 817 13 43
F + 41 (43) 817 13 44
M + 41 (79) 452 78 49

rachel.adam@visicon.ch

visicon

Sebastian Raum
Managing Director

Visicon GmbH

Hardstrasse 219/K2
CH-8005 Zürich

T + 41 (43) 817 13 43
F + 41 (43) 817 13 44
M + 41 (76) 596 82 63

...raum@visicon.ch

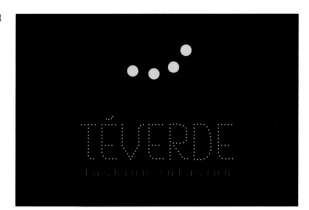

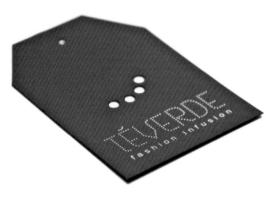

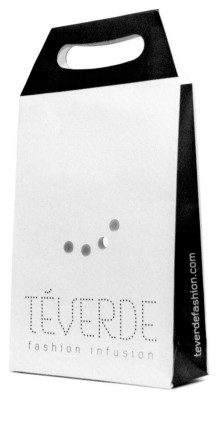

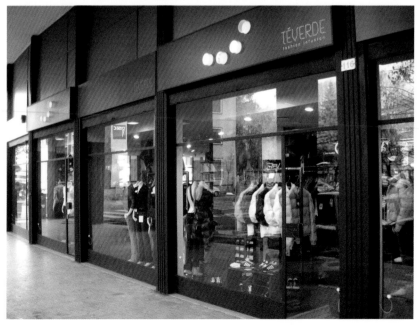

Cacao Design

Title : "Téverde" Branding
Creative Director : Mauro Pastore, Masa
Magnoni, Alessandro Floridia
Design : Giulia Landini
Country : Italy

Title : Mexas Hairwise
Design : Chris Trivizas
Country : Greece

Chris Trivizas Design

Title : Mexas Hairwise
Design : Chris Trivizas
Country : Greece

Naroska Design

Title : Santaverde
Country : Germany

SANTAVERDE
Natural Cosmetics and Nutrifood

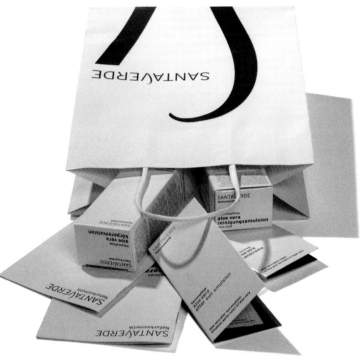

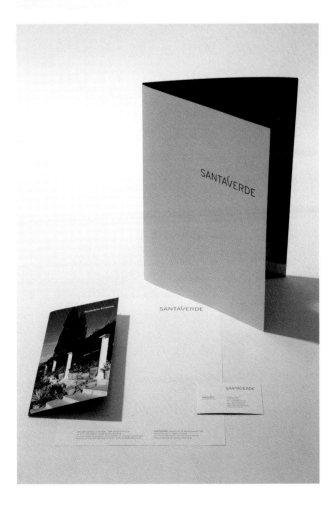

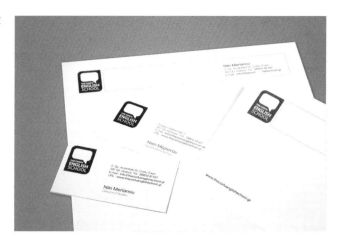

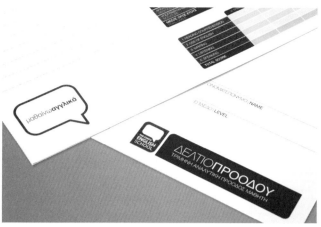

Chris Trivizas Design

Title : The Corfu English School
Creative Director : Chris Trivizas
Design : Katerina Kotti
Country : Greece

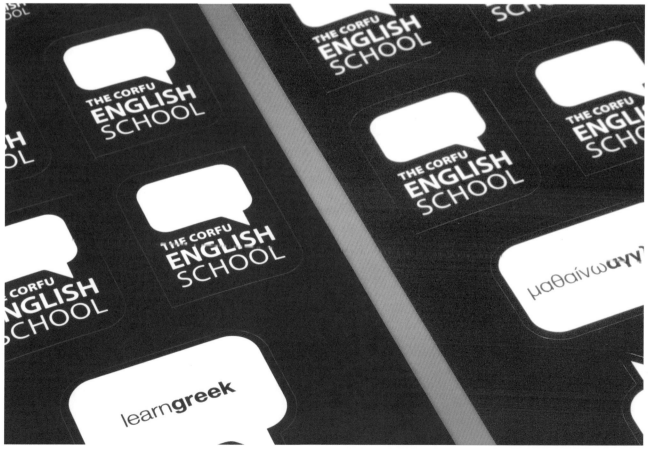

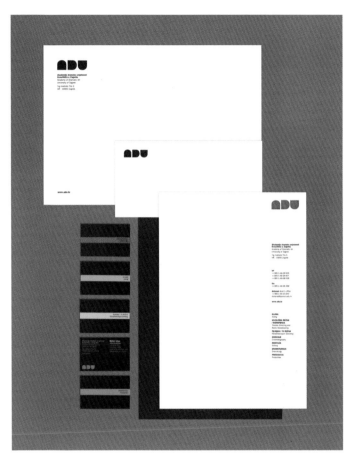

Laboratorium

Title : ADU logo / Stationary
Design : Ivana Vucic, Orsat Frankovic
Country : Croatia

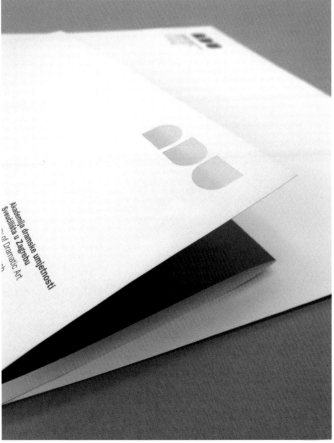

GLUMA
Acting

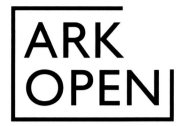

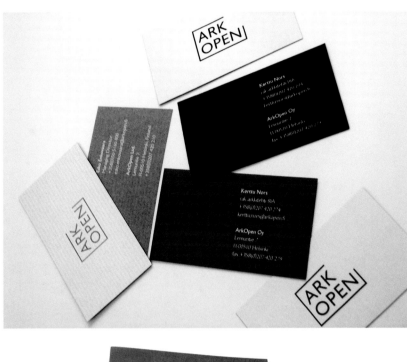

Hahmo Design Ltd

Title : Ark Open
Art Director : Antti Raudaskoski
Design : Antti Raudaskoski, Paco Aguayo
Country : Finland

moor

Hahmo Design Ltd

Title : Moor
Design : Pekka Piippo
Country : Finland

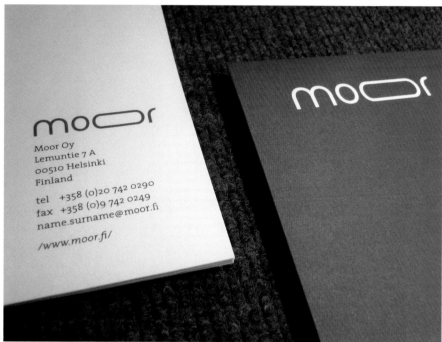

moor

Moor Oy
Lemuntie 7 A
00510 Helsinki
Finland

tel +358 (0)20 742 0290
fax +358 (0)9 742 0249
name.surname@moor.fi

/www.moor.fi/

SARI
ANTTONEN

moor

muotoilujohtaja · DESIGN MANAGER

sari.anttonen@moor.fi
tel +358 (0)20 742 0292
mob +358 (0)40 503 6536
fax +358 (0)20 742 0249

Moor Oy
Lemuntie 7 A
00510 Helsinki
Finland

/www.moor.fi/

Naroska Design

Title : Baltic Study Net
Country : Germany

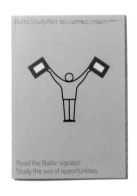

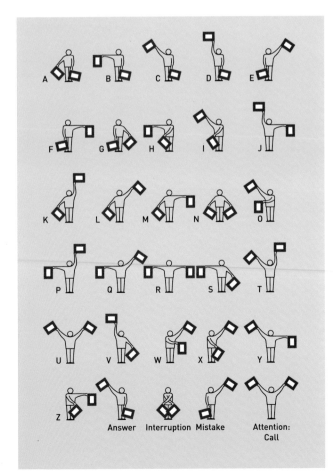

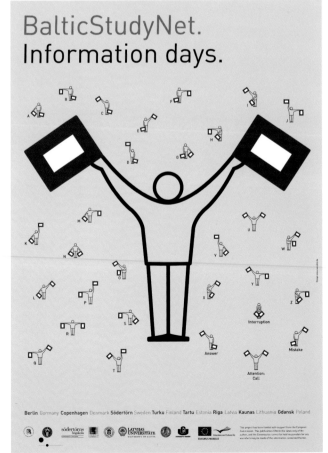

Naroska Design

Title : C\O Berlin
Country : Germany

C|O Berlin

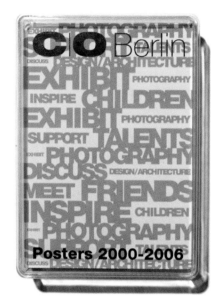

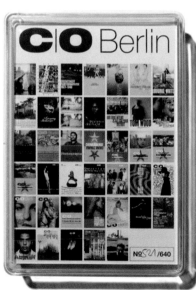

Naroska Design

Title : M100 Sanssouci Colloquium
Country : Germany

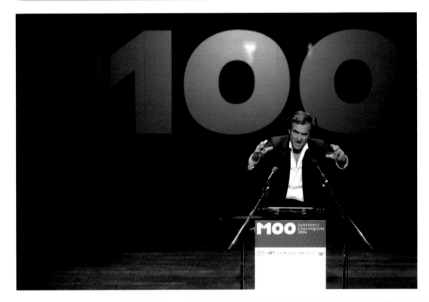

Ohlsonsmith

Title : CarrierCarrier
Design : Ohlsonsmith
Country : Sweden

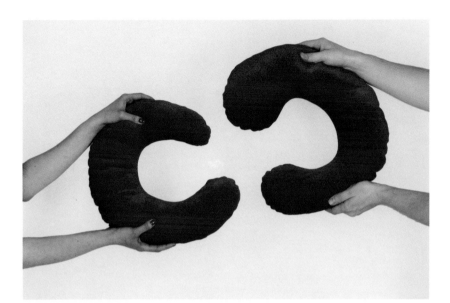

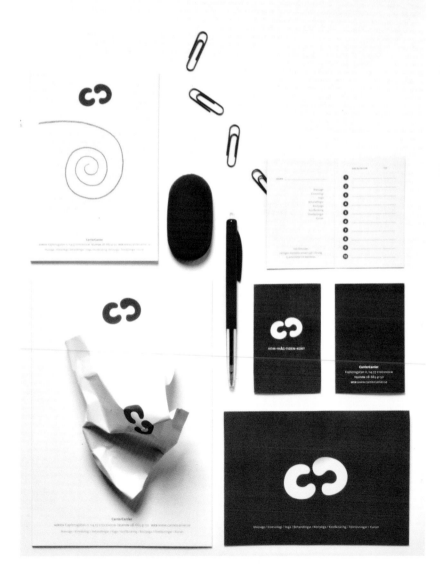

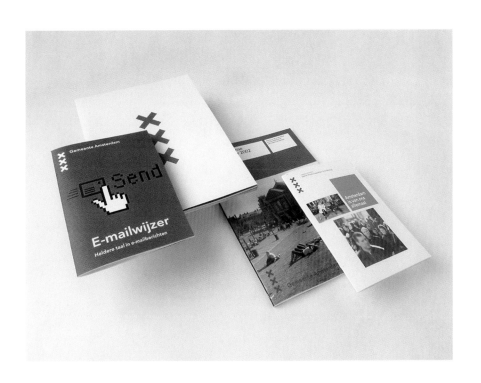

Eden Design & Communication

Title : The Style of Amsterdam
Creative Director : Edovan Dijk, Jan Brinkman
Strategy : Joost Mogendorff
Project Management : Bart Leupen, Maartje Kuijpers
Design : Earik Wiersma, Thomas Widdershoven, Nikki
Gonnissen, Walter van Gerwen, Bas Mulder, Margriet
Blom, Rik Koster, Jasper van Delft and many others
Country : The Netherlands

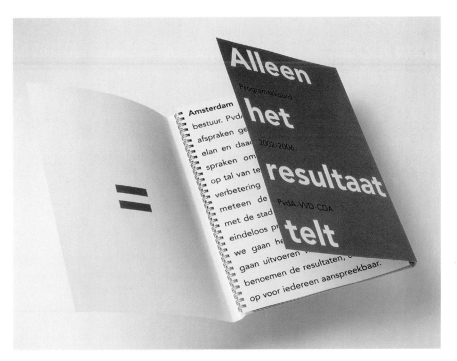

Hesse Design

Title : AAP Corporate Design
Creative Director : Klaus Hesse
Art Director : Christoph Zielke
Design : Sandra Klemt
Illustration : Christoph Eielke, Carsten Hardt
Country : Germany

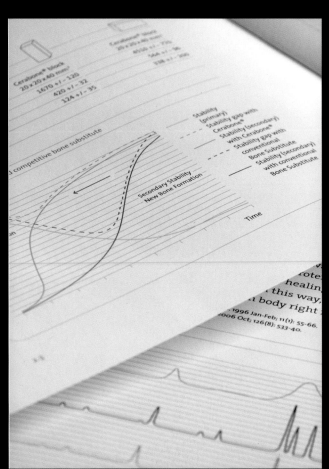

BACHE

Muggie Ramadani
Design Studio APS

Title : Mikkel Bache, Photographer / Corporate Identity
Design : Muggie Ramadani
Country : Denmark

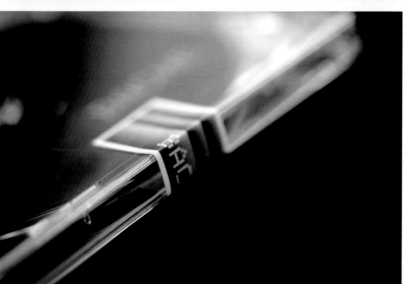

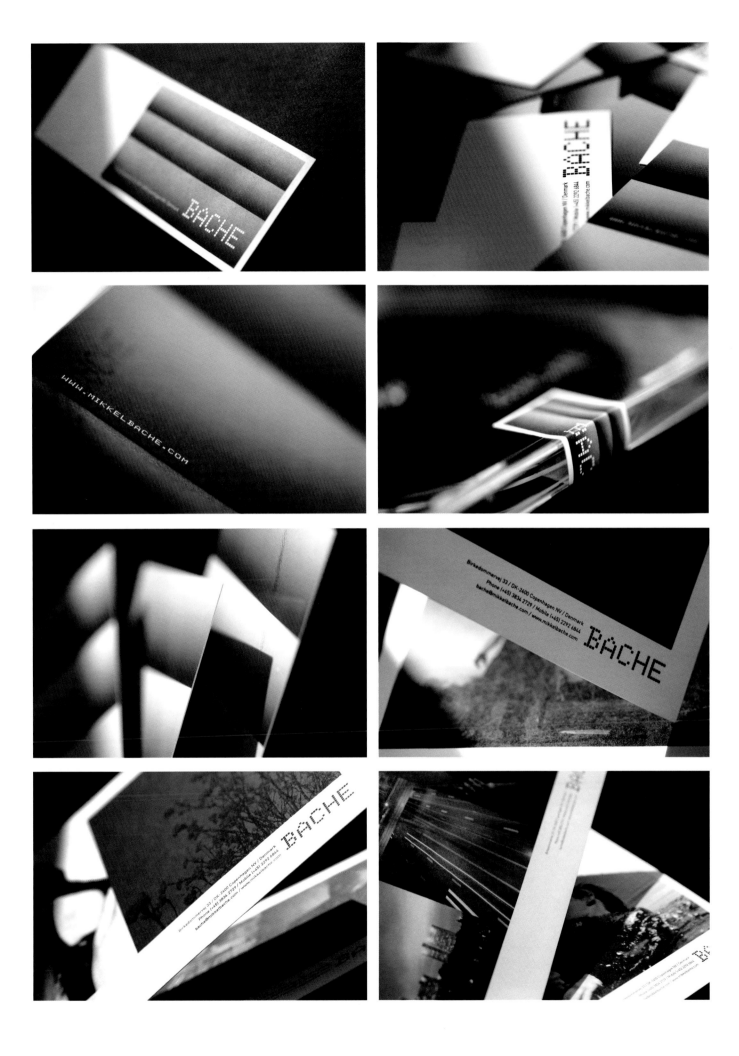

Muggie Ramadani Design Studio APS

Title : Bitsch + Lundquist / Corporate Identity
Design : Muggie Ramadani
Country : Denmark

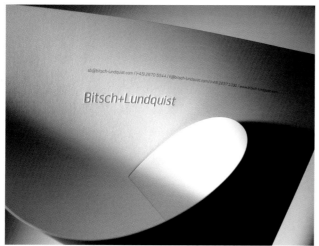

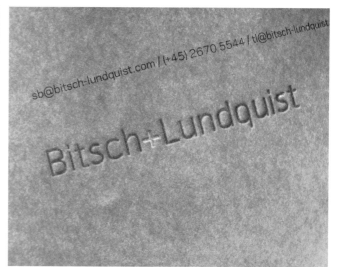

Muggie Rmadani Design Studio ApS

Title : Teedot / Corporate Identity
Design : Muggie Ramadani
Country : Denmark

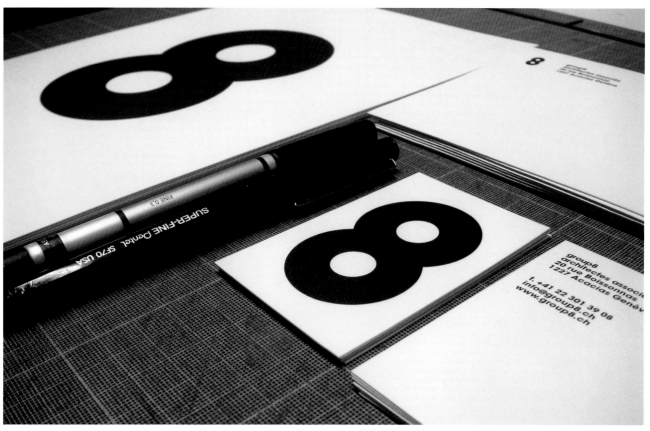

GVA Studio

Title : Corporate Identity for Group
8 Associate Architects
Country : Switzerland

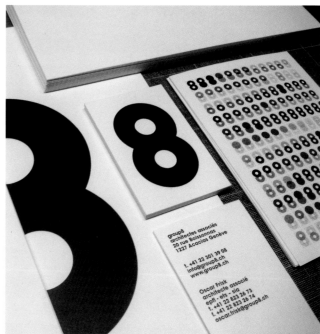

Brachia

premium maslinovo ulje
bračkih maslinika

Trudvajedan Market Communication Ltd.

Title : Brachia - Visual Identity and Products
Design : Izvoka Juric
Country : Croatia

Muggie Ramadani Design Studio APS

Title : ELI Digital Imagining / Corporate Identity
Design : Muggie Ramadani
Country : Denmark

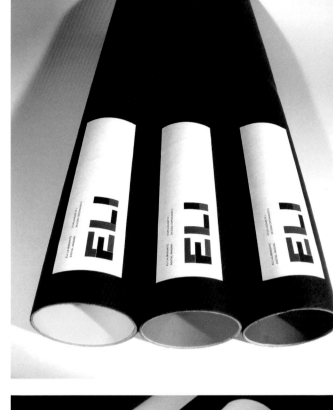

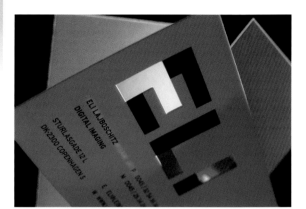

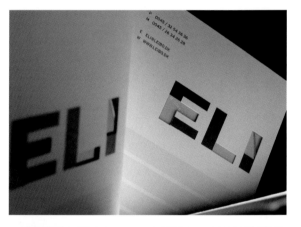

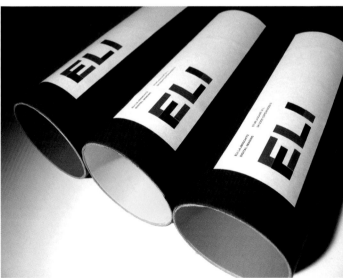

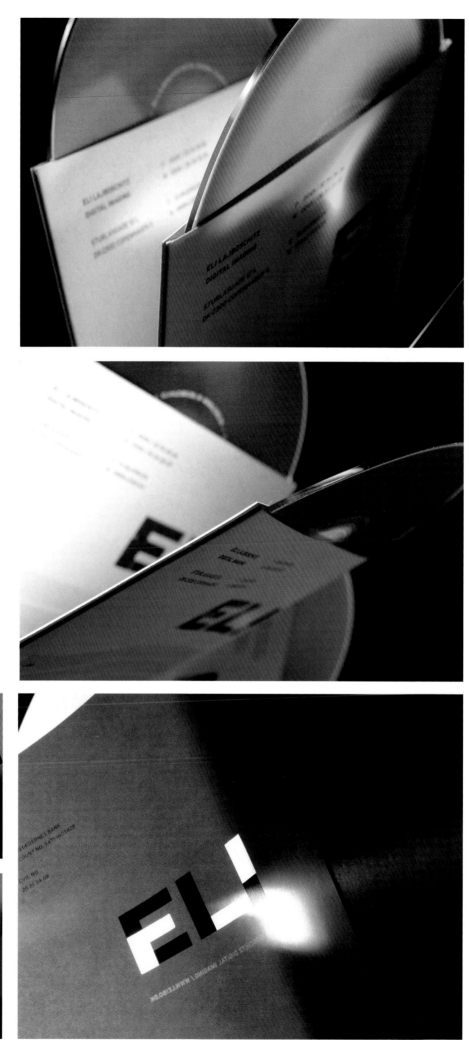
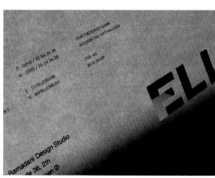
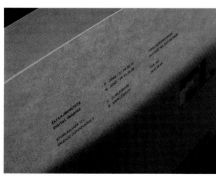

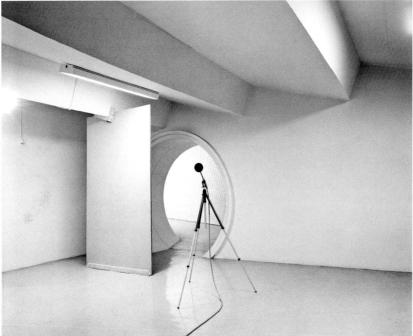

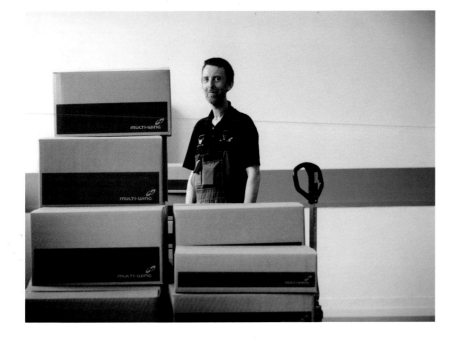

Muggie Ramadani Design
Studio APS

Title : Multi - Wing International / Corporate Identity
Design : Muggie Ramadani
Photography : Mikkel Bache
Country : Denmark

MULTI-WING

Ask any of our clients, and they'll tell you that our [...] reasons for Multi-Wing being the first choice of engi[...] Why? Because not only has the tunnel enabled us to [...] impeller design and to develop the most comprehens[...] in the market. It also produces vital empirical data of [...] and reliability.

Thanks to the tunnel, we can even offer to suggest impro[...] own application. Not only can we qualify the precise airfl[...] the impact on performance of construction changes to the [...] All you have to do is let us know.

› More at multi-wing.com/windtunnel

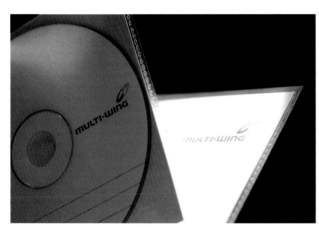

Muggie Ramadani
Design Studio APS

Title : Quadric / Corporate Identity
Design : Muggie Ramadani
Country : Denmark

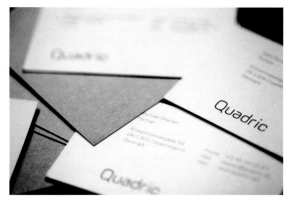

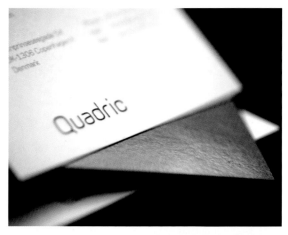

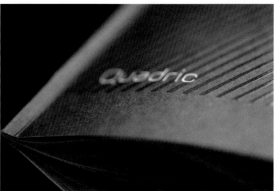

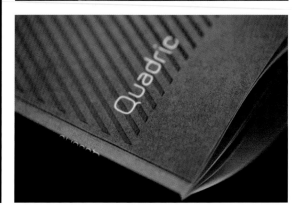

Muggie Ramadani Design
Studio APS

Title : Portfolio - CPH / Corporate Identity
Design : Muggie Ramadani
Country : Denmark

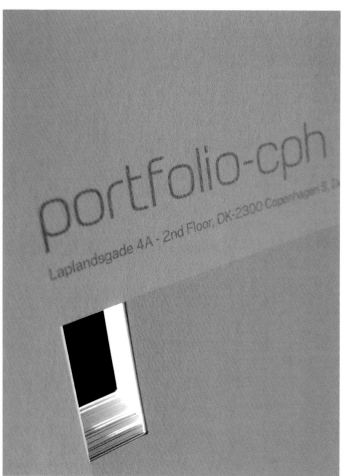

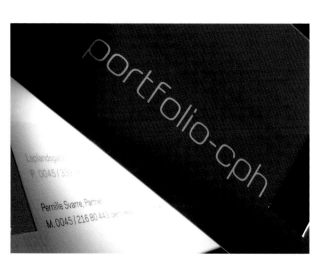

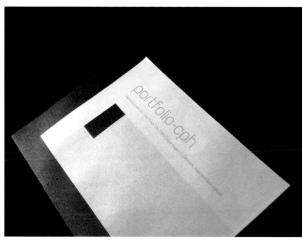

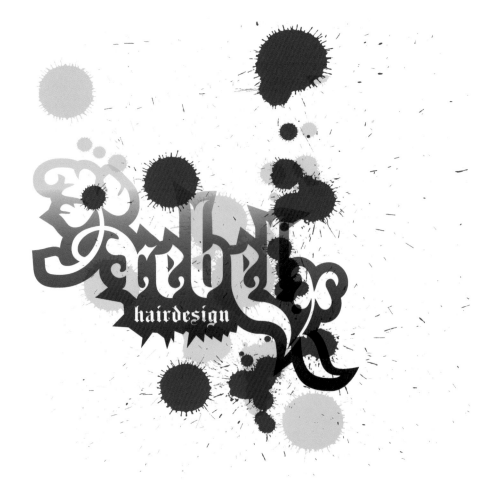

Muggie Ramadani Design Studio APS

Title : Rebel Hairdesign / Corporate Identity
Design : Muggie Ramadani
Illustration : Muggie Ramadani
Photography : Mikkel Bache
Country : Denmark

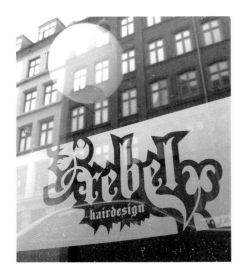

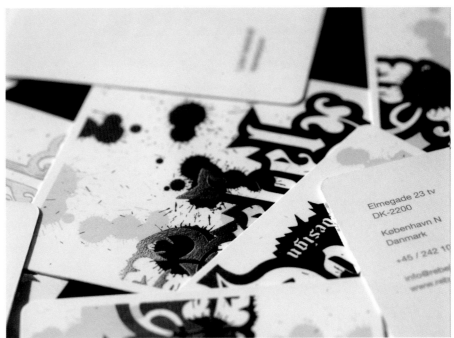

Elmegade 23 tv
DK-2200

København N
Danmark

+45 / 242 10

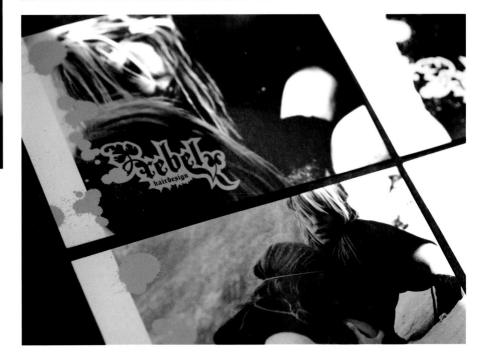

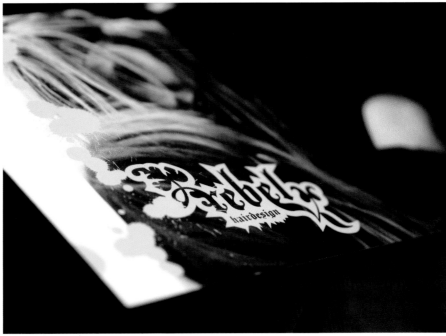

TRIDVAJEDAN *tržišne komunikacije*

TRIDVAJEDAN *tržišne komunikacije*

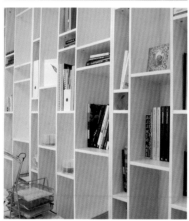

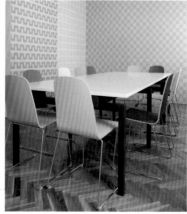

Tridvajedan Market
Communication Ltd.

Title : Tridvajedan - Rebranding
Design : Izvorka Juric
Country : Croatia

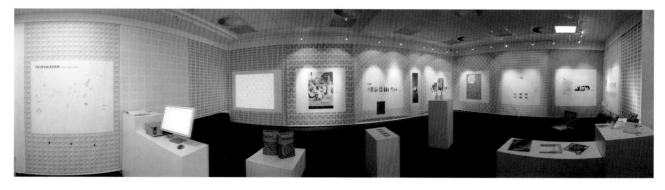

TRIDVAJEDAN *tržišne komunikacije*

www.tridvajedan.hr

ETK galerija
Ericsson Nikola Tesla, Zagreb, Krapinska 45
25.01. - 02.02.2007.

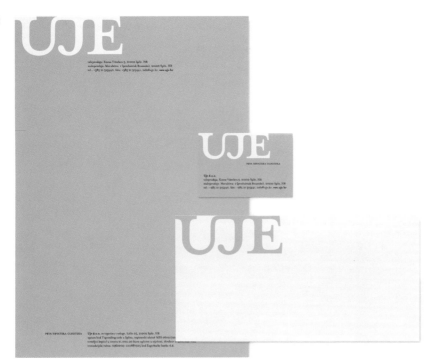

THE FIRST CROATIAN OLIVE OIL SHOP

Tridvajedan Market
Communication Ltd.

Title : Uje - Visual Identity
Design : Izvorka Juric
Country : Croatia

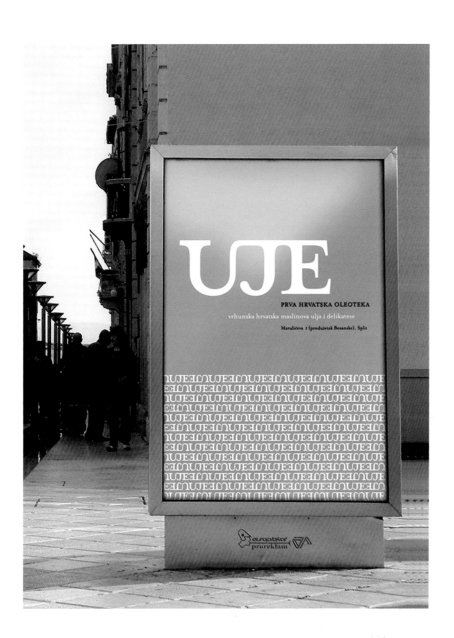

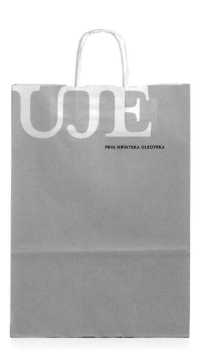

Neue Marke fähige wurzelten er-ourg an der Wise 2000 ausgestellt. Die
presente der Messestands betische höchst verstärkt formulation/kit-en von
flage. Die Untersdung wurchen produe nachem auf ein betricks-fallen
routenderbud über die Rücks paut des Messestands zapp bei highlight bei
produkter, der als Sektion unster wieder neue Produkte in Serie setzt.

ng'n

orporate Design
Christine Hesse
nus Hesse
ph Zielke, Silke Heiburg,

er Oprach
laudia Kempt
any

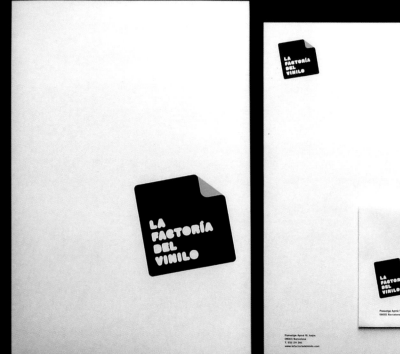
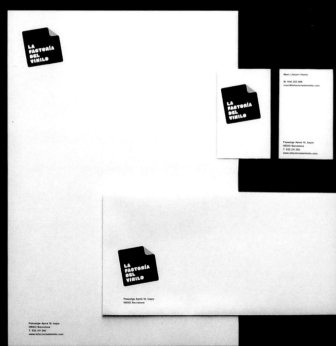
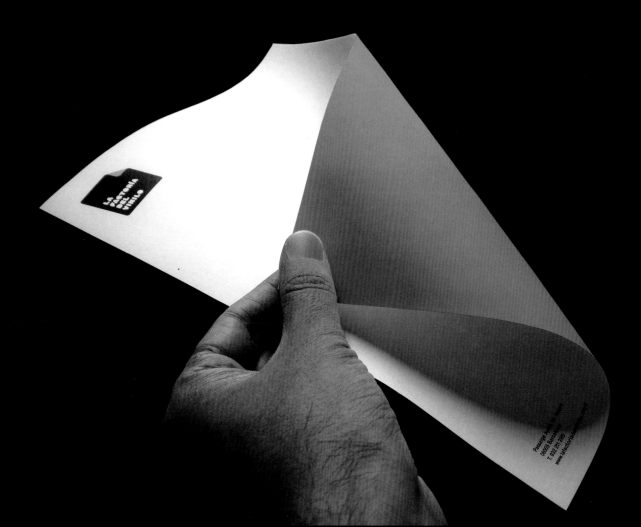

Siv**Kraft**

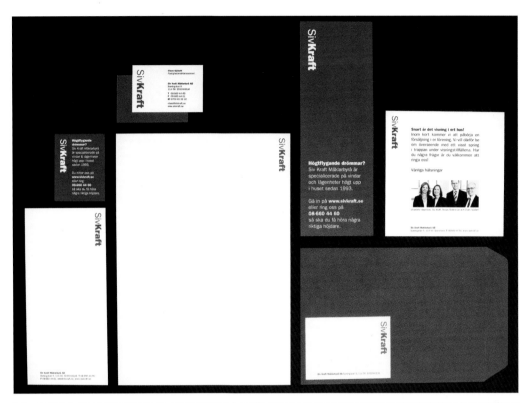

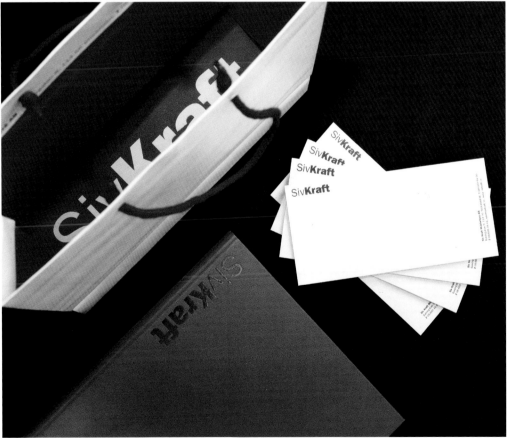

Erika Rennel Bjorkman
Graphic Design

Title : Siv Kraft Estate Agent
Design : Erika Rennel Bjorkman
Country : Sweden

alsterdorf

krankenpflegeschule

krankenpflegeschule

Büro Uebele Visuelle Kommunikation

Title : Visual Identity Evangeli-sche Stiftung Alsterdorf, Hamburg 2007
Creative Director : Andreas Uebele
Art Director : Alexandra Busse
Design : Katrin Hafner
Country : Germany

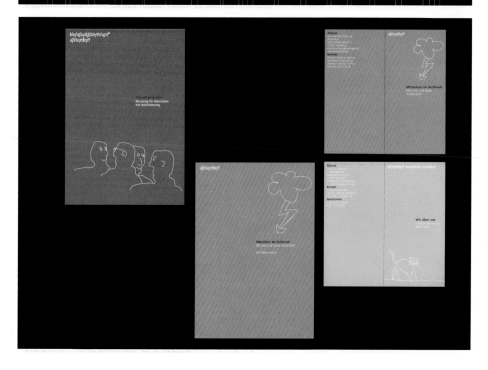

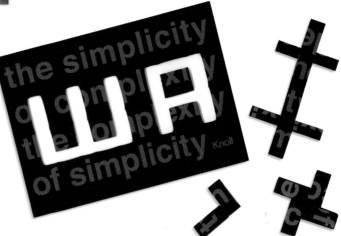

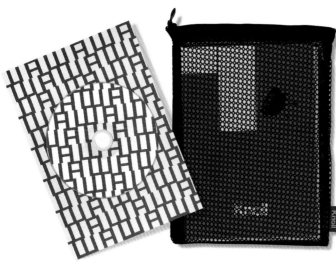

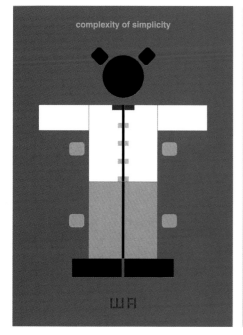

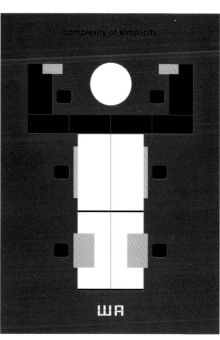

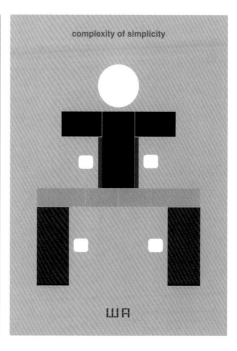

Ginette Caron
Communication Design

Title : WA Technical Catalogue
Design : Ginette Caron
Photography : Mario Carrieri
Country : Italy

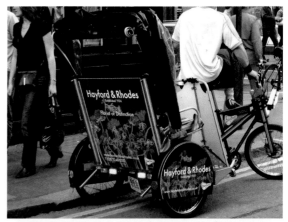

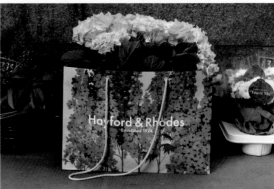

Company

Title : Hayford and Rhodes
Illustration : Farioa El Gazzar
Country : Britain

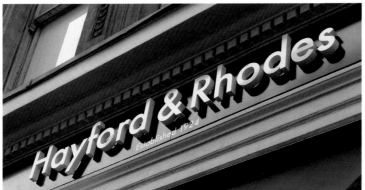

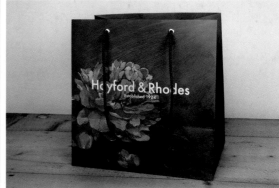

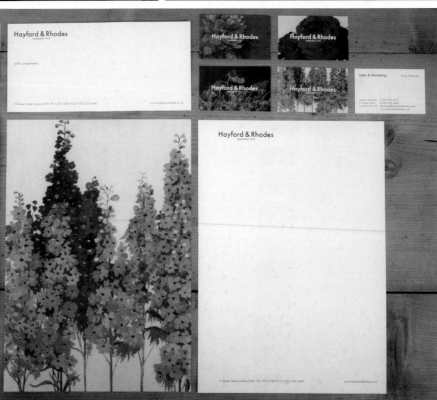

Orientation System

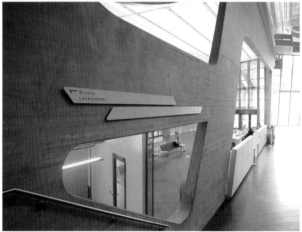

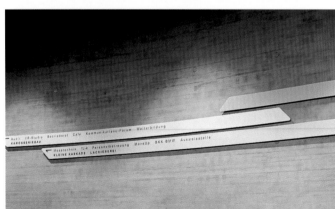

Moniteurs

Title : BMW Plant Leipzig
Country : Germany

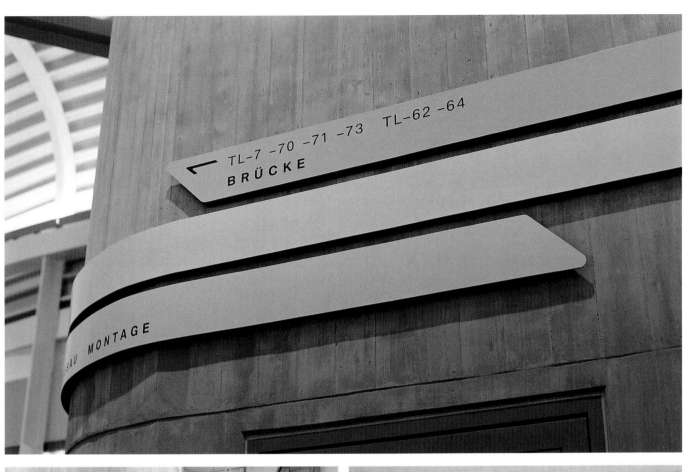

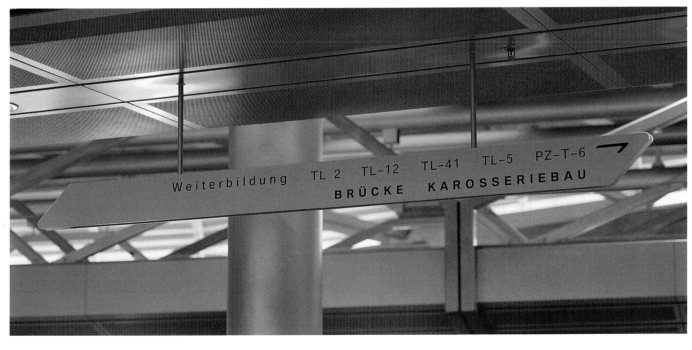

ABCDEFGHIJKLN
OPQRSTUVWXYZ
1234567890(!?)

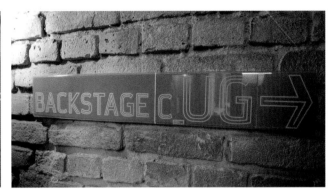

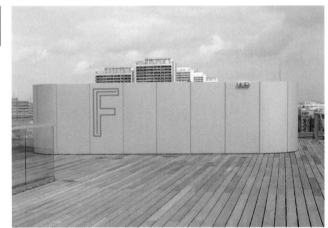

Monteurs

Title : E-Werk
Country : Germany

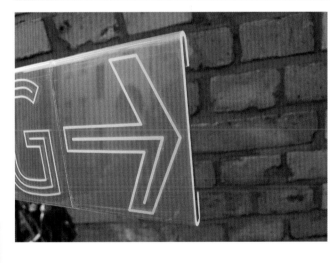

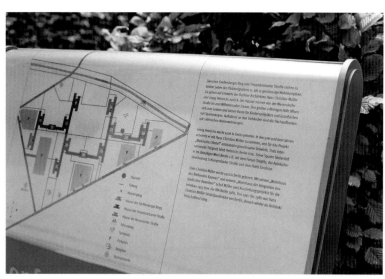

Monteurs

Title : Markisches Viertel
Country : Germany

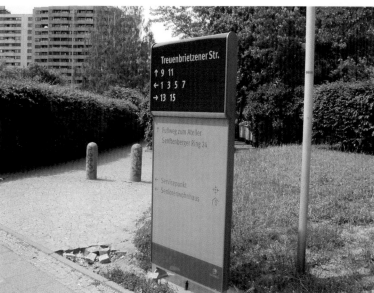

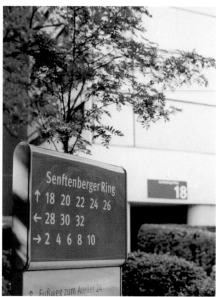

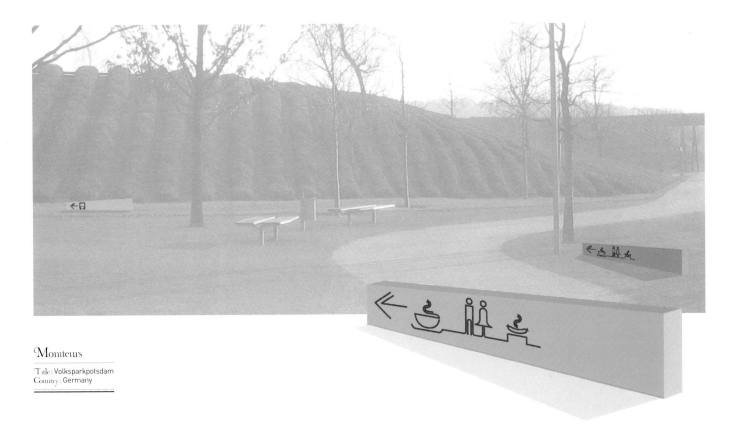

Monteurs

Title : Volksparkpotsdam
Country : Germany

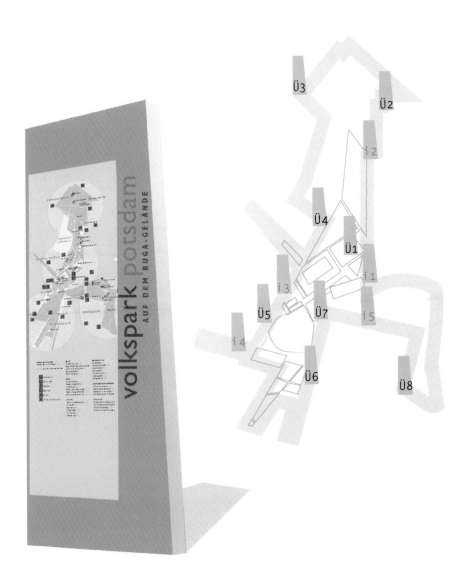

POI

++++++++ POINTS OF INTEREST
++07++WELCOME!

POI

Monteurs

Title : Points of Interest
Country : Germany

InfoTracks

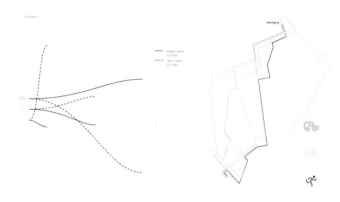

::::: WWW.MONITEURS.DE/INFOTRACKS
::::: GRAFIK UND TYPOGRAFIE IM STADTRAUM BERLIN

::::: BERLIN BLANKO

Moniteurs

Title : Infotracks
Country : Germany

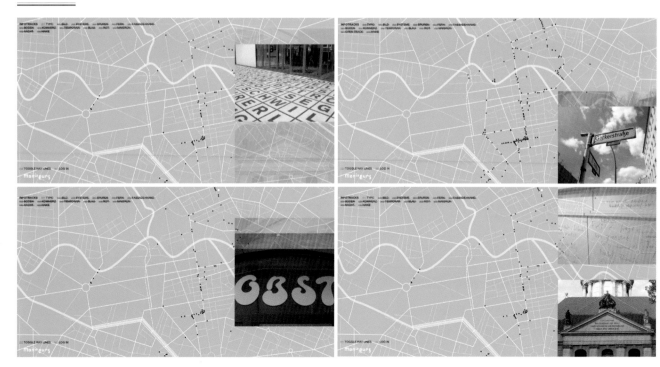

Turkish

US English

Estonian

Norwegian

Chinese

Hijack Your Life

Title : Colour System
Design : Kalle Mattsson
Country : The Netherlands

Hahmo Design Ltd

Title : Ideapark Orientation System
Creative Director : Antti Raudaskoski, Ilona Tormikoski
Art Director : Antti Raudaskoski, Jenni Kuokka
Design : Ilona Tormikoski, Antti Raudaskoski, Jenni kuokka, Jenni Huttunen, Tanja Sipil
Country : Finland

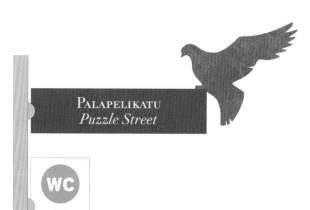

Keskuspuistoon
To Central Park

Palapelikadulle
To Puzzle Street

Vanhaan Kaupunkiin
To Old Town

Kompassikadulle
To Compass Street

Pallokadulle
To Ring Street

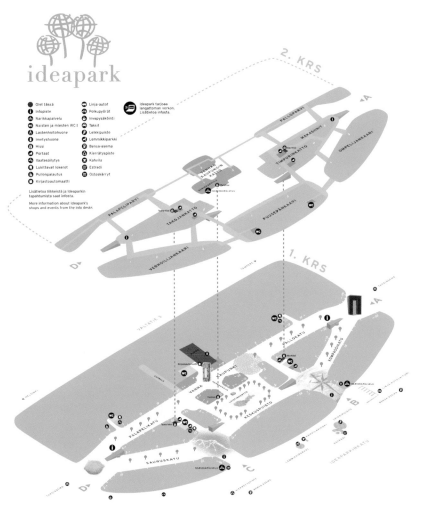

LIIKKEET

A
Aitoleipä *Keskuspuisto 1*
A-Sofia *Pallokatu 3*
Aleksi 13 *Kompassikatu 18*
Alko *Palapelikatu 5*
Andiata *Catwalk, Palapelikatu 27*
Anni lautteet *Makasiinit, Timpurinkatto 3*
Apteekki Ideapark *Sauruskatu 24*
Arnold's Donuts *Pallokatu 2*
Ateljeekatu *Vanha Kaupunki 15*

B
Bag Stage *Pallokatu 19*
Bianco Footwear *Palapelikatu 23*
Bobo *Keskuspuisto 22*
Body Shop *Keskuspuisto 16*
Bono & Nero *Catwalk, Palapelikatu 27*
BR-Lelut *Kompassikatu 15*
Budget Sport *Palapelikatu 11*

C
Café Delisa, Liisan Leipomo *Vanha Kaupunki 18 / Keskuspuisto 9*
Café Linkosuo *Keskuspuisto 3*
Captain Hook *Keskuspuisto 8*
Catwalk Square *Catwalk, Palapelikatu 27*
Change *Pallokatu 4*
CS lahjat, sisustus, matkamuistot *Sauruskatu 17*
Cult *Catwalk, Palapelikatu 27*

D
Dansko *Sauruskatu 14*
Dna Kauppa *Pallokatu 14*
Dressmann *Keskuspuisto 28*

E
Ecco Shop *Kompassikatu 9*
Elega-Keittiöt *Makasiinit, Timpurinkatto 3*
Enfantti *Palapelikatu 18*
Erlund-talot *Makasiinit, Timpurinkatto 3*
Esprit *Sauruskatu 18*
Eurokangas *Ompelijankaari 2*
Euromarket *Palapelikatu 1*
Euronehouse, indesign ti *Palapelikatu 21*
Expert Konepiste *Sauruskatu 8*

F
Farkkujen tehtaanmyymälä *Sauruskatu 23*
Faunatar *Kompassikatu 3*
Figura Shop *Kompassikatu 7*
Finlayson *Pallokatu 21*

G
Galleria A *Vanha Kaupunki 17*
Galleria Valo ja Varjo *Vanha Kaupunki 7*
Gant *Catwalk, Palapelikatu 27*
Geopro maalämpöpumput *Makasiinit, Timpurinkatto 3*
Glitter *Sauruskatu 14*
Golden Rax Pizzabuffet, Martina *Keskuspuisto 17*
Golden Rose *Vanha Kaupunki 1*

H
H&M Hennes&Mauritz *Keskuspuisto 26*
HairStore *Pallokatu 3*
Hemtex *Sauruskatu 21*
Hesburger *Keskuspuisto 15*

I
IdeaKimara *Palapelikatu 10*
Ideapark uutiset *Palapelikatu*
Ikivihreä *Pallokatu 8*
Indiq Living *Palapelikatu 25*
Instrumentarium *Sauruskatu 19*
Isku *Verhoilijankaari 3*

J
Jalokivigalleria *Sauruskatu 13*
JC Jeans&clothes, Brothers, Sisters *Kompassikatu 12*
Jesper Junior *Palapelikatu 5*

K
Kahvila Piparkakku *Keskuspuisto 6*
KappAhl *Pallokatu 26 / Kompassikatu 11*
Karkkiparkki *Keskuspuisto 25*
Katse Hinnoksa Optiikka *Pallokatu 12*
Kenkäidea, Anne Linnanmaa *Kompassikatu 3*
Kermansavi *Palapelikatu 21*
Keskiaika *Vanha Kaupunki 3*
Kicks *Pallokatu 5*
Kirami *Makasiinit, Timpurinkatto 3*
Kirjapörssi *Sauruskatu 5*
Kirjatori *Pallokatu 10*
K-kenkä *Sauruskatu 10*
Kodin Onni *Verhoilijankaari 2*
Kolvaan Kala *Vanha Kaupunki 12*
Kotamestarit Lapland Wood Oy *Makasiinit, Timpurinkatto 3*
Koti-Idea, Toivenaitto *Puusepänkaari 1*
Kotipalvi, Levonen Iitapuoli *Keskuspuisto 5*
Kotipizza *Vanha Kaupunki 19*
Kruunukaluste *Pallokatu 1*
Kukkakauppa Orvokki *Palapelikatu 9*
Kultajousi *Palapelikatu 6*
Kultamuratti *Sauruskatu 7*
KuumaLähde *Makasiinit, Timpurinkatto 3*
Käsityöpaja Kivinen *Vanha Kaupunki 1*

L
Lahja ja Sisustus Pussukka *Sauruskatu 2*
Lasten ja nuorten kulttuurikeskus
Leipomo Ståhlberg *Vanha Kaupunki 10*
Lindex *Kompassikatu 5*
Logistiikkakeskus
Lumo Käsityöläisten puoti *Vanha Kaupunki 2*
Lundia *Palapelikatu 25*
Luonto Taika *Palapelikatu 3*

M
Majakivi *Makasiinit, Timpurinkatto 3*
Makuelämys *Keskuspuisto 11*
Mango *Keskuspuisto 18*

Marc O'Polo *Catwalk, Palapelikatu 27*
Marimekko *Kompassikatu 20*
MarkanTalo *Palapelikatu 1*
Marlboro Classics *Catwalk, Palapelikatu 27*
Martinello Mosaics *Makasiinit, Timpurinkatto 3*
Maruseki *Vanha Kaupunki 9*
Masku *Ompelijankaari 1 / Timpurinkatto 2*
Mekka *Palapelikatu 14 / Sauruskatu 15*
Minimani *Pallokatu 17*
Moko *Keskuspuisto 13*
Mummola Lahjapuoti *Vanha Kaupunki 8*

N
Nahka Albert *Pallokatu 9*
Netrauta.fi *Makasiinit, Timpurinkatto 3*
Nettiemme.fi, Home 4 You Helsinki *Makasiinit, Timpurinkatto 3*
Nicky & Nelly *Sauruskatu 16*
NP *Pallokatu 18*
Nunnaäluni *Makasiinit, Timpurinkatto 3*

O
Ollon *Makasiinit, Timpurinkatto 3*
Oscar Jacobson *Catwalk, Palapelikatu 27*
Osmia *Vanha Kaupunki 21*
Oui moments *Catwalk, Palapelikatu 27*

P
Pancho Villa *Vanhankaupunginkatto 3*
Partiokauppa *Palapelikatu 12 / Sauruskatu 11*
Pentik *Kompassikatu 13*
Pertti Palmroth *Pallokatu 23*
Pihla Ikkunat ja Ovet *Makasiinit, Timpurinkatto 3*
Pizzeria Hovikokki *Keskuspuisto 17*
Potti *Keskuspuisto 19*
Pullonpalautus *Palapelikatu 3*

R
REA Keittiöt *Makasiinit, Timpurinkatto 3*
R-Kioski *Sauruskatu 3*
Robert's Coffee, Spice Ice *Palapelikatu 22*
Rosendahl *Makasiinit, Timpurinkatto 3*

S
Saku's Galley *Keskuspuisto 2*
Saniroc kylpytilat, Kahi kivitalot *Makasiinit, Timpurinkatto 3*
Saunansydän Spas *Makasiinit, Timpurinkatto 3*
Seppälä *Keskuspuisto 11*
Shake'm Smooth *Keskuspuisto 10*
Shoe Park *Catwalk, Palapelikatu 27*
Signature Outlet *Catwalk, Palapelikatu 27*
Sin City *Pallokatu 7*
Sinelli *Kompassikatu 4*
SirunKaupat *Palapelikatu 3*
Sisustajan käsikirjasto *Keskuspuisto 3*
Sisustus.kangas.lahja.Marli *Sauruskatu 9*
Sisustus TeeGee *Palapelikatu 20*
Sonera Piste *Pallokatu 13*
Stadium *Keskuspuisto 13*
Stemma, Beds *Verhoilijankaari 1*
Stockmann Beauty *Sauruskatu 4*
Suklaakahvila *Vanha Kaupunki 13*
Sun FM *Palloparvi*
Suomen Asuntomarkkinat *Sauruskatu 5*
Suomen Kultapörssi, Kultasepänmestars
Aurlaber *Vanha Kaupunki 20*
Suomi-Soffa *Palapelikatu 3*
Superkuva *Sauruskatu 7*

T
TakkaCenter *Makasiinit, Timpurinkatto 3*
Tamaris, Mekka Outlet *Pallokatu 15*
Tampereen työterveys, Ideaparkin lääkäriasema, Pirkanmaan Fysio Center *Sauruskatu 26*
Taontapaja Tulikoira *Vanha Kaupunki 5*
Tapas *Kompassikatu 6*
Ten Art *Pallokatu 25*
Thaimaalainen ravintola *Vanha Kaupunki 16*
Tiimari *Kompassikatu 16*
Tilt Pelaajan Pelikauppa *Keskuspuisto 24*
Timantliset *Pallokatu 20*
Timberland *Catwalk, Palapelikatu 27*
Timon Kulta *Pallokatu 23*
Tokmanni *Pallokatu 1*
Tommy Hilfiger *Catwalk, Palapelikatu 27*
Top-Sport *Keskuspuisto 20*
Toys 'R' Us *Pallokatu 13*
Tähtiloptikko *Palapelikatu 8*
Tähtisaunat *Makasiinit, Timpurinkatto 3*

U
Unikulma *Timpurinkatto 1*

V
Veikon Kone *Sauruskatu 12*
Vepsäläinen, Bedroom Vepsäläinen, BoConsept *Puusepänkaari 2*
Veromoda, Jack&Jones, Exit *Kompassikatu 8*
Via Café *Vanha Kaupunki 20*
Vihannesmyynti P. Lehti *Vanha Kaupunki 14*
Villa Rosmarin *Pallokatu 6*

W
Wagner *Pallokatu 19*
Wellness Forum *Palloparvi*
Womena *Catwalk, Palapelikatu 27*

Y
Your Face *Keskuspuisto 12*

IDEAPARKIN TOIMISTO, KOKOUS- JA NÄYTTELYTILAT

Ideapark toimisto *Vanhankaupunginkatto 3*
Kokouskabinetti Kotka *Palapelikatu*
Kokouskabinetti Peippo *Palloparvi*
Kokouskabinetti Pääsky *Palapeliparvi*
Kokouskabinetti Tikka *Palapeliparvi*
Kokouskabinetti Tiihi *Palapeliparvi*
VIP Galleria *Vanhankaupunginkatto 1*
VIP Kokous *Vanhankaupunginkatto 1*

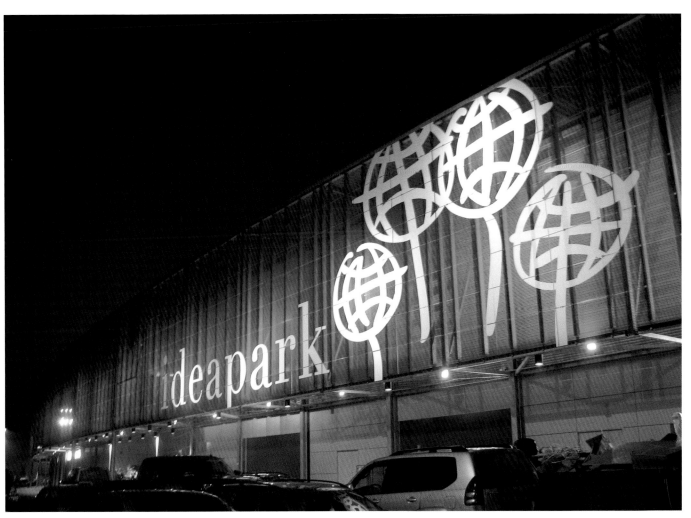

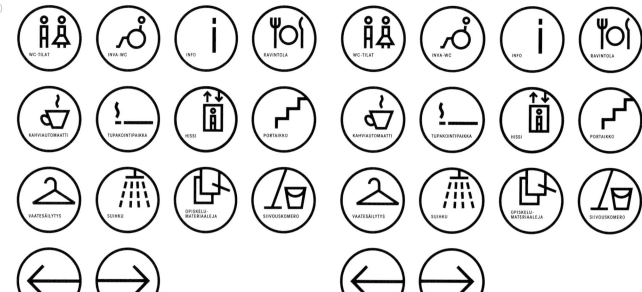

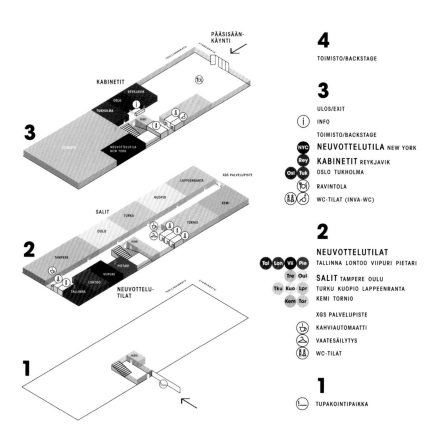

Hahmo Desig'n Ltd

Title : Rastor Orientation System
Creative Director : Ilona Tormikoski
Art Director : Jenni Kuokka
Desig'n : Jenni Kuokka, Hanna Nissila
Illustration : Jenni Kuokka
Country : Finland

Studio Annelys de Vet

Title : Interventies
Design : Annelys de Vet
Country : The Netherlands & Belgium

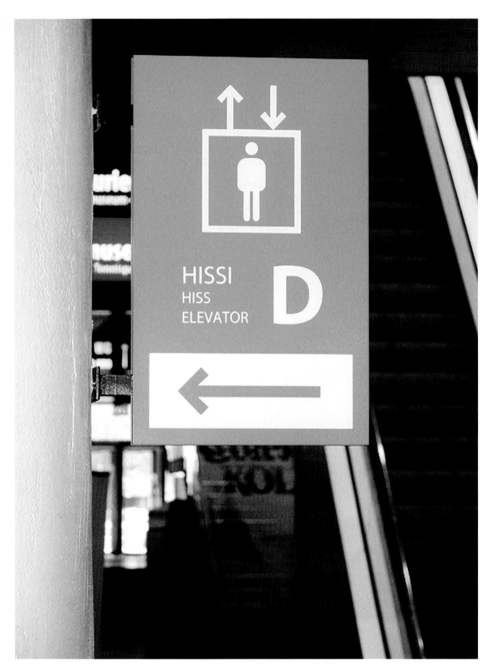

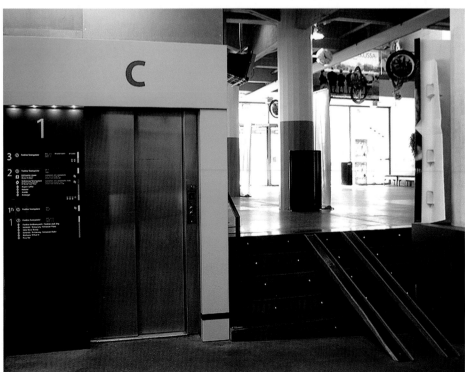

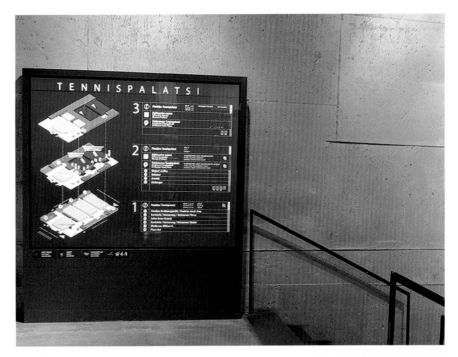

Hahmo Design Ltd

Title : Tennispalatsi
Creative Director : Antti Raudaskoski, Ilona Tormikoski
Art Director : Antti Raudaskoski
Design : Paco Aguayo, Antti Raudaskoski, Tanja Sipila
Country : Finland

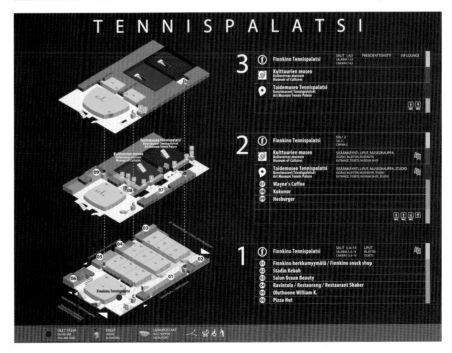

Büro Uebele Visuelle
Kommunikation

Title : Signage System DGF Stoess ag
Creative Director : Andreas Uebele
Art Director : Gerd Haubler
Photography : Andreas Korner
Country : Germany

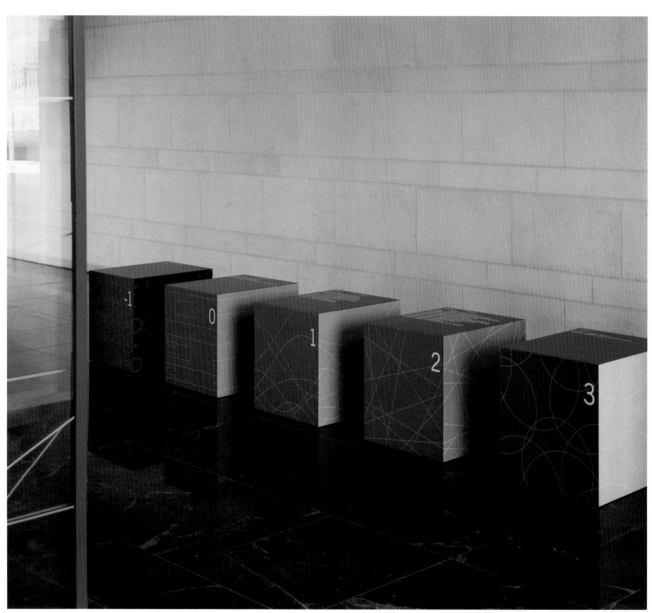

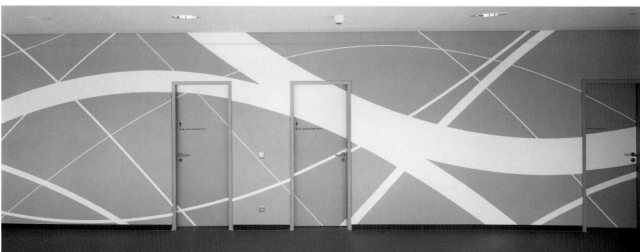

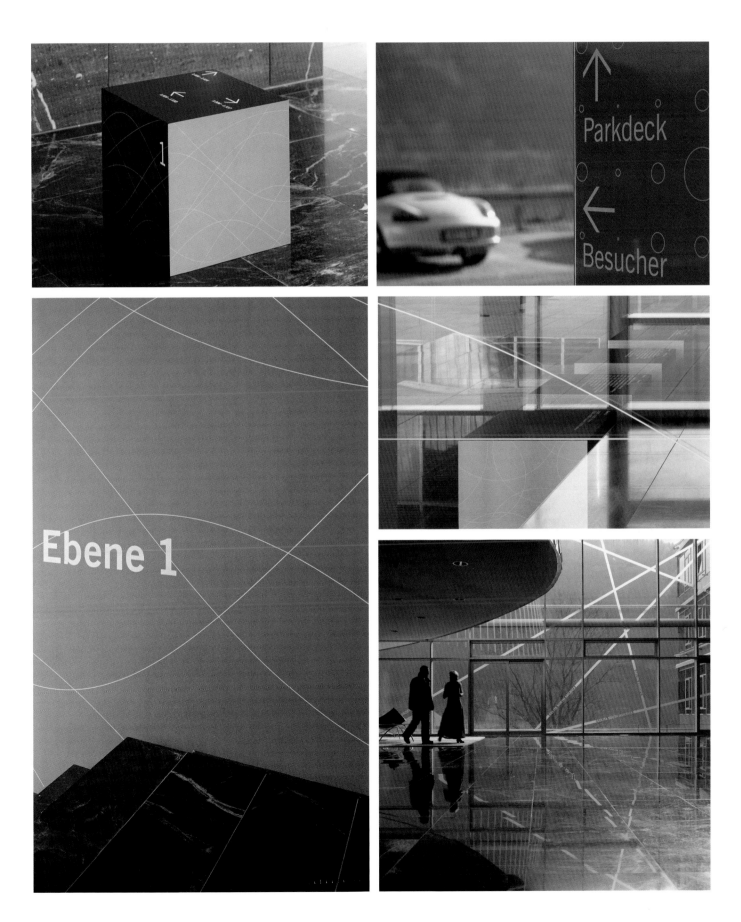

Büro Uebele Visuelle Kommunikation

Title : Information and Signage System Trade Fair and
Exhibition Center, Stuttgart 2007
Creative Director : Andreas Uebele
Art Director : Katrin Oittmann
Design : Katrin Hafner, Frank Geiger, Beate Gerner,
Benedikt Haid, Sabine Schonhaar
Photography : Andreas Korner, Christian Richters
Country : Germany

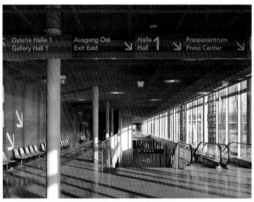
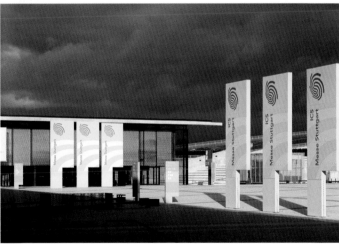

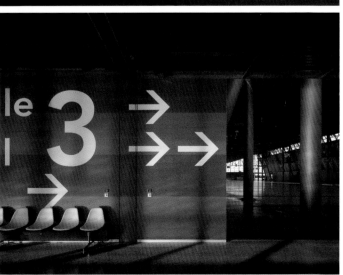
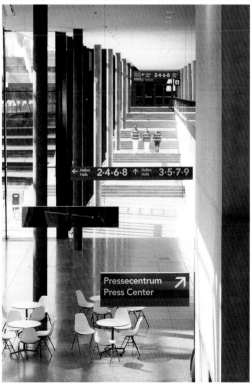

Büro Uebele Visuelle Kommunikation

Title : Signage System Osnabrock University of Applied Sciences
Creative Director : Andreas Uebele
Art Director : Gerd Haußler
Design : Gerd Haußler
Photography : Andreas Korner
Country : Germany

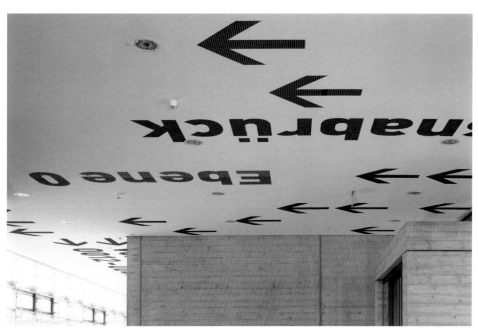

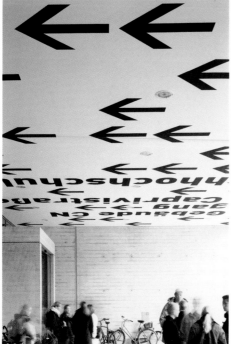

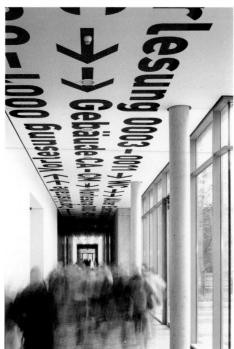

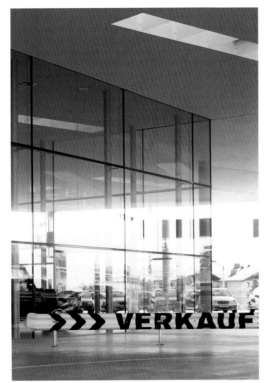

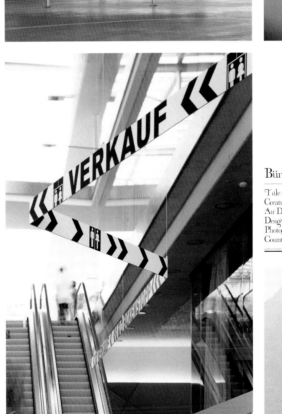

Büro Uebele Visuelle Kommunikation

Title : Signage System Car Dealer Pappas Salzburg 2006
Creative Director : Andreas Uebele
Art Director : Beate Gerner
Design : Beate Gerner
Photography : Andreas Korner
Country : Germany

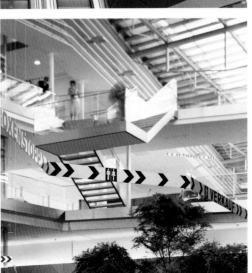

Büro Uebele Visuelle Kommunikation

Title : Signage System and Brand Land Walter Knoll Herrenberg
Creative Director : Andreas Uebele
Art Director : Marc Engenhart
Design : Andrea Bauer
Photography : Andreas Korner
Country : Germany

Packaging

Waitrose
INDULGENT RECIPE
Shredded Chicken
Flakes with Duck
in Gravy

Waitrose
INDULGENT RECIPE
Tuna White Meat
with Tiger Shrimp
in Gravy

Waitrose
INDULGENT RECIPE
Cutlets of Sardine &
Mackerel with Clams
in Jelly

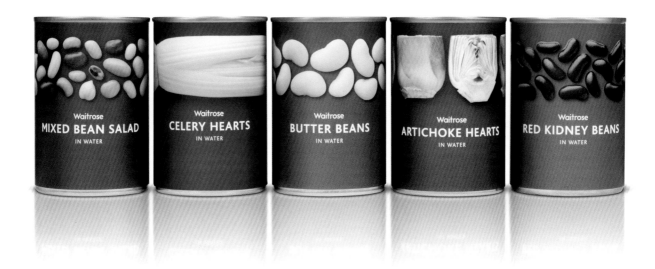

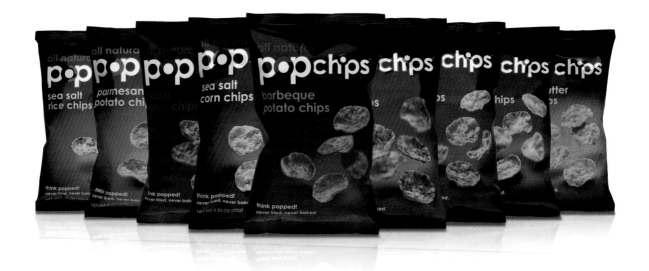

Turner Duckworth: London & San Francisco

Title : Waitrose Ltd., Premium Cat Food
Creative Directors : David Turner and Bruce Duckworth
Designer : Sarah Moffat
Photographer : Steve Hoskins
Retoucher : Peter Ruane
Country : UK & USA

Turner Duckworth: London & San Francisco

Title : Waitrose Canned Vegetables & Pulses
Creative Directors : David Turner and Bruce Duckworth
Designer : Sarah Moffat
Photographer : Andy Grimshaw
Retoucher : Peter Ruane
Artwork : Reuben James
Country : UK & USA

Turner Duckworth: London & San Francisco

Title : Popchips
Creative Directors : David Turner and Bruce Duckworth
Designer of Logo & Packaging : Chris Garvey
Designers of Tradeshow Booth & Stationery : Ann Jordan, Rebecca Williams
Photographer : Richard Eskite
Copywriter : Jacki Rigoni
Country : UK & USA

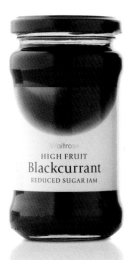 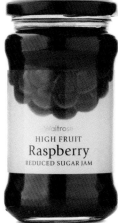 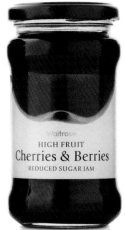 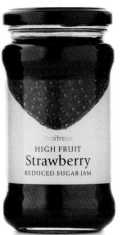 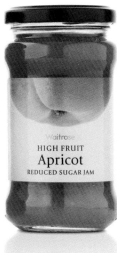

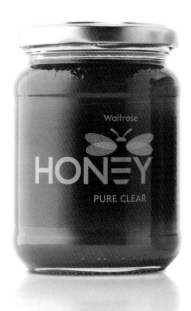 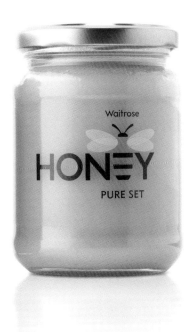

Turner Duckworth:
London & San Francisco

Title : High Fruit Jams
Creative Directors : David Turner and Bruce Duckworth
Designer : Mike Harris
Photographer : Andy Grimshaw
Retouching : Reuben James
Artworker : Reuben James
Country : UK & USA

Turner Duckworth:
London & San Francisco

Title : Honey: Good
Creative Directors : David Turner and Bruce Duckworth
Designer : Christian Eager
Illustrator : John Geary
Artworker : Reuben James
Country : UK & USA

Turner Duckworth:
London & San Francisco

Title : Flawless Paint
Creative Directors : David Turner and Bruce Duckworth
Designer : Emma Thompson, Mike Harris
Photographer : Andy Grimshaw
Retoucher : Matt Kay
Artworker : Reuben James
Country : UK & USA

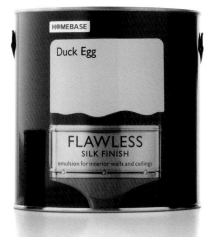 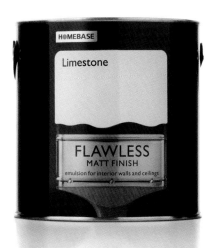 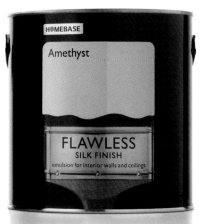

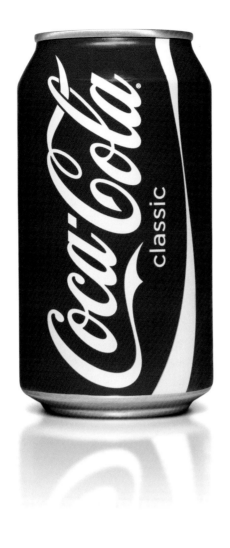

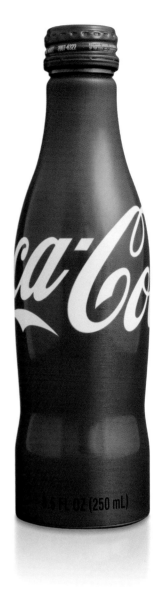

Turner Duckworth: London & San Francisco

Title : Coca-Cola Classic Packaging
Creative Directors : David Turner and Bruce Duckworth
Designer : Jonathan Warner
Country : UK & USA

Turner Duckworth: London & San Francisco

Title : Coca-Cola Aluminium Bottle
Creative Directors : David Turner and Bruce Duckworth
Designer : Chris Garvey
Country : UK & USA

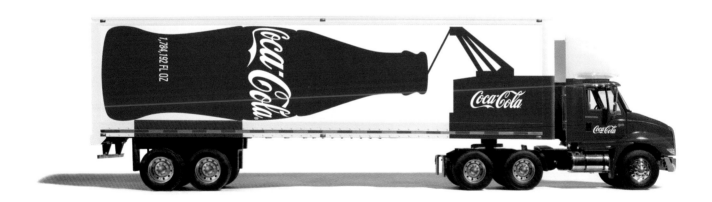

Turner Duckworth: London & San Francisco

Title : Coca-Cola VIS
Creative Directors : David Turner and Bruce Duckworth
Design Director : Sarah Moffat
Designer : Jonathan Warner, Radu Ranga, Josh Michels, Rebecca
Williams, Chris Garvey
Country : UK & USA

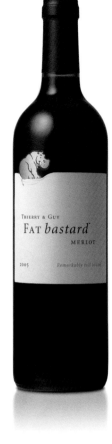 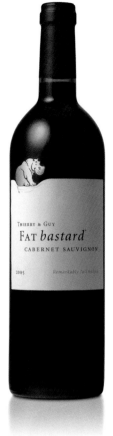 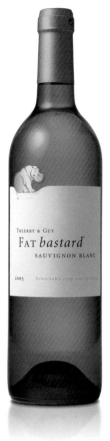 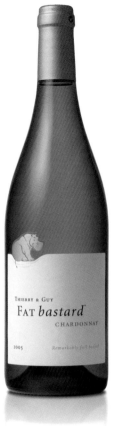 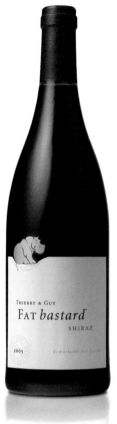

Turner Duckworth:
London & San Francisco

Title : Click Wine Group, Fat Bastard
Creative Directors : David Turner and Bruce Duckworth
Designer : David Turner, Shawn Rosenberger, Chris
Garvey, Brittany Hull and Rachel Shaw
Illustrator : John Geary
Country : UK & USA

Turner Duckworth:
London & San Francisco

Title : S.A. Gold – Range Extension
Creative Director : David Turner and Bruce Duckworth
Designer : Mark Waters
Typography : David Bateman
Illustration : John Geary
Artworker : Reuben James
Country : UK & USA

Turner Duckworth:
London & San Francisco

Title : Click Wine Group Root : 1
Creative Directors : David Turner and Bruce Duckworth
Designer : Shawn Rosenberger
Illustrator : Shawn Rosenberger
Copywriter : David Turner
Country : UK & USA

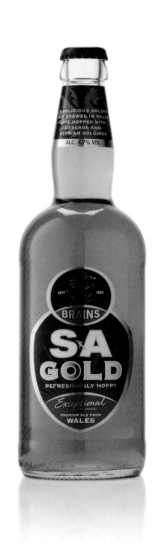

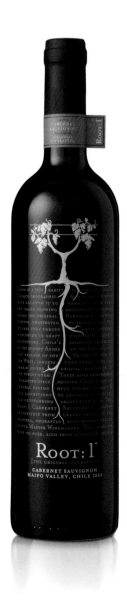

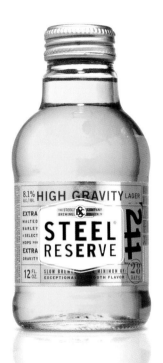

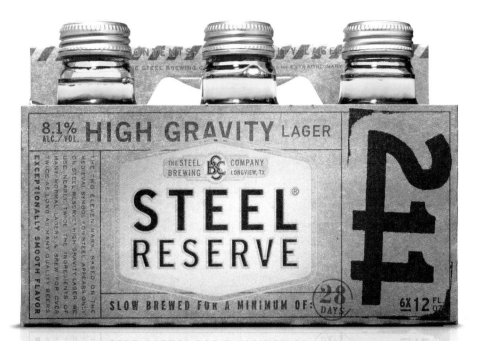

Turner Duckworth:
London & San Francisco

Title : Mackenzie River Brewing Co., Steel Reserve
Creative Directors : David Turner and Bruce Duckworth
Designer : David Turner
Client : Mackenzie River Brewing Co.
Country : UK & USA

Turner Duckworth:
London & San Francisco

Title : Lilt
Creative Directors : David Turner and Bruce Duckworth
Designer : Christian Eager, Anthony Biles
Typographer : David Bateman
Country : UK & USA

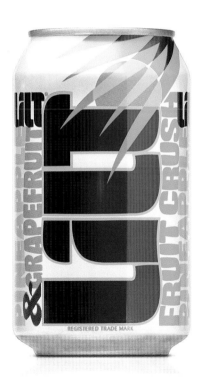

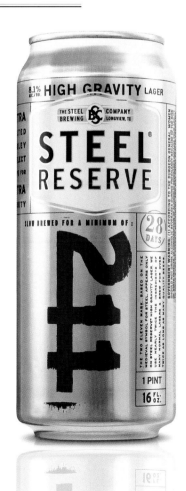

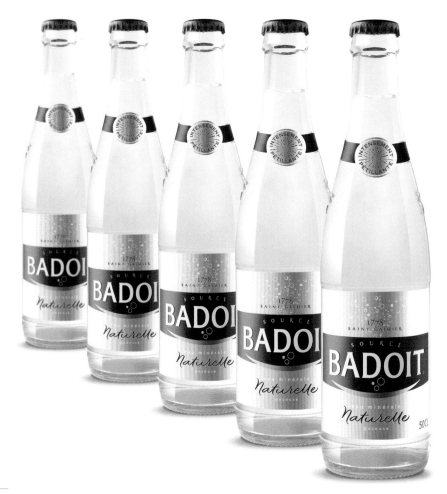

Blackandgold

Title : Badoit
Creative Director : Yannick Soubrier
Art Director : Cathy Vautier
Photography : Frédéric Besson
Country : France

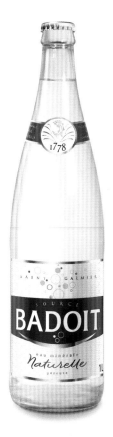

Blackandgold

Title : Champion Collection
Creative Director : Yannick Soubrier
Photography : Frédéric Besson
Country : France

Alberto Ghirardello

Title : Citrus
Country : Italy

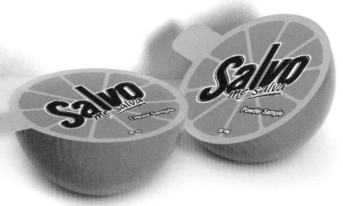

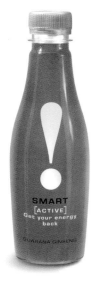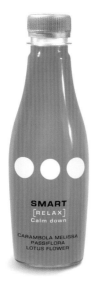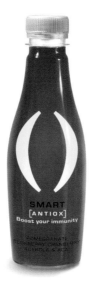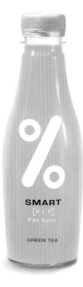

Blackandgold

Title : Smart / AGROKO
Creative Director : Mélaine Gransart
Photography : Frédéric Besson
Country : France

Blackandgold

Title : Saveur à l'Ancienne/BELIN
Creative Director : Mélanie Gransart
Photography : Frédéric Besson
Country : France

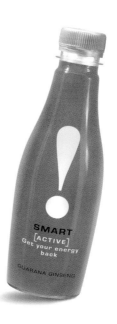

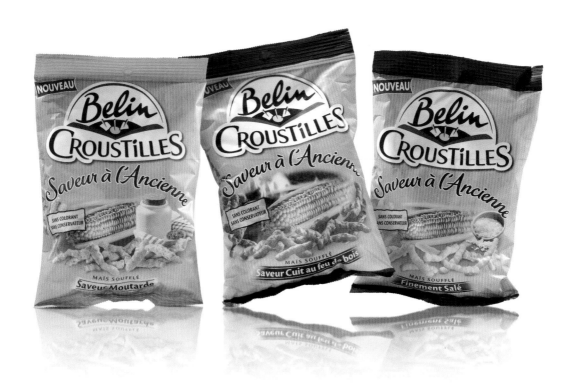

Blackandgold

Title : V33
Creative Director : Yannick Soubrier
Photography : Frédéric Besson
Country : France

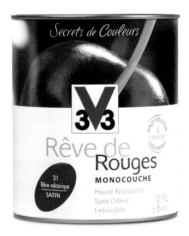

Laboratorium

Title : Aroma Ragusea
Creative Director : Orsat Frankovic, Ivana Vucic
Art Director : Orsat Frankovic, Ivana Vucic, Ana Vickovic
Design : Ana Vickovic
Country : Croatia

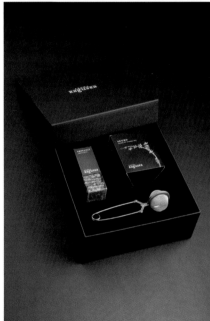

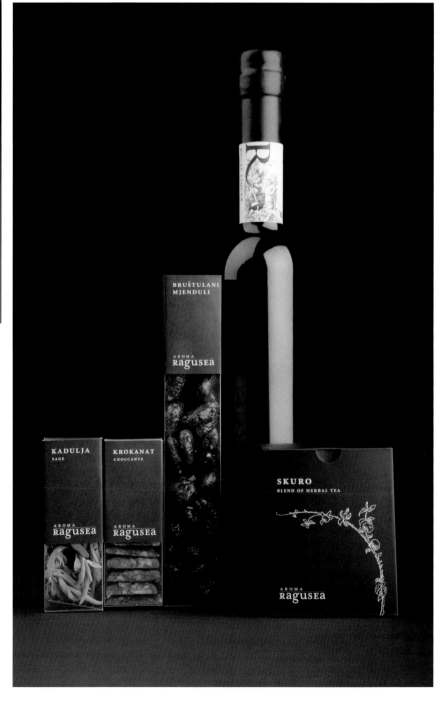

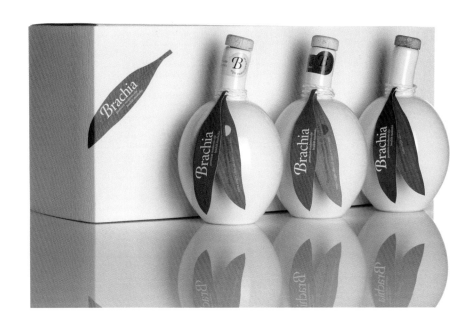

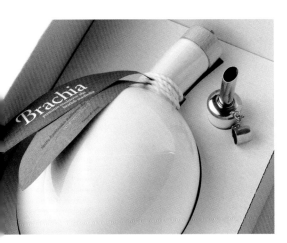

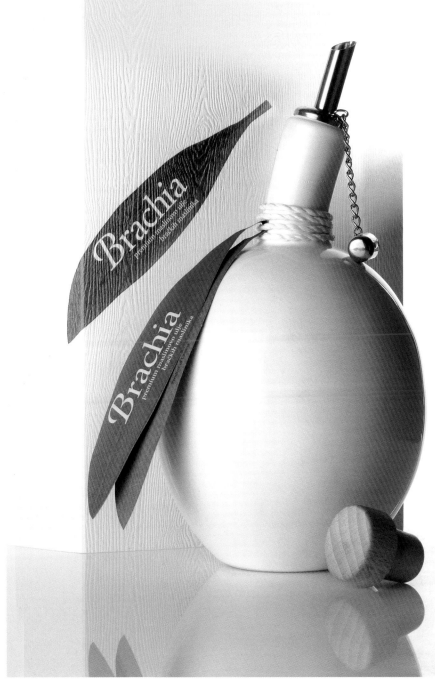

Tridvajedan Market
Communication Ltd.

Title : Brachia-Olive
Design : Jelena Gvozdanovic, Izvorka Juric
Country : Croatia

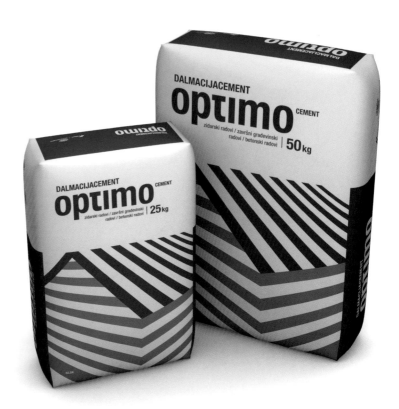

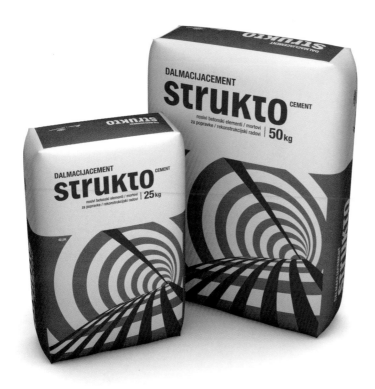

Tridvajedan Market
Communication Ltd.

Title : Optimo & Strukto
Design : Izvorka Juric
Collaborator : Matej Korlaet
Country : Croatia

Trudvajedan Market
Communication Ltd.

Title : St. Peter Christmas Card
Creative Director : Jelena Gvozdanovic, Izvorka Juric
Art Director : Izvorka Juric
Design : Jelena Gvozdanovic, Izvorka Juric
Copyriter : Jelena Gvozdanovic
Country : Croatia

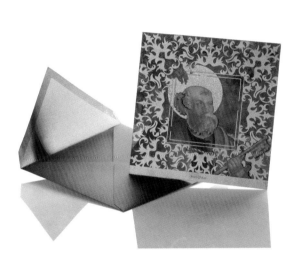

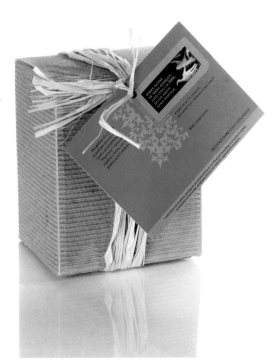

Dew Gibbons Ltd

Title : Good Natured
Creative Director : Steve Gibbons, Shaun Dew
Design : Nick Vaus
Copywriter : Cherry
Photography : John Ross
Country : Britain

David del Olmo Gines

Title : Boca
Country : Spain

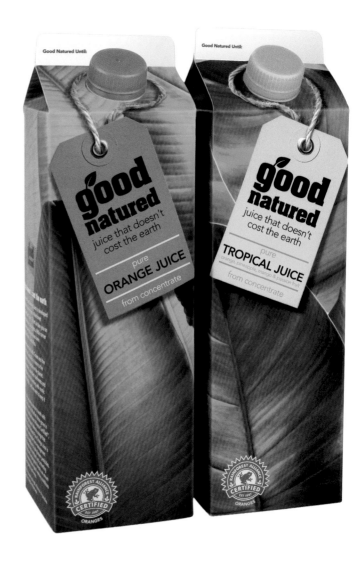

khdesign gmbh

Title : Love Collection
Creative Director : Knut Hartmann
Design : khdesign-Team
Photography : Holger Pless
Logo Development : Ricardo Rousselot (Barcelona)
Country : Germany

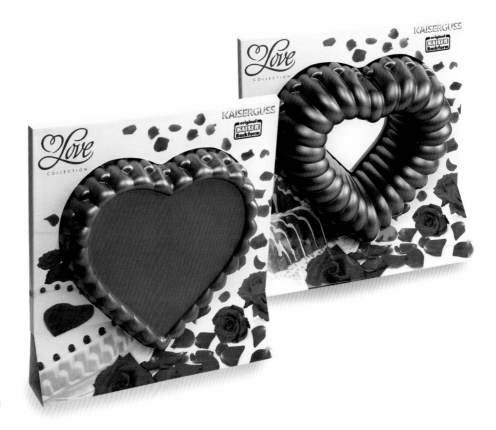

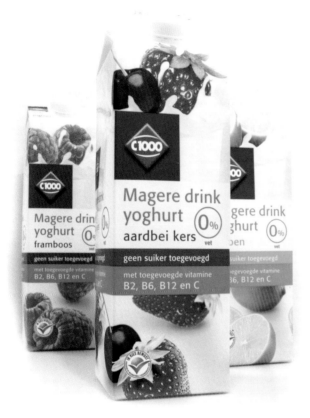

Keja Doma

Title : C1000 Private Label
Country : The Netherlands

Warmrain

Title : Sketch Parlour Packaging
Country : Britain

Keja Donia

Title : C1000 Private Label
Country : The Netherlands

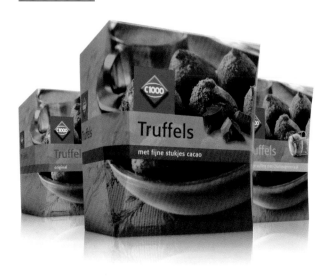

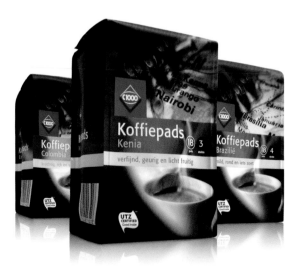

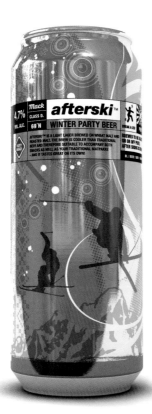

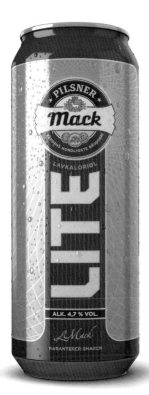

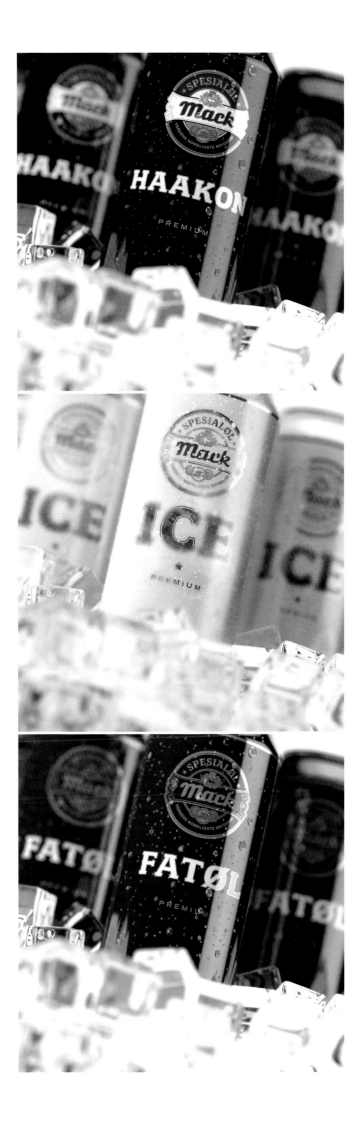

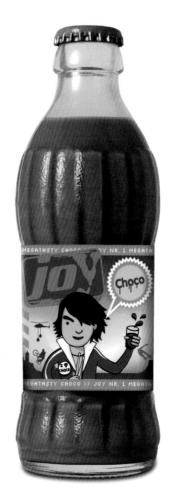

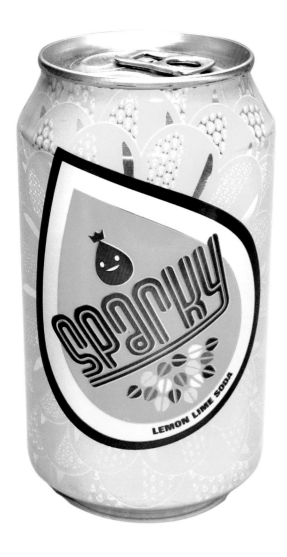

Sweden Graphics

Title : "Sparky" Soft Drink Design
Country : Sweden

Studio Kluif

Title : Packaging Joy
Creative Director : Paul Roeters, Jeroen Hoedjes
Art Director : Paul Roeters, Jeroen Hoedjes
Design : Jeroen Hoedjes
Illustration : Jelena Peeters, Christina Casnellie
Country : The Netherlands

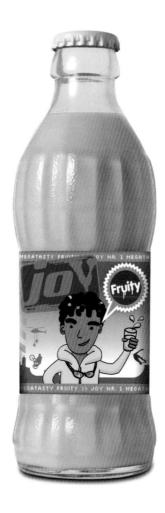

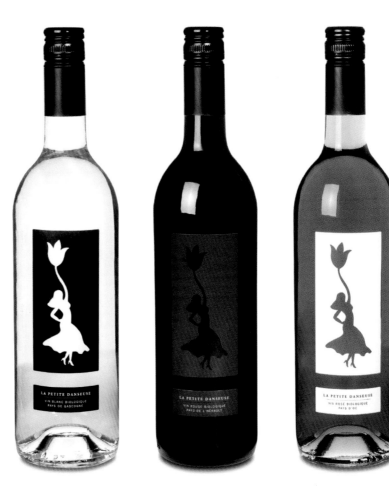

Studio Kluf

Title : Organic Wine Labeling-
La petite Danseuse
Creative Director : Paul Roeters
Art Director : Paul Roeters
Design : Anne van Arkel
Illustration : Anne van Arkel
Country : The Netherlands

Studio Copyright

Title : Mas Romani
Design : Gabriel Morales
Country : Spain

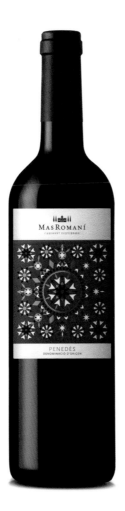
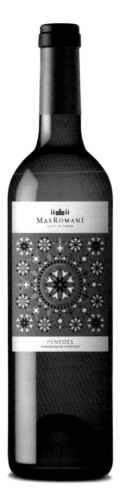
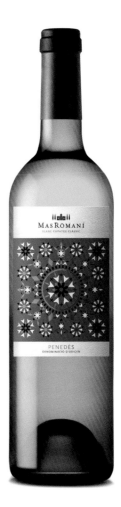

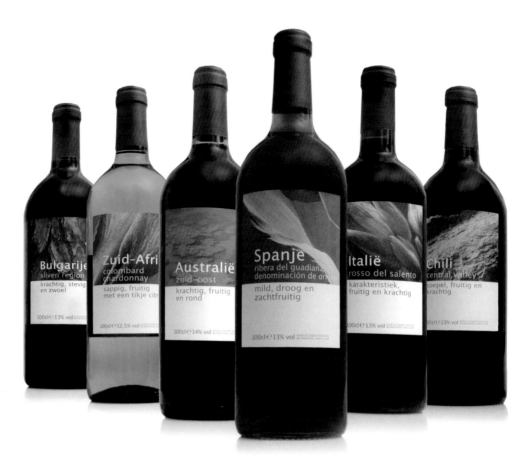

Studio Kluif

Title : Packaging 'Summer Fruit' Products
Creative Director : Paul Roeters, Jeroen Hoedjes
Art Director : Paul Roeters, Jeroen Hoedjes
Design : Jeroen Hoedjes, Jeroen Hoedjes
Illustration : Jeroen Hoedjes
Country : The Netherlands

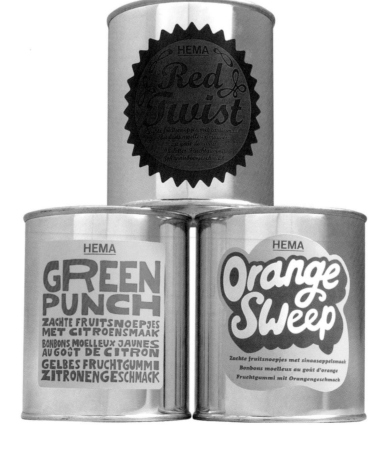

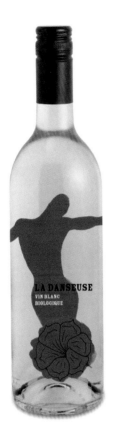
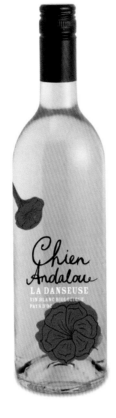

Studio Kluf

Title : Propocals Organic Wine Labeling
Creative Director : Paul Roeters
Art Director : Paul Roeters
Design : Christina Casnellic
Illustration : Christina Casnellic
Country : The Netherlands

Studio Kluf

Title : Packaging Tood Products for Kids
Creative Director : Paul Roeters, Jeroen Hoedjes
Art Director : Paul Roeters,Jeroen Hoedjes
Design : Angèlique Döbber
Photography : Arthur Dries
Illustration : Angèlique Döbber
Country : The Netherlands

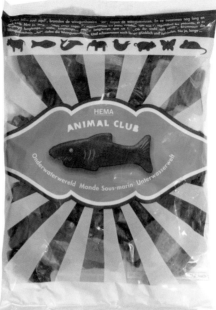

Studio Kluif

Title : Packaging Candy 'Animal Club'
Creative Director : Paul Roeters, Jeroen Hoedjes
Art Director : Paul Roeters, Jeroen Hoedjes
Design : Paul Roeters, Jeroen Hoedjes
Copywriter : Eric Alink, Angelique Döbber
Photography : Arthur Dries fotografie
Illustration : Jeroen Hoedjes
Country : The Netherlands

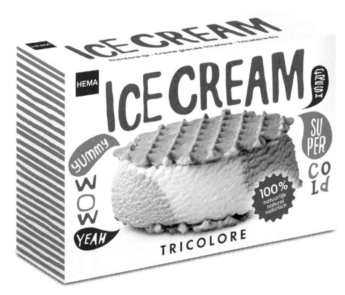

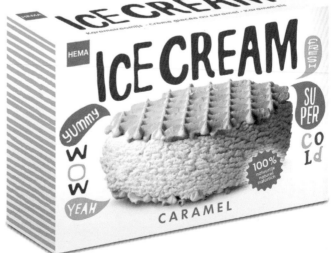

Studio Kluif

Title : Packaging Waffle Ice Cream
Creative Director : Paul Roeters
Art Director : Paul Roeters
Design : Sander Tielen
Photography : Petra Steenkamer fotografie
Illustration : Sander Tielen
Country : The Netherlands

100%

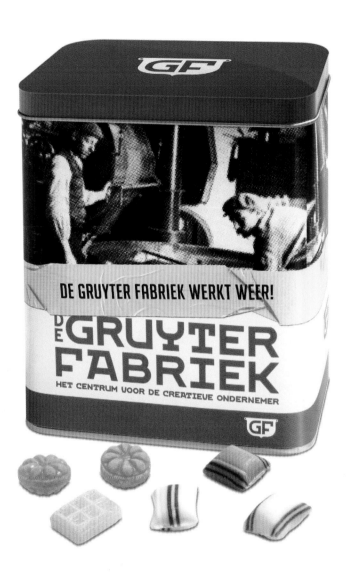

Studio Kluif

Title : Give Away Tin Can
Creative Director : Paul Roeters
Art Director : Paul Roeters
Design : Sander Tielen
Illustration : Sander Tielen
Country : The Netherlands

Warmrain

Title : Sketch Croissant Packaging
Country : Britain

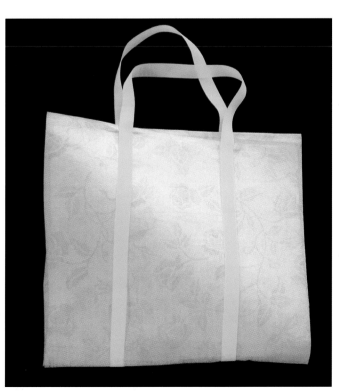

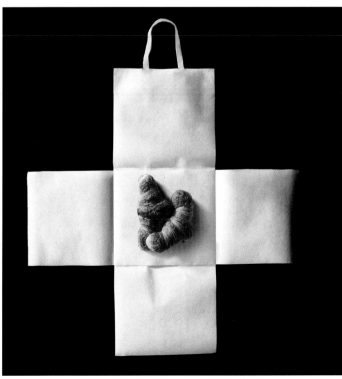

Laura Millán

Title : Reversible Container
Photography : Diethild Meier & Dustan Lee Shepard
Country : Spain

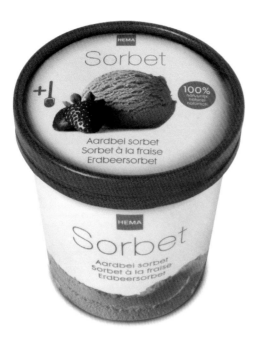

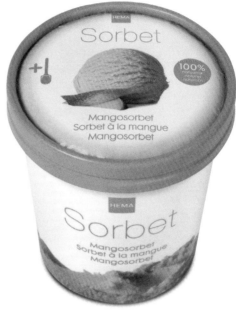

Studio Kluif

Title : Packaging Premium Sorbet Ice
Creative Director : Paul Roeters, Jeroen Hoedjes
Art Director : Paul Roeters, Jeroen Hoedjes
Design : Jeroen Hoedjes
Photography : Petra Steenkamer fotografie
Illustration : Jeroen Hoedjes
Country : The Netherlands

Studio Kluif

Title : Packaging Snacks, 'Bite'
Creative Director : Paul Roeters, Jeroen Hoedjes
Art Director : Paul Roeters, Jeroen Hoedjes
Design : Jeroen Hoedjes
Photography : Willem Groeneveld
Illustration : Jeroen Hoedjes
Country : The Netherlands

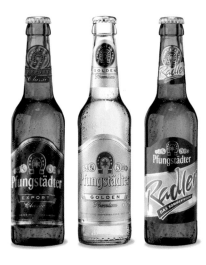

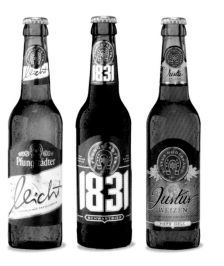

khdesign gmbh

Title : Pfungstädter
Creative Director : Knut Hartmann
Design : khdesign-Team
Country : Germany

Dragon Rouge

Title : Perrier (Nestlé Waters)
Creative Director : Patrick Veyssiére
Country : France

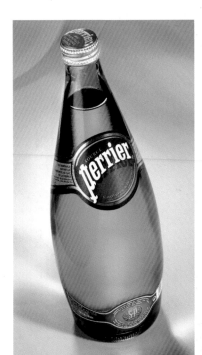

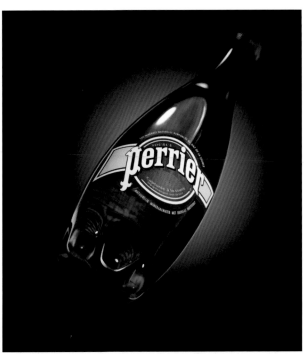

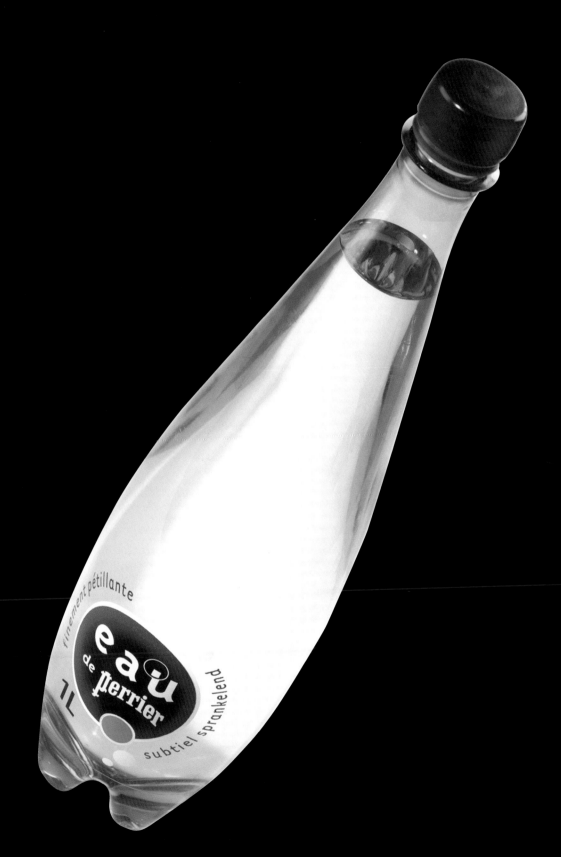

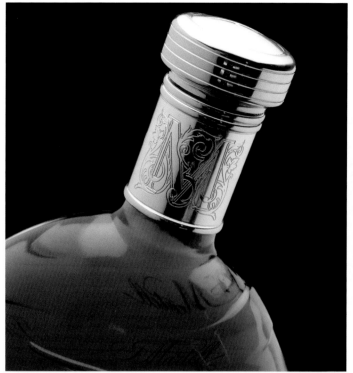
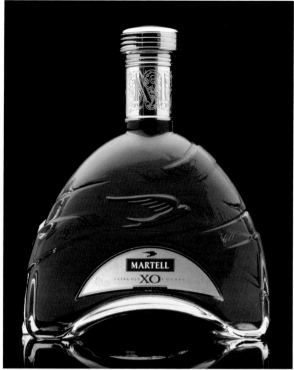
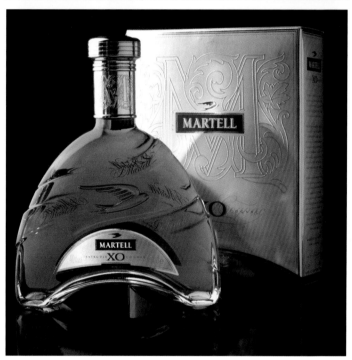
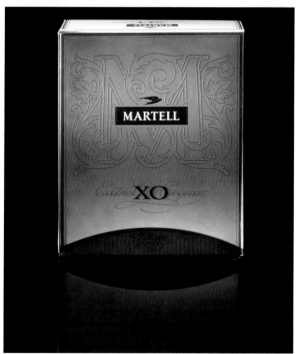

Dragon Rouge

Title : Martell (Pernod Ricard)
Creative Director : Patrick Veyssière
Country : France

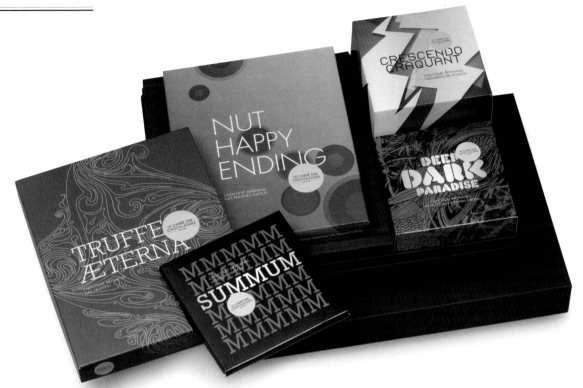

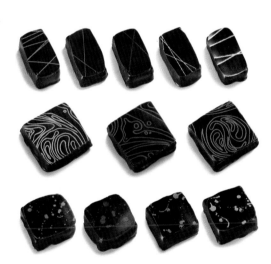

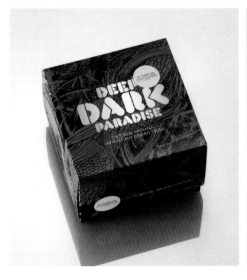

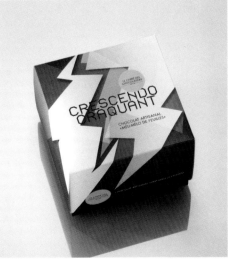

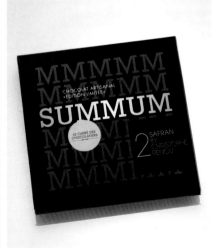

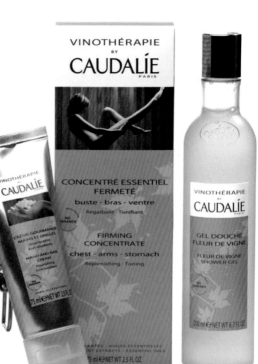

VINOTHÉRAPIE
BY
CAUDALÍE
PARIS

CONCENTRÉ ESSENTIEL
FERMETÉ
buste · bras · ventre
Regalbant · Tonifiant

FIRMING
CONCENTRATE
chest · arms · stomach
Replenishing · Toning

Vinothérapie
BY
CAUDALÍE PARIS

GEL DOUCHE
FLEUR DE VIGNE
FLEUR DE VIGNE
SHOWER GEL

200 ml ⊖NET WT 6.7 FL OZ

Vinothérapie
BY
CAUDALÍE PARIS

GOMMAGE SAUVIGNON
SAUVIGNON SCRUB
250 g ⊖ NET WT 8.8 OZ

CAUDALÍE
CRÈME GOURMANDE
MAINS ET ONGLES
Anti-crevasses
HAND AND NAIL
CREAM
Nourishing
Anti-crevasses

75 ml ⊖ NET WT 2.5 FL OZ

CAUDALÍE
PARIS

CONCENTRÉ ESSENTIEL
ÉNERGISANT
Régénérant · Éclat du teint

ENERGIZING CONCENTRATE
Regenerating · Glowing complexion

PEAUX SENSIBLES
SENSITIVE SKIN

HUILES ESSENTIELLES · ESSENTIAL OILS

CAUDALÍE
PARIS

CAUDALÍE
PARIS

NEW
VINOPULP

PULPE
VITAMINÉE

PULPE VITAMINÉE

CRÈME ÉNERGISANTE

CRÈME ÉNERGISANTE
Anti-rides · Liftante

ENERGIZING CREAM

ENERGIZING CREAM
Anti-wrinkle · Lifting

PEAUX NORMALES À SÈCHES
NORMAL TO DRY SKIN

HYPO-ALLERGÉNIQUE

Sergio Calatroni
Artroom srl

Title : Stephanemarais
Country : Italy

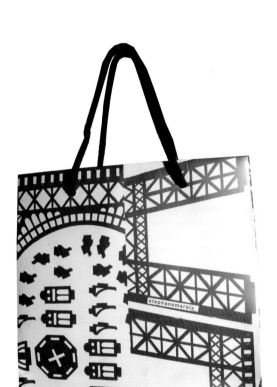

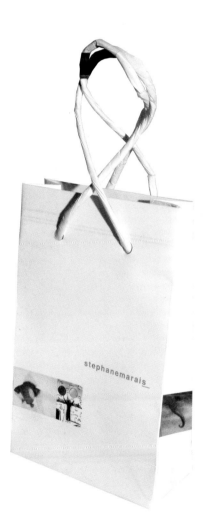

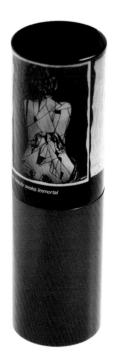

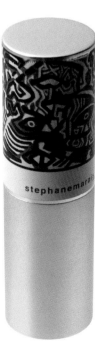

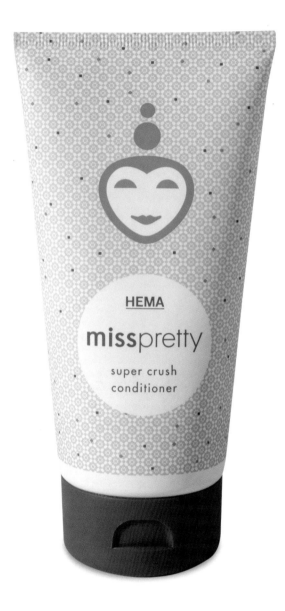

Studio Kluf

Title : Packaging Care Products 'Miss Pretty'
Creative Director : Paul Roeters, Jeroen Hoedjes
Art Director : Paul Roeters, Jeroen Hoedjes
Design : Anne van Arkel
Illustration : Anne van Arkel
Country : The Netherlands

HEMA

**REFATTING
BATH OIL**

verzorgt het tere babyhuidje
soigne la peau fragile de bébé
Pflegt die zarte Babyhaut

B A B Y

HEMA

BELLY CREAM

verstevigend en herstellend
raffermissante et régénératrice
straffend und regenerierend

M A M A

HEMA
**50
OIL PADS**

B A B Y

Studio 'Kluif'

Title: Packaging Baby Care Products
Creative Director: Paul Roeters, Jeroen Hoedjes
Art Director: Paul Roeters, Jeroen Hoedjes
Design: Paul Roeters, Anne van Arkel
Illustration: Anne van Arkel
Country: The Netherlands

Sergio Calatroni Artroom srl

Title: Untied
Creative Director: Sergio Calatroni
Art Director: Sergio Calatroni, Miyuki Yajima
Design: Hisayuki Amae
Photographer: Sergio Calatroni
Country: Italy

untied

FACE
SCRUB

SHISEIDO
INTERNATIONAL

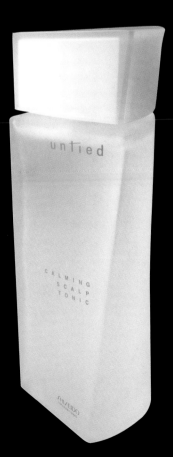

untied

CALMING
SCALP
TONIC

SHISEIDO

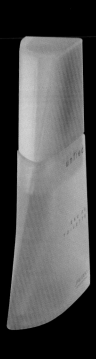

untied

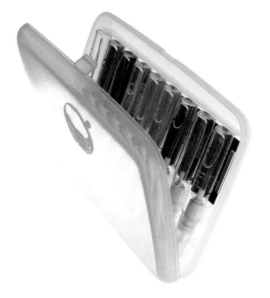

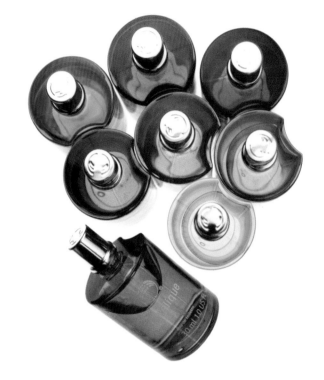

Dew Gibbons Ltd

Title : Invent Your Scent
Creative Director : Shaun Dew
Country : Britain

Dew Gibbons Ltd

Title : Ghost Anticipation
Creative Director : Shaun Dew
Design : Dana Bar
Country : Britain

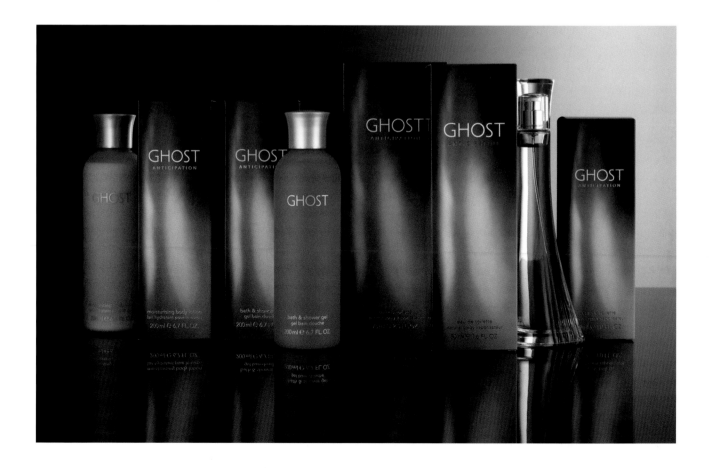

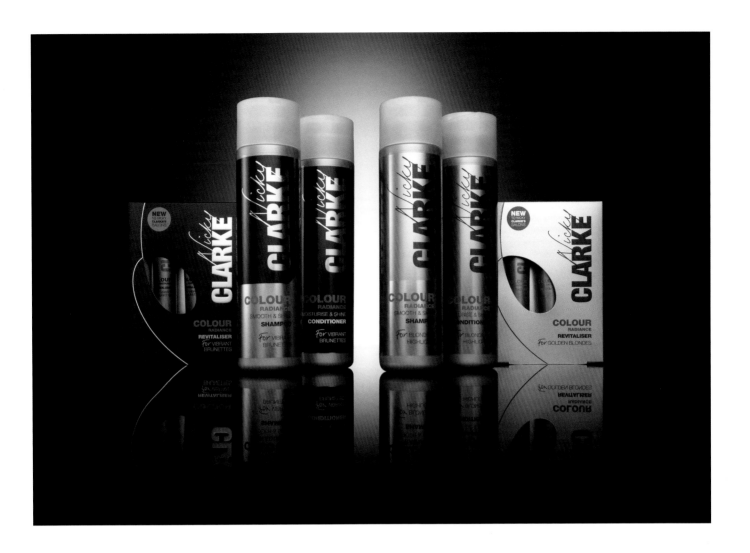

Dew Gibbons Ltd

Title : Nicky Clarke
Creative Director : Shaun Dew
Art Director : Steve Gibbons
Design : Alex Lazarevic
Country : Britain

Dew Gibbons Ltd

Title : Sassoon Professional
and Sassoon Shade Card
Creative Director : Shaun Dew
Country : Britain

Dew Gibbons Ltd

Title : Ghost Sweetheart
Creative Director : Shaun Dew
Design : Alex Lazarevic
Country : Britain

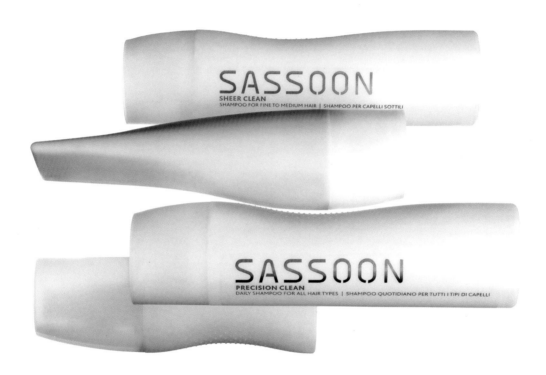

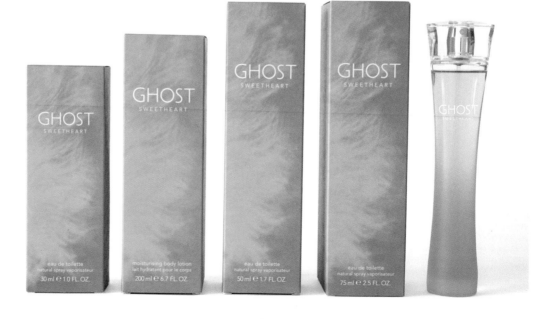

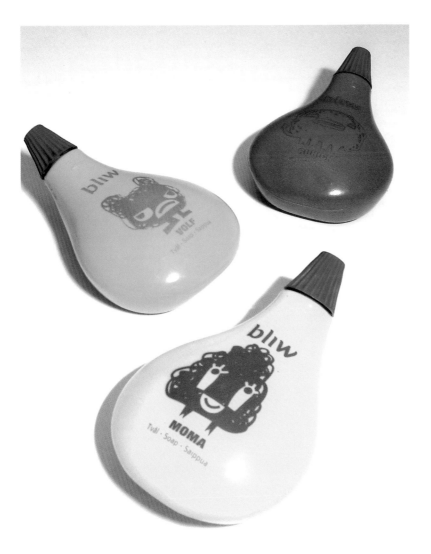

Sweden Graphics

Title : "Bliw" Soap Packaging Design for Kids
Country : Sweden

Sweden Graphics

Title : Packaging System for Divided Denim
Country : Sweden

Turner Duckworth:
London & San Francisco

Title : Superskin Concentrate
Creative Directors : David Turner and Bruce Duckworth
Designer : Sarah Moffat
Illustration : Darren Whittington
Artworker : Reuben James
Country : UK & USA

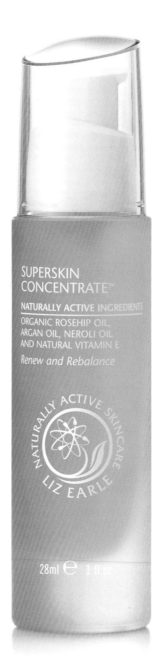

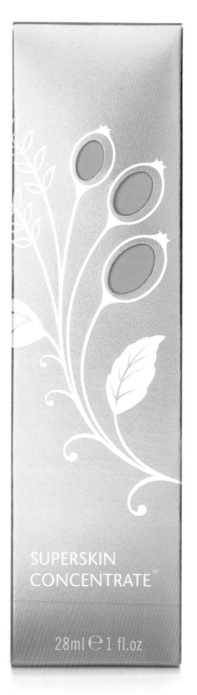

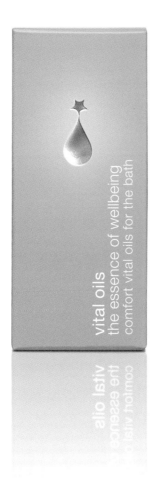
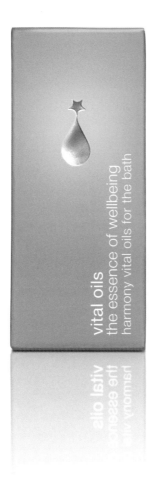
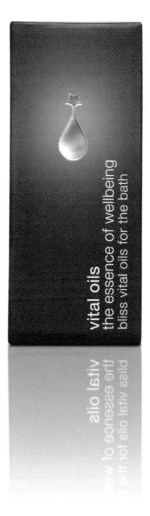
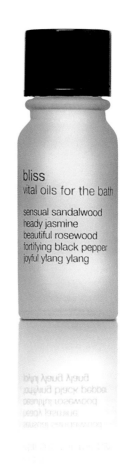

vital oils
the essence of wellbeing
comfort vital oils for the bath

vital oils
the essence of wellbeing
harmony vital oils for the bath

vital oils
the essence of wellbeing
bliss vital oils for the bath

bliss
vital oils for the bath

sensual sandalwood
heady jasmine
beautiful rosewood
fortifying black pepper
joyful ylang ylang

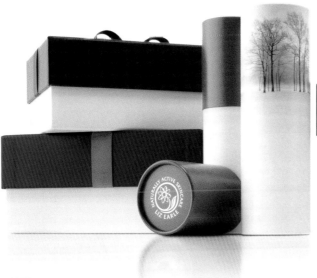

Turner Duckworth: London & San Francisco

Title : Vital Oils of Liz Earle Cosmetics Ltd.,
Creative Director : David Turner and Bruce Duckworth
Designer : Bruce Duckworth, Janice Davison
Account Manager : Moira Riddell
Client : Liz Earle Cosmetics
Country : UK & USA

Turner Duckworth: London & San Francisco

Title : Liz Earle Natural Active Skincare/Christmas Gift Packs
Creative Directors : David Turner and Bruce Duckworth
Designer : Jamie McCathie
Retoucher : Neil McCall
Artwork : Neil McCall
Country : UK & USA

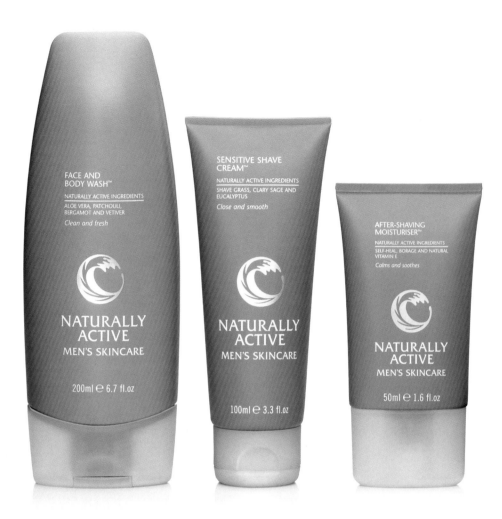

FACE AND
BODY WASH™
NATURALLY ACTIVE INGREDIENTS
ALOE VERA, PATCHOULI,
BERGAMOT AND VETIVER
Clean and fresh

NATURALLY
ACTIVE
MEN'S SKINCARE

200ml ℮ 6.7 fl.oz

SENSITIVE SHAVE
CREAM™
NATURALLY ACTIVE INGREDIENTS
SHAVE GRASS, CLARY SAGE AND
EUCALYPTUS
Close and smooth

NATURALLY
ACTIVE
MEN'S SKINCARE

100ml ℮ 3.3 fl.oz

AFTER-SHAVING
MOISTURISER™
NATURALLY ACTIVE INGREDIENTS
SELF-HEAL, BORAGE AND NATURAL
VITAMIN E
Calms and soothes

NATURALLY
ACTIVE
MEN'S SKINCARE

50ml ℮ 1.6 fl.oz

Turner Duckworth: London & San Francisco

Title : Liz Earle Cosmetics Ltd – Naturally Active Men's Skincare
Creative Directors : David Turner and Bruce Duckworth
Designer : Christian Eager
Illustration : John Geary
Country : UK & USA

Turner Duckworth: London & San Francisco

Title : Liz Earle Naturally Active Skincare
Creative Directors : David Turner and Bruce Duckworth
Designer : Bruce Duckworth
Country : UK & USA

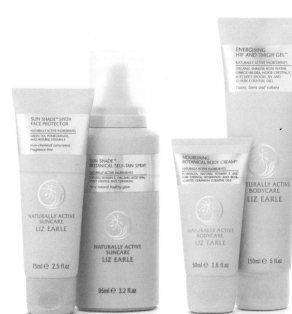

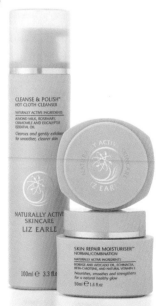

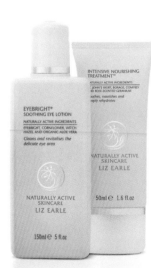

Hahmo Design Ltd.

Title : Inni Parnanen Jewellery
Design : Jenni Huttunen, Inni Parnanen,
Antti Raudaskoski
Country : Finland

Naroska Design

Title : Michalsky
Country : Germany

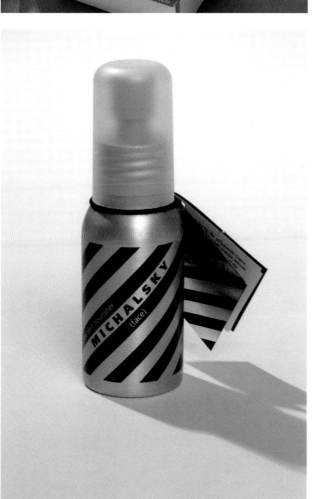

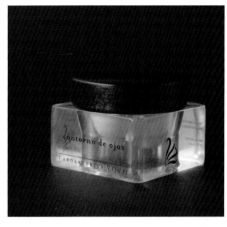

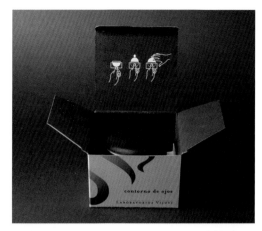

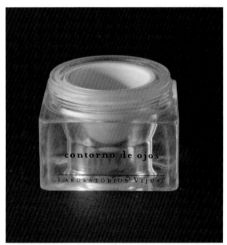

Laura Mullán

Title : Reversible Container
Photography : Diethild Meier & Dustan Lee Shepard
Country : Spain

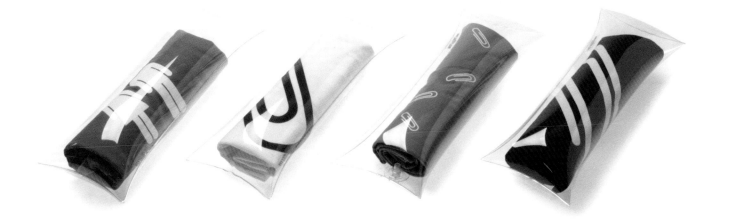

BAG.Disseny

Title : Clippack
Creative Director : Sandre Compte
Art Director : Xavi Mora
Country : Spain

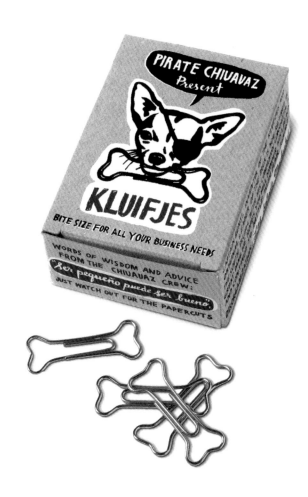

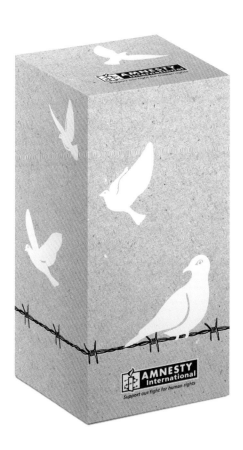

Studio Kluf

Title : Box with Bone-shaped Paperclips
Creative Director : Paul Roeters
Art Director : Paul Roeters
Design : Christina Casnellie
Copywriter : Christina Casnellie
Illustration : Christina Casnellie
Country : The Netherlands

Studio Kluf

Title : Packaging Classic Candle
Creative Director : Paul Roeters
Art Director : Paul Roeters
Design : Christina Casnellie
Illustration : Christina Casnellie
Country : The Netherlands

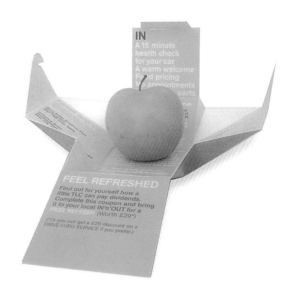

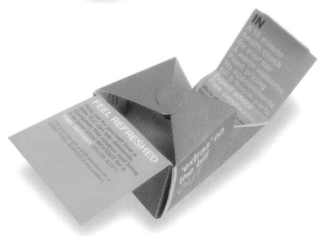

Warmrain

Title : Applebox
Country : Britain

Sergio Calatroni Artroom srl

Title : Carshoe
Creative Director : Sergio Calatroni
Art Director : Miyuki Yajima
Design : Antonio Pio Giovanditto
Photography : Sergio Calatroni
Country : Italy

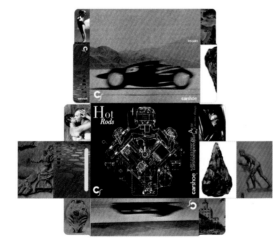

Dew Gibbons Ltd

Title : De Beers Luxury Brand
Identity and Packaging
Creative Director : Shaun Dew
Art Director : Sebastian Bergna
Photography : Richard Foster
Country : Britain

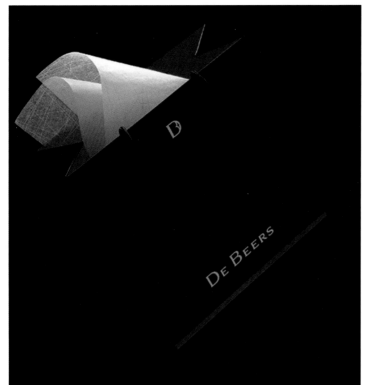

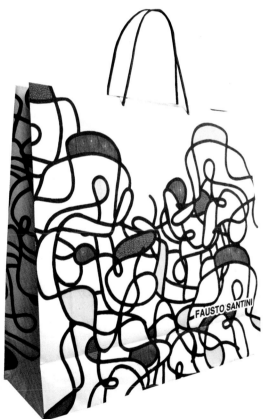
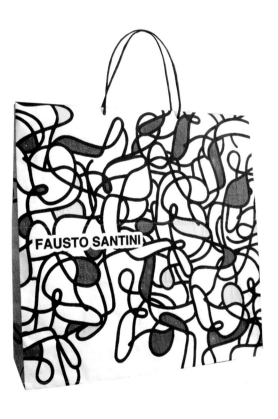

Sergio Calatroni Artroom srl

Title : Fausto Santini
Creative Director : Sergio Calatroni
Art Director : Miyuki Yajima
Design : Hisayuki Amae, Antonio Pio Giovanditto
Photography : Sergio Calatroni
Country : Italy

Title : Sonidos en agua Vol. 03
Creative Director : Joel Lozano, Laura Alejo
Art Director : Incuo the Sign
Design : Joel Lozano, Laura Alejo
Illustration : Jordi Cabeza
Country : Spain

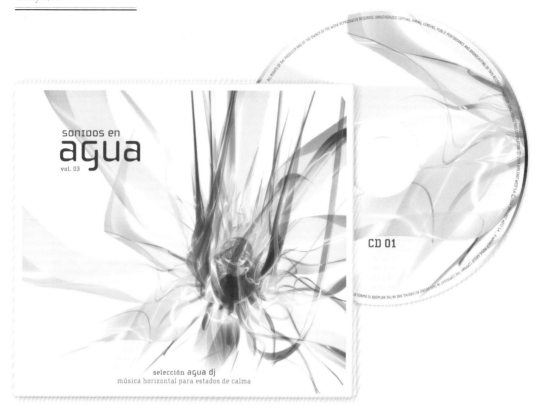

01. ELECTROMATIC
02. PLAY
03. RAIN IN AUSTRALIA
04. LIFE FOR RENT
05. CALA JONDAL
06. LOOP IN LOVE
07. THE SEERESS PROPHECY
08. SILVER SANDS
09. THOSE FATTIES
10. EL MOMENTO
11. LAKEME

Studio Copyright

Title : Wine Store Mood (CD)
Design : Joel Lozano
Country : Spain

Ivo Valadares

Title : A Calçada Portuguesa Tapetes de Pedra
Country : Portugal

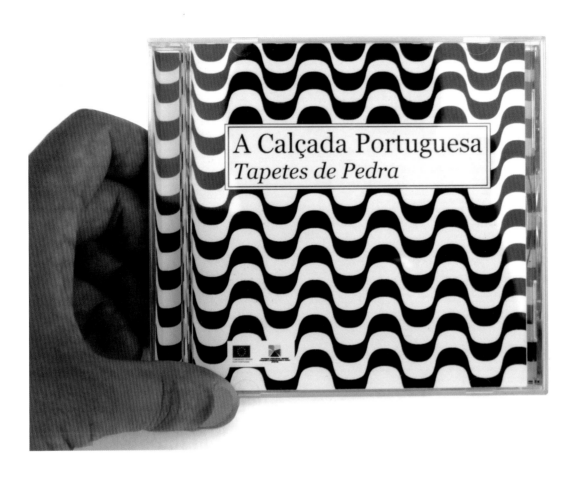

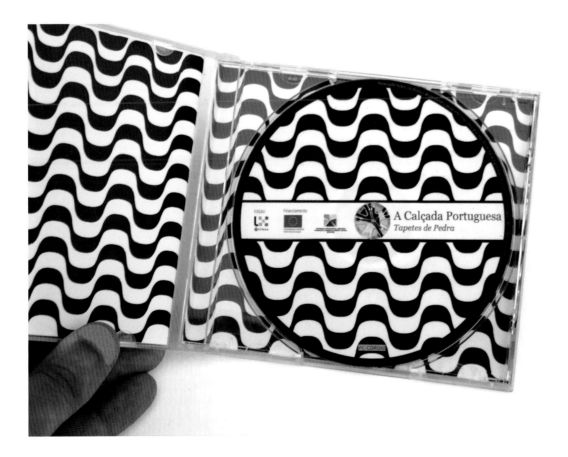

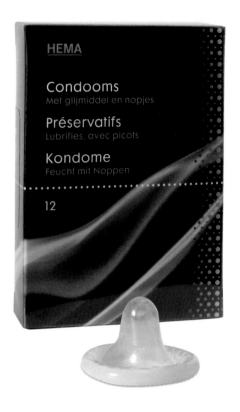

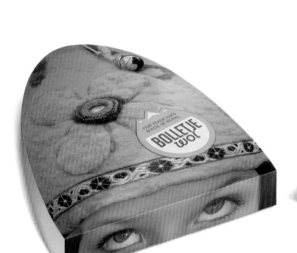

Studio Kluf

Title : Condoms Packaging
Creative Director : Paul Roeters, Jeroen Hoedjes
Art Director : Paul Roeters, Jeroen Hoedjes
Design : Jeroen Hoedjes
Photography : Arthur Dries
Illustration : Jeroen Hoedjes
Country : The Netherlands

Studio Kluf

Title : Packaging Fair Trade Hats for Kids
Creative Director : Paul Roeters
Art Director : Paul Roeters
Design : Sander Tielen
Illustration : Sander Tielen
Country : The Netherlands

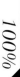

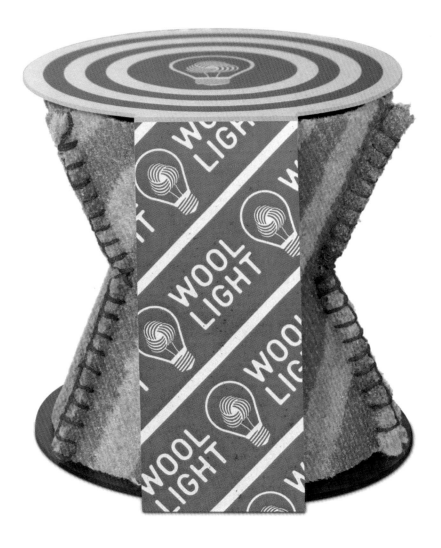

Studio Kluf

Title : Packaging Woollight Lamps
Creative Director : Paul Roeters
Art Director : Paul Roeters
Design : Sander Tielen
Illustration : Sander Tielen
Country : The Netherlands

Studio Kluf

Title : Contact Lens Product Packaging
Creative Director : Paul Roeters, Jeroen Hoedjes
Art Director : Paul Roeters, Jeroen Hoedjes
Design : Jeroen Hoedjes
Illustration : Jeroen Hoedjes
Country: The Netherlands

Studio Kluf

Title : Packaging Jar Candles
Creative Director : Paul Roeters
Art Director : Paul Roeters
Design : Jelena Peeters, Christina Casnellie
Illustration : Jelena Peeters, Christina Casnellie
Country : The Netherlands

Studio Kluf

Title: Packaging Hobby Kit
Creative Director : Paul Roeters, Jeroen Hoedjes
Art Director : Paul Roeters, Jeroen Hoedjes
Design : Jeroen Hoedjes, Anke Schalk
Photography : Arfhur Dries fotografie
Illustration : Jeroen Hoedjes, Anke Schalk
Country : The Netherlands

Studio Kluif

Title : Packaging Crafts Products
Creative Director : Paul Roeters, Jeroen Hoedjes
Art Director : Paul Roeters, Jeroen Hoedjes
Design : Jeroen Hoedjes, Jelena Peeters, Anne van Arkel
Photography : Jelena Peeters
Illustration : Anne van Arkel, Jelena Peeters
Country : The Netherlands

Studio Kluif

Title : Packaging Washing Powder
Creative Director : Paul Roeters, Jeroen Hoedjes
Art Director : Paul Roeters, Jeroen Hoedjes
Design : Jeroen Hoedjes
Illustration : Jeroen Hoedjes
Country : The Netherlands

Laura Millán & Belen Hermosa

Title : Chopsticks for the Incompetents
Photography : Joan Sunyol
Country : Spain

Warmrain

Title : Incense Matchbook
Country : Britain

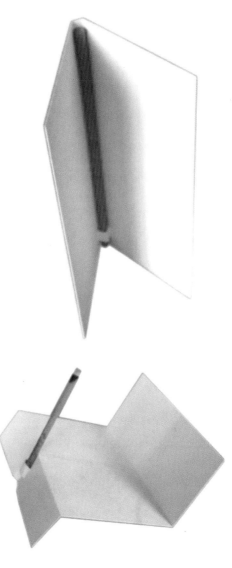

Chris Trivizas Design

Title : Coasters
Design : Chris Trivizas
Country : Greece

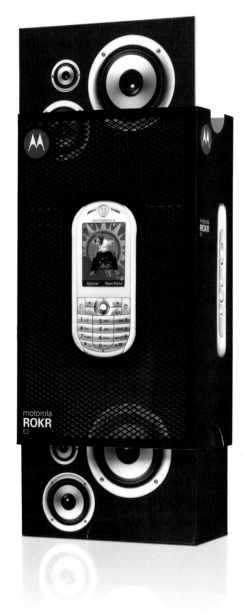

Turner Duckworth: London & San Francisco

Title : Motorola Packaging
Creative Directors : David Turner and Bruce Duckworth
Designer : Shawn Rosenberger, Ann Jordan, Josh Michaels, Rebecca Williams, Brittany Hull and Radu Ranga
Structural Designers : BurgoPak and Turner Duckworth
Photo Illustration : Terry Dudley (motokrzr) and Michael Brunsfeld (motorokr)
Photographer : Lloyd Hryciw (motorokr)
Product Imagery : Paul Obleas, Motorola
Country : UK & USA

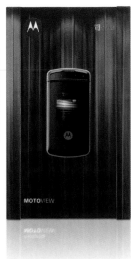

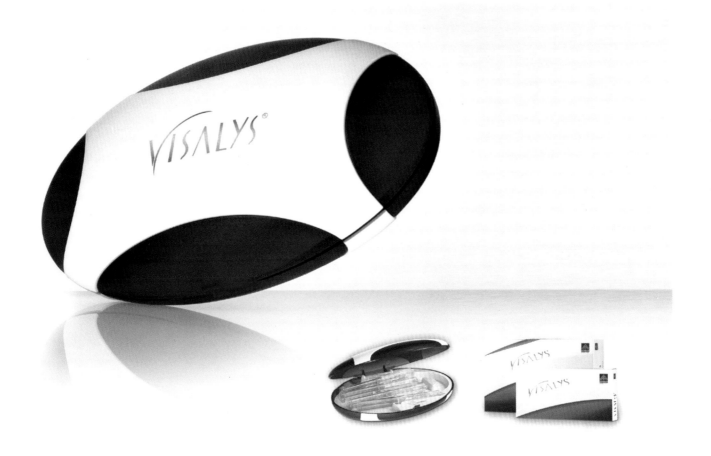

khdesign gmbh

Title : Visalys
Creative Director : Knut Hartmann
Design : khdesign-Team
Country : Germany

khdesign gmbh

Title : Bikey
Creative Director : Knut Hartmann
Art Director : Andreas Karl
Design : khdesign-Team
Country : Germany

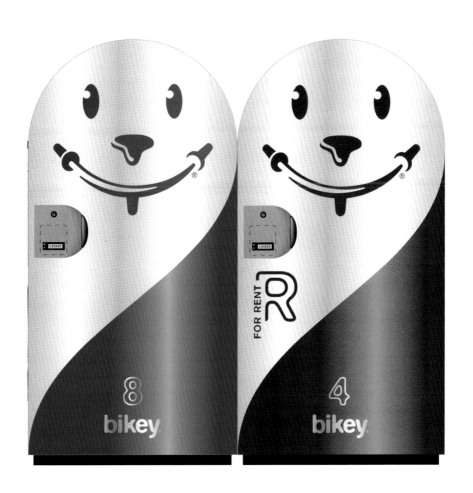

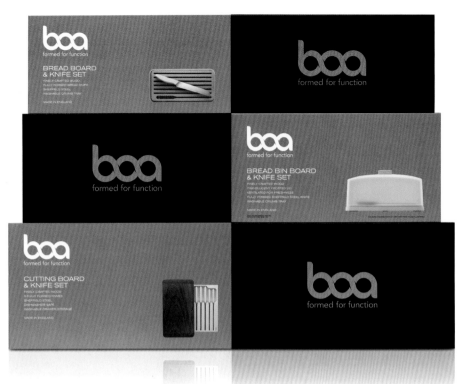

Turner Duckworth:
London & San Francisco

Title : BOA: Housewares & Excalibur Logo
Creative Directors : David Turner and Bruce Duckworth
Designer : Janice Davidson, Anthony Biles
Typographer : Janice Davidson, Mike Pratley
Country : UK & USA

Sergio Calatroni Artroom srl

Title : A+A
Creative Director : Sergio Calatroni
Art Director : Miyuki Yajima
Design : Antonio Pio Giovanditto
Photography : Sergio Calatroni
Country : Italy

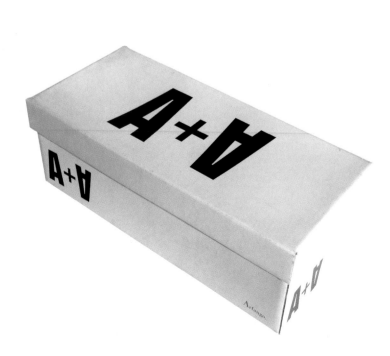

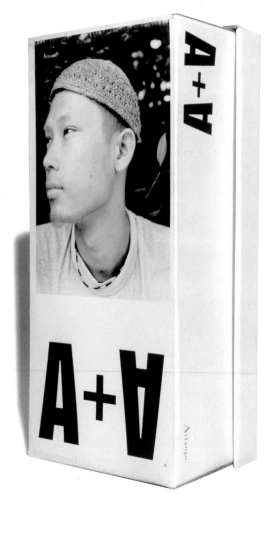

autism now organisation
autism spectrum and similar
komunication disorders

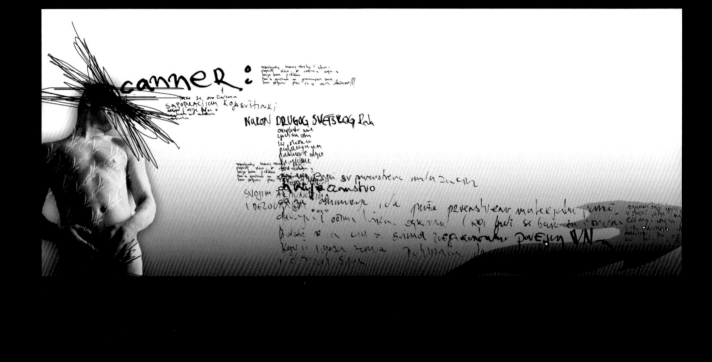

Vladimir Svorcan

Title : Autism Now Brochure
Country : Serbia

THE PAVLE BELJANSKI MEMORIAL COLLECTION

ART AS LIFE

Vladimir Svorcan

Title : Art as Life
Country : Serbia

CONTENTS

A Museum for a Magnificent Collection.................................8

Gallery location..11

History, Building..12

Permanent Exhibition, Artist´s Memorial Hall,

Collection..14

The Pavle Beljanski Memorial Hall.......................................16

Pavle Beljanski...19

The Pavle Beljanski Award..22

La Grande Iza..23

Pavle Beljanski Art Collection...25

Theme Exhibitions, Art Workshop.....................................206

Concerts and Promotions, Art Academy Student´s Exhibition...........208

6

HISTORY
BUILDING

HISTORY

The Pavle Beljanski Memorial Collection bears the name of its founder and contributor Pavle Beljanski, a great art collector, who donated his collection of paintings, sculptures and tapestries to the Serbian people in November 1957, according to a special contract with the Government of the Autonomous Province of Vojvodina. He continued to add works of art to this significant collection until the end of his life and according to the latest inventory, it consists of 185 works by 37 authors. The Pavle Beljanski Memorial Collection was opened to the public on October 22, 1961.

BUILDING

The Memorial Collection is situated in a new building, specifically designed by architect Ivo Kurtović for the purpose of housing the art collection. The building was built in 1961 and in October of the same year, it opened to public under the name of The Pavle Beljanski Memorial Collection. The great architectural value of the structure was achieved through the architect's good evaluation of its specific requirements which he organized into a functional whole.

Layout of the ground floor

1 Entrance hall
2 Exhibition area

Layout of the first floor

1 Upper lobby
2 Exhibition area
3 The Pavle Beljanski Memorial
4 The Artists' Memorial

13

teorija
tragikomedije

„Stvari imaju različita svojstva a duša različite sklonosti, jer ništa što se duši nudi nije jednostavno a duša nikad ničemu sebe ne nudi jednostavno. Otud se u isto vreme jedan smeje a drugi plače."
Blez Paskal, Misli, br. 112

DRUGO POGLAVLJE

[značenje]
[i značaj]
moderne tragikomedije

Delmont: Igram sve, klasične i moderne drame, tragedije i komedije.
Izabela: I nikada se ne zabunite i pobrkate ih?
Delmonte: U stara vremena, nikad! Komedija je bila komedija a tragedija tragedija! Ali s ovim današnjim dramama, naravno?
Žan Anuj, Porodična večera

TREĆE POGLAVLJE

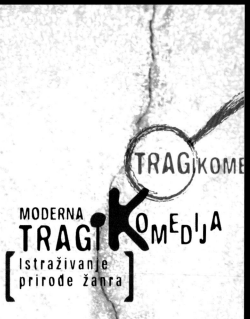

TRAGIKOME

MODERNA
TRAGIKOMEDIJA
[Istraživanje
prirode žanra]

·K Karl S. Gutke

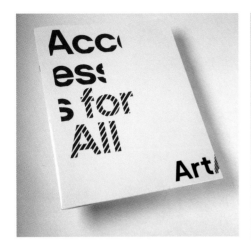

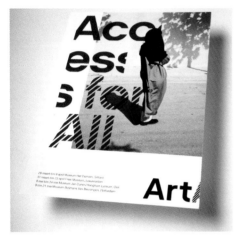

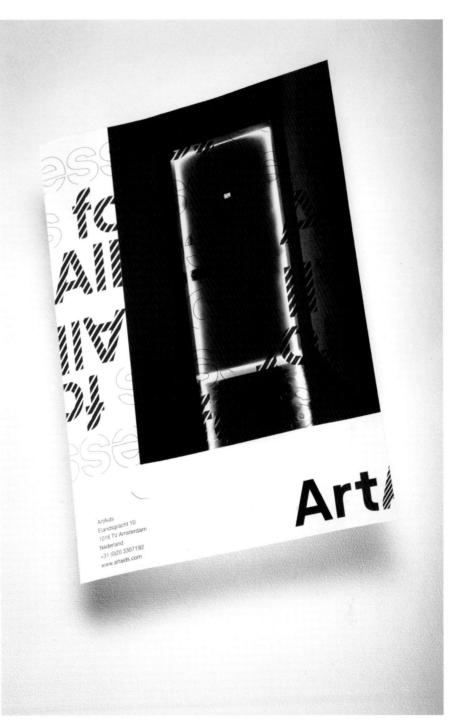

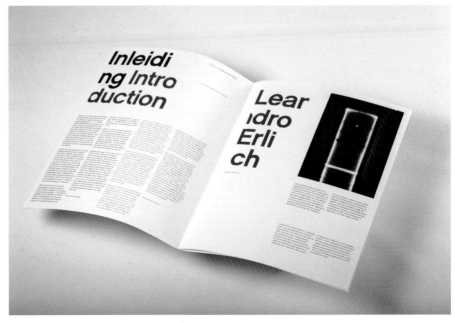

Studio Dumbar

Title : Brochure and Flyer of Art Aids
Country : The Netherlands

Studio Dumbar

Title : Brochure of Champalimaud Foundation
Photography : Dieter Schütte
Country : The Netherlands

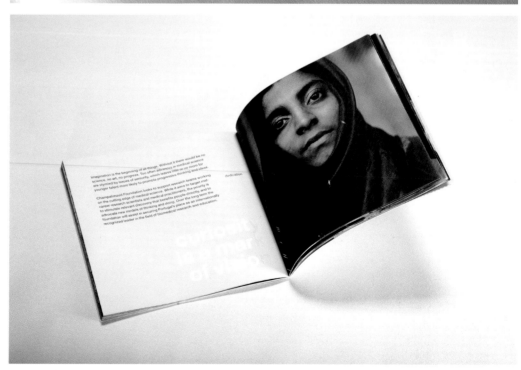

www.omd.com

About us

OMD is the largest media communications specialist in the world and, with the power of more than 4,500 people working in over 80 countries worldwide, we can continue to guarantee easyJet a media partnership that is second to none.

We have endured the challenges of working with easyJet over the past three years and have geared our management structure to deal with the dynamic communications landscape in which easyJet operates.

OMD currently works with easyJet in 16 markets across Europe: the UK, France, Germany, Spain, Italy, Switzerland, Netherlands, Denmark, Greece, Portugal, the Czech Republic, Hungary, Poland, Slovakia, Slovenia and Estonia.

We are very proud of the working partnership we have with easyJet and have created this book to provide an overview of our media highlights since winning your business in 2003.

3

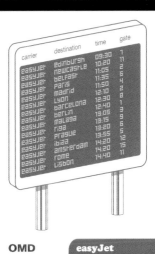

carrier	destination	time	gate
easyJet	Edinburgh	09:30	7
easyJet	Newcastle	10:20	11
easyJet	Belfast	11:05	2
easyJet	Paris	11:35	6
easyJet	Madrid	11:50	2
easyJet	Lyon	12:10	8
easyJet	Barcelona	12:30	1
easyJet	Berlin	12:40	3
easyJet	Malaga	13:05	9
easyJet	Riga	13:15	6
easyJet	Prague	13:20	5
easyJet	Ibiza	13:55	12
easyJet	Amsterdam	14:20	15
easyJet	Rome	14:20	11
easyJet	Lisbon	14:40	11

Itinerary

Checking in
Cost improvements so far
7

Boarding
Process, procedures and people
19

Attention!
Flying through innovation
29

Buckle up!
Turbulence ahead
51

Touch down
You're in safe hands
57

OMD has a significant buying performance track record

OMD enjoys the reputation of being the most efficient buying network, and we are renowned for trading rigorously on behalf of our clients to ensure that their money is spent effectively to gain maximum value. We guarantee that, through our people positioning and philosophy, we can extend this strong performance to new markets across the region.

Operating locally, easyJet already benefits from our volume; however, there are opportunities for you to benefit further by leveraging your volume with media owners across markets for added value.

The map opposite highlights the markets where we handle your business, and where we are already making considerable savings on your behalf.

Locations
UK
France
Germany
Spain
Italy
Switzerland
Netherlands
Denmark
Greece
Portugal
Czech Republic
Hungary
Poland
Slovenia
Estonia
Slovakia

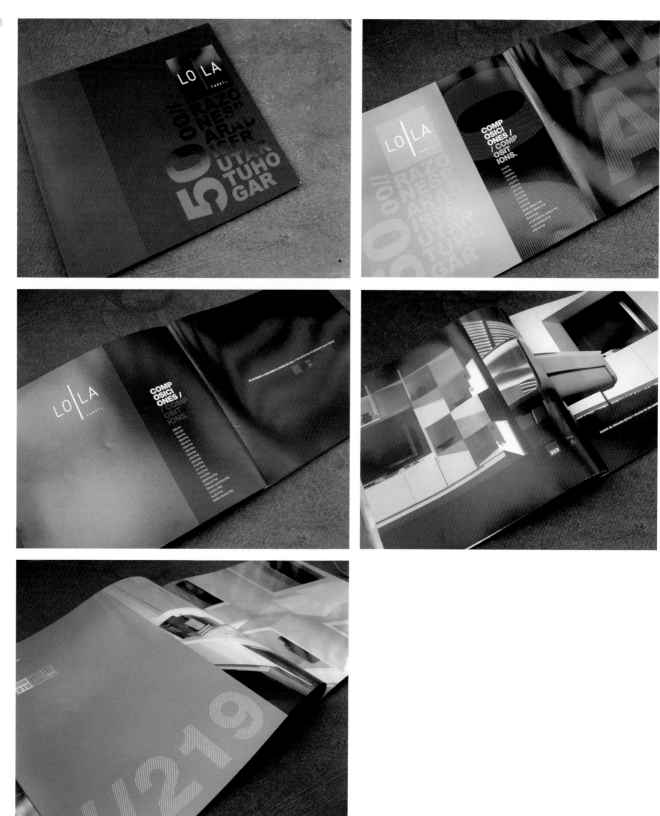

Yonoh

Title : LOLA 2006–2007–Catalogue Design of Furniture Company
Design : Alex Selma
Country : Spain

Company

Title : Freman College Year Book
Design : Alex Swain, Chrysostomos Naselos
Country : Britain

Company

Title : Inside Out
Design : Alex Swain, Chrysostomos Naselos
Country : Britain

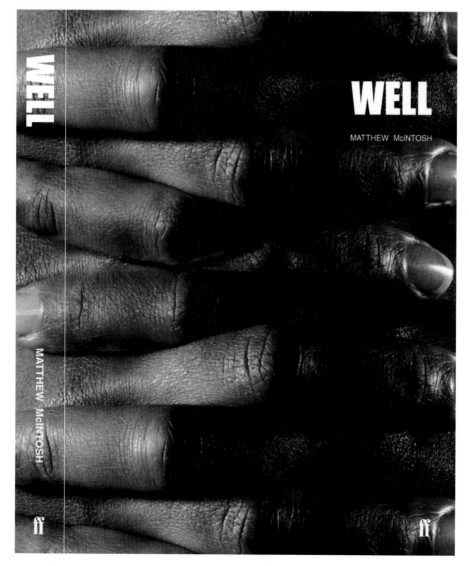

Mark Richardson
Graphic Design

Title : Well
Country : Britain

100%

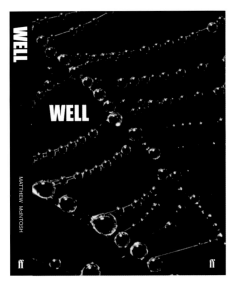

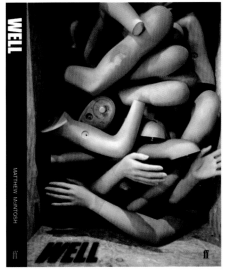

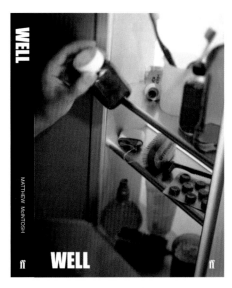

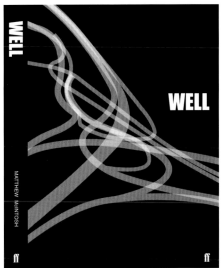

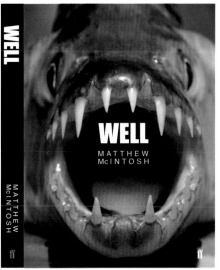

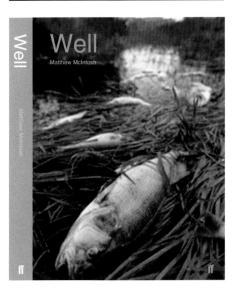

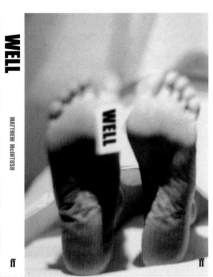

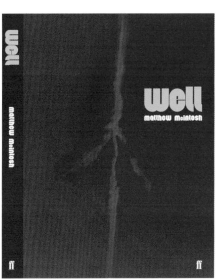

Bard Hole Standal

Title : Playtimes Issue 11
Country : Norway

Alexander Egger

Title: Maybe I Have Been Looking
in the Wrong Place
Country: Italy

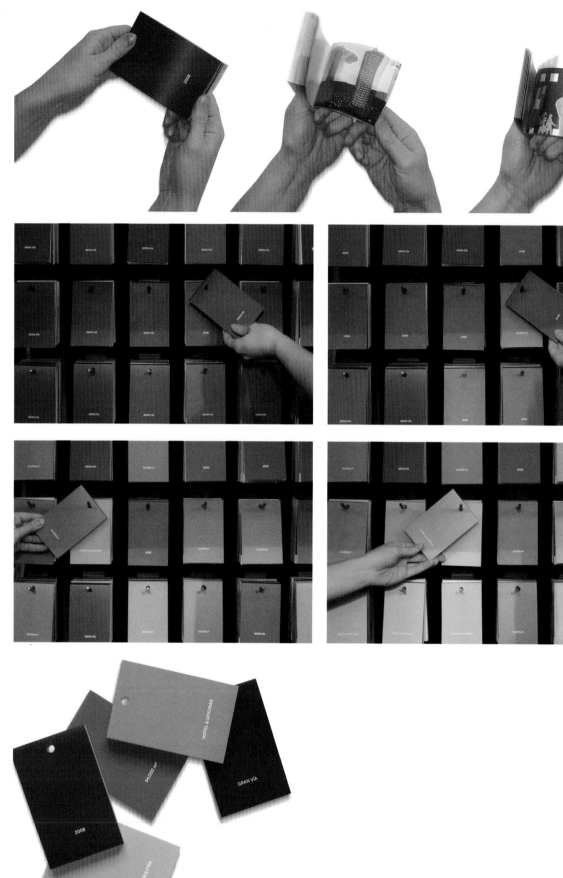

BAG.Disseny

Title : Stand for Layetana Real Estate
Creative Director : Xavi Mora
Art Director : Sandra Compte
Designer : BAG
Photography : BAG
Country : Spain

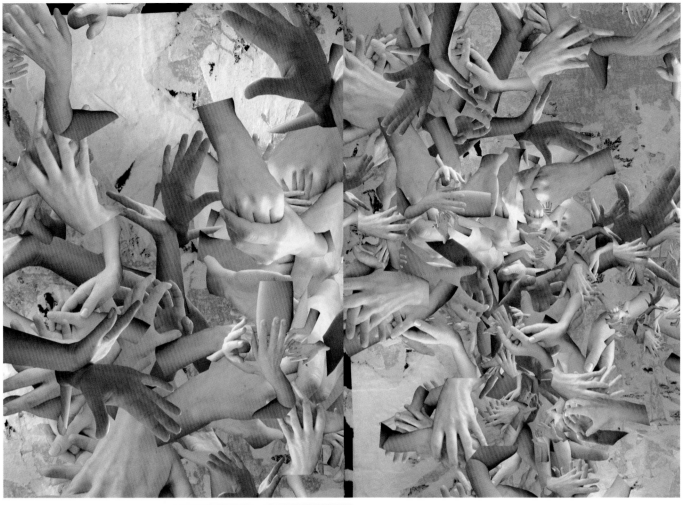

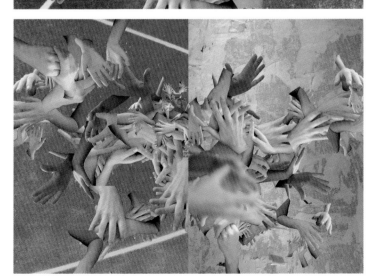

Alexander Egger

Title : Critical Mass
Country : Italy

ARM THE
LONELY

ARM THE
LONELY
RECORDS

ARM THE
LONELY
RECORDS
–

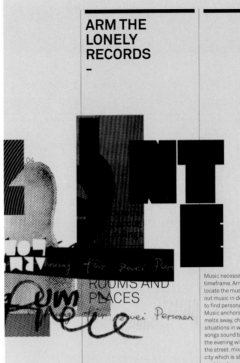

ROOMS AND
PLACES

Music necessarily happens in a defined timeframe. Arm the Lonely is also trying to locate the music in a specific space. Trying out music in different places is a criterion to find personal, specific, subjective access. Music anchors in a room and spreads out, melts away, changes according to room situations in which music occurs. Some songs sound best in a second floor flat in the evening with the windows open onto the street, mixing up with the sounds of the city which is slowly getting tired of a hard working day.

Some songs need a close listening situation together with a person you adore, some a tense concert situation with sweaty bodies, some open car windows in the summer sun, some maybe a dark sleeping room and the noises of your neighbour having sex with his new girlfriend coming through the wall and others profit from dogs barking or the voices of children playing in the park, with the ornamental decoration in a viennese café or the white walls of my own living room.

ARM THE
LONELY
RECORDS
–
–

CONTEXT AND
RELATIONS

Arm the Lonely is embedded in a wide relational and referential system which manifests itself in several collaborations and extentions of the label program including booking, tour organisation, art exhibitions, performances, graphic design and literature.
–
–
The label stands for a critical reflection of culture and consumerism. Engagement against conformity between music and consumer taking in a position without opposition or aggression but procuring possibilities and choices.
–

SATELLITES MISTAKEN FOR STARS
–
More emissions and pollutions of Alexander Egger, graphic designer of all Arm the Lonely releases and co-founder of the label.
–
www.satellitesmistakenforstars.com
–

DLGO BOOKING
–
All Arm the Lonely artists can be booked through DLGO. We especially love to do label nights.
–

HORSES OF CALIGULA
–
Open source music project of full-time barbeque superstars Gerd Oberlechner and Arnold Spachinger.
–

ARM THE
LONELY
RECORDS
–
–

CONTACT
INFORMATION
–
–

We like to hear from you. For further and more detailed information, conditions, distribution, collaboration please get in touch with us directly.
–

ARM THE LONELY
c/o Lorenz Delago
Anichstrasse 44
6020 Innsbruck
Austria
–
E-mail: ask@armthelonely.com
www.armthelonely.com
–
Telephone: +43 23 35 80 01
–
–

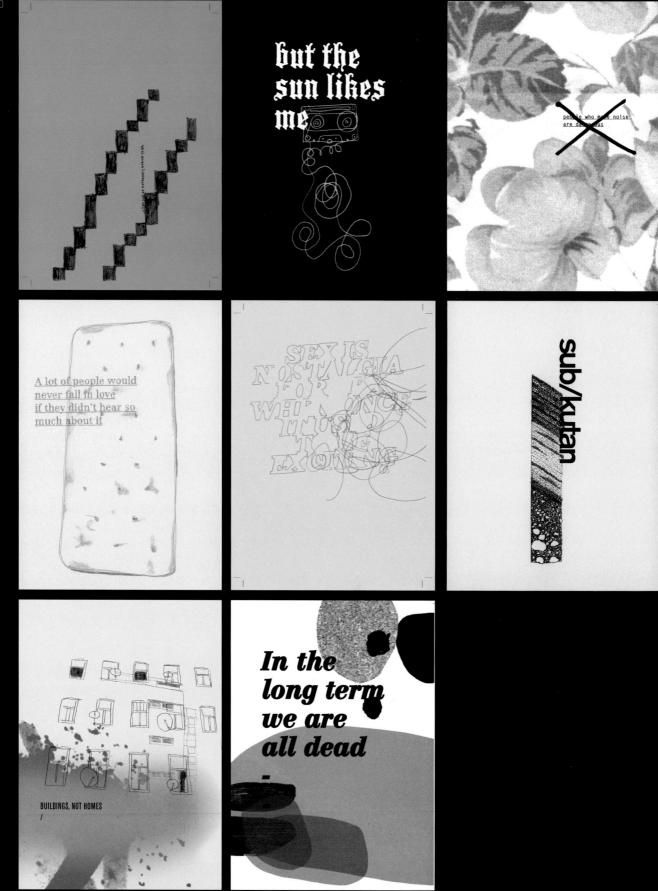

but the
sun likes
me

people who make noise
are dangerous

A lot of people would
never fall in love
if they didn't hear so
much about it

SEX IS
NOSTALGIA
FOR
WHAT ONCE
IT MUST
TO BE
COMING

sub/kutan

In the
long term
we are
all dead
–

BUILDINGS, NOT HOMES

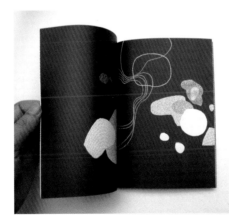

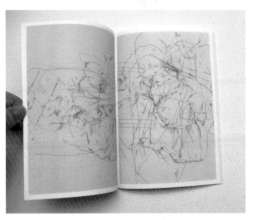

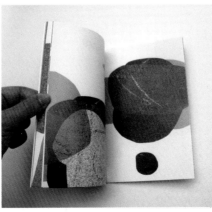

Alexander Egger
Title : Pilot Projekt
Country : Italy

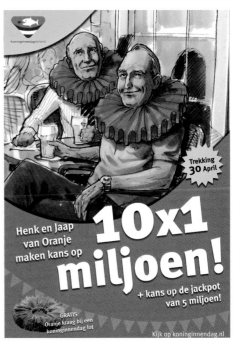

Peter Raczko

Title : Staatsloterij
Country : The Netherlands

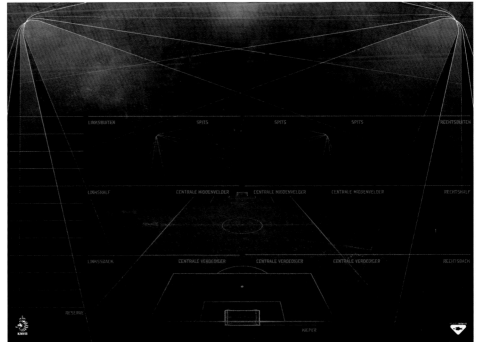

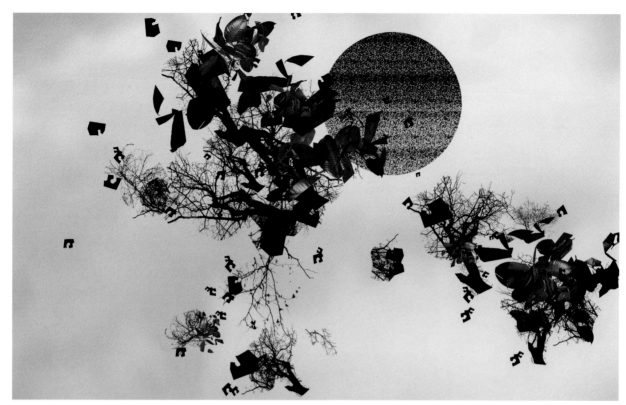

Alexander Egger

Title : Satellites Mistaken for Stars
Country : Italy

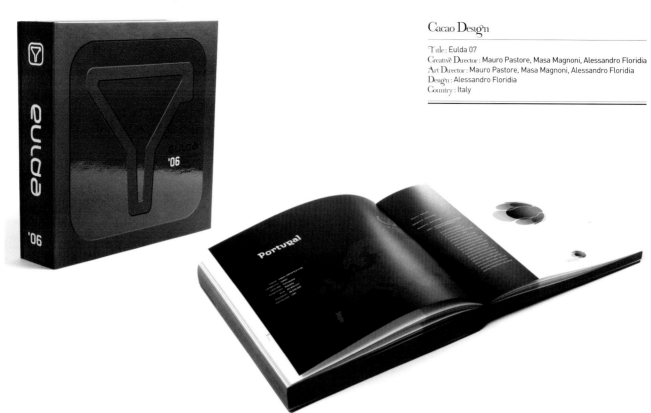

Cacao Design

Title : Eulda 07
Creative Director : Mauro Pastore, Masa Magnoni, Alessandro Floridia
Art Director : Mauro Pastore, Masa Magnoni, Alessandro Floridia
Design : Alessandro Floridia
Country : Italy

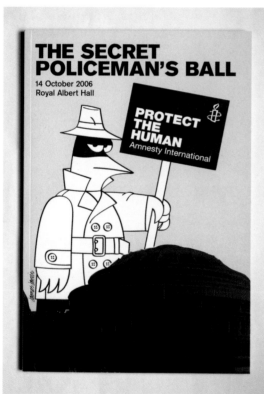

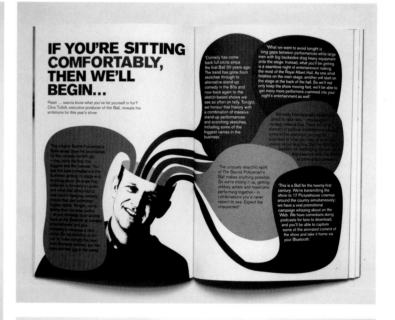

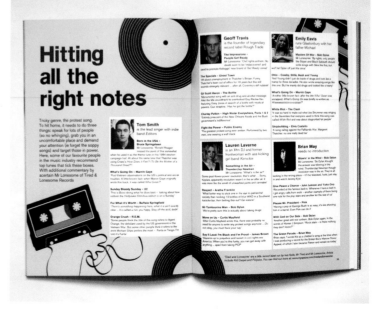

New Future Graphic

Title: The Secret Policemans Ball-Amnesty International
Creative Director: Marcus Walters & Gareth White
Country: Britain

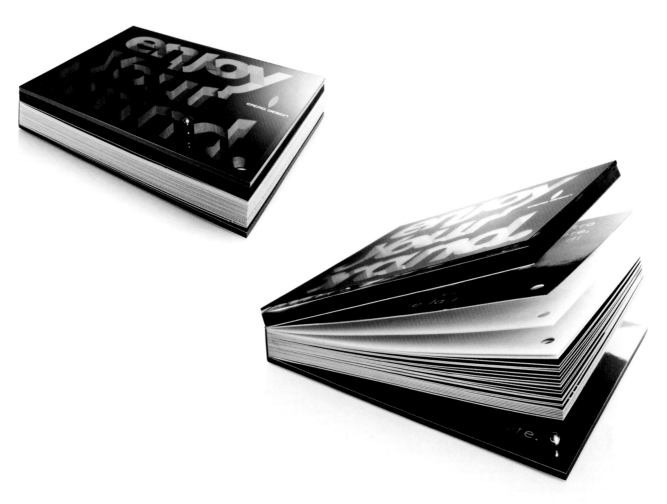

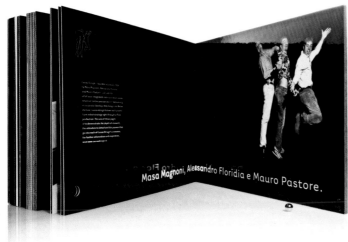

Masa Magnoni, Alessandro Floridia e Mauro Pastore.

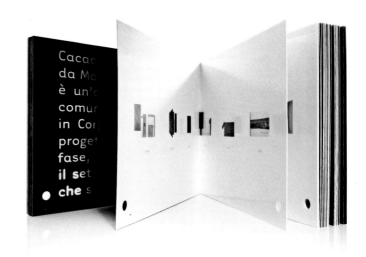

Cacao Design

Title : "Enjoy your Brand"-Cacao Design Brochure
Creative Director : Mauro Pastore, Masa Magnoni, Alessandro Floridia
Art Director : Mauro Pastore, Masa Magnoni, Alessandro Floridia
Design : Alessandro Floridia
Photography : Giuseppe Toja, Claudio Gaiaschi
Country : Italy

Leve 2007 !

COEN!

Title : VVD
Design : Coen van Ham
Country : The Netherlands

Laboratorium

Title : Death in Venice & Dido and Aeneas
Creative Director : Ivana Vucic, Orsat Frankovic
Art Director : Orsat Frankovic, Ivana Vucic, Zeljka Zupanic
Design : Zeljka Zupanic, Ivana Vucic, Sasa Stubicar
Photography : Ivana Vucic
Country : Croatia

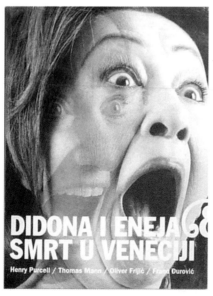

Rotbraun Informationsgestaltung

Title : Goodyear – Eagle Gold
Designer : Nora Bilz, Pia Schneider
Country : Germany

KONZEPT Tassilo Trastow/ Thomas Herbst
UMSETZUNG Tassilo Trastow unter Mitwirkung von Thomas Herbst,
Peter Deisenberger, Christian Kollmann, Dr. Stefan Schaeffer
LEKTORAT Stefan Schwär
LAYOUT Alexander Egger
ILLUSTRATION Alexander Egger

INHALT

00 / 03	**EINLEITUNG**
01 / 05	**UNTERSCHIEDLICHE WELTEN**
02 / 07	**PARTNERWAHL**
03 / 09	**BRIEFING**
04 / 11	**TEAMBILDUNG**
05 / 13	**RECHTLICHES UMFELD**
06 / 15	**FAKTOR GESCHMACK**
07 / 20	**WERTE VON GESTALTUNG**
08 / 22	**REGEL VS. KREATIVITÄT**
09 / 24	**FEHLER MIT SPÄTWIRKUNG**

IT TAKES A VILLAGE
TO CREATE A BRAND

Ein Leitfaden für die Zusammenarbeit
zwischen Unternehmen und Kreativen

PARTNERWAHL

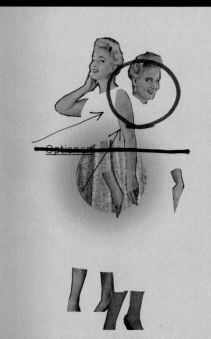

Dieses Zitat einer großen Markenagentur bringt es auf den Punkt. Durch die
hohe Spezialisierung in der Kreativ- und Kommunikationsbranche sind heute
wesentlich mehr Modelle möglich als nur die Zusammenarbeit mit so genannten
„Full-Service-Agenturen", also Kreativ-Unternehmen, die ihren Kunden alles aus
einer Hand bieten, von der Konzeption bis zur Realisierung einer Kampagne.
Bevor eine Zusammenarbeit entstehen kann, müssen erst die richtigen Partner
gefunden werden. Diese werden oft über Wettbewerbe ausgewählt, aber auch
persönliche Empfehlungen führen zu Kooperationen.

Die Auswahl der möglichen Partner orientiert sich in der Regel an einer ganz
banalen Grundsatzfrage: Was ist die Aufgabe? In der Antwort steckt zumeist auch
schon die Strategie für mögliche Partnerschaftsmodelle. Dabei stehen grundsätzlich
drei Konstellationen zur Diskussion: die Zusammenarbeit mit einer Agentur
(Full-Service), mit einer „Lead-Agentur" oder mit einem reinen Agentur-Netzwerk.
Weitere Parameter, die bei der Auswahl der Partner hilfreich sein können, sind die
Zielgruppen, die Komplexität und die Kanäle des Projekts oder auch das angestrebte
Niveau. Übrigens: Laut einer Umfrage 2006 hat das Modell Agentur-Netzwerk
bereits eine satte Mehrheit hinter sich.

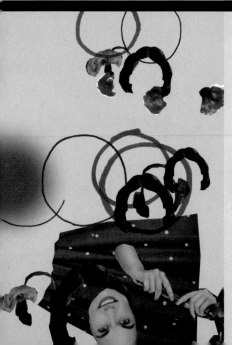

Dieses Zitat einer großen Markenagentur bringt es auf den Punkt. Durch die
hohe Spezialisierung in der Kreativ- und Kommunikationsbranche sind heute
wesentlich mehr Modelle möglich als nur die Zusammenarbeit mit so genannten
„Full-Service-Agenturen", also Kreativ-Unternehmen, die ihren Kunden alles aus
einer Hand bieten, von der Konzeption bis zur Realisierung einer Kampagne.
Bevor eine Zusammenarbeit entstehen kann, müssen erst die richtigen Partner
gefunden werden. Diese werden oft über Wettbewerbe ausgewählt, aber auch
persönliche Empfehlungen führen zu Kooperationen.

Die Auswahl der möglichen Partner orientiert sich in der Regel an einer ganz
banalen Grundsatzfrage: Was ist die Aufgabe? In der Antwort steckt zumeist auch
schon die Strategie für mögliche Partnerschaftsmodelle. Dabei stehen grundsätzlich
drei Konstellationen zur Diskussion: die Zusammenarbeit mit einer Agentur
(Full-Service), mit einer „Lead-Agentur" oder mit einem reinen Agentur-Netzwerk.
Weitere Parameter, die bei der Auswahl der Partner hilfreich sein können, sind die
Zielgruppen, die Komplexität und die Kanäle des Projekts oder auch das angestrebte
Niveau. Übrigens: Laut einer Umfrage 2006 hat das Modell Agentur-Netzwerk
bereits eine satte Mehrheit hinter sich.
hohe Spezialisierung in der Kreativ- und Kommunikationsbranche sind heute
wesentlich mehr Modelle möglich als nur die Zusammenarbeit mit so genannten
„Full-Service-Agenturen", also Kreativ-Unternehmen, die ihren Kunden alles aus
einer Hand bieten, von der Konzeption bis zur Realisierung einer Kampagne.
Bevor eine Zusammenarbeit entstehen kann, müssen erst die richtigen Partner
gefunden werden. Diese werden oft über Wettbewerbe ausgewählt, aber auch
persönliche Empfehlungen führen zu Kooperationen.

Die Auswahl der möglichen Partner orientiert sich in der Regel an einer ganz
banalen Grundsatzfrage: Was ist die Aufgabe? In der Antwort steckt zumeist auch
schon die Strategie für mögliche Partnerschaftsmodelle. Dabei stehen grundsätzlich
drei Konstellationen zur Diskussion: die Zusammenarbeit mit einer Agentur
(Full-Service), mit einer „Lead-Agentur" oder mit einem reinen Agentur-Netzwerk.
Weitere Parameter, die bei der Auswahl der Partner hilfreich sein können, sind die
Zielgruppen, die Komplexität und die Kanäle des Projekts oder auch das angestrebte
Niveau. Übrigens: Laut einer Umfrage 2006 hat das Modell Agentur-Netzwerk
bereits eine satte Mehrheit hinter sich.

1:1-Netzwerk

In dieser Form der Kooperation vergibt der Auftraggeber das gesamte Projekt an
eine externe Partneragentur zur Abwicklung. Das bedeutet, dass alle Entscheidungen
und Prozesse zwischen dem Marketingverantwortlichen eines Unternehmens und

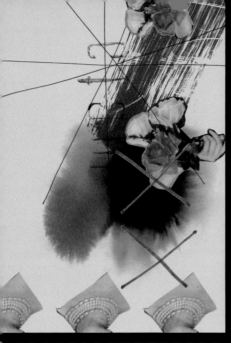

FEHLER MIT SPÄTWIRKUNG

Alles kommuniziert. Daher sollte alles bewusst gestaltet sein. Oft wird der Gestalter aber erst beim teuersten Kommunikationsmittel als sinnvoller Partner geortet – bei der Werbung. Damit werden große Kommunikationspotenziale außer Acht gelassen, womit die Wirkung der Werbung massiv geschwächt wird. Denn Kunden nehmen an jedem „Touchpoint" der Marke wahr, was tatsächlich „hier" ist und was eben doch nur „pfui". Wir wissen aus eigener Erfahrung, dass sich alles laufend verändert. Während werbliche Entscheidungen sich dieser Veränderung anpassen müssen, bleiben die Grundstory und die wichtigsten Signale gleich (Name, Logo, Schrift, Farbe, Produkte, Design). Die Strategie eines Unternehmens wird über das Branding definiert und schafft Werte, die sich auf alle Berührungspunkte des Unternehmens übertragen lassen. Werte geben auch Partner (und Gegner) vor und halten in der Regel 7 Jahre und länger. Wenn ein Unternehmen sich also stets an den aktuellen Trends anstatt an strategischen Richtlinien orientiert, führt das spätestens nach 3 bis 4 Jahren zu einem kommunikativen Chaos. Erfolgreiche Kreativprojekte berücksichtigen daher vom Ansatz her die Integration in bestehende Strategien und beziehen sich auch auf Arbeitsprozesse, auf die Mitarbeiter oder auch die Büroeinrichtung. Dann muss die Werbung nur mehr bei jenen Stärken ansetzen, die tatsächlich erlebbar sind. Eine der wichtigsten Regeln, die daher zu beachten sind, lautet: Hab immer eine Strategie!

UNTERSCHIEDLICHE WELTEN

Dieses Zitat einer großen Markenagentur bringt es auf den Punkt. Durch die hohe Spezialisierung in der Kreativ- und Kommunikationsbranche sind heute wesentlich mehr Modelle möglich als nur die Zusammenarbeit mit so genannten „Full-Service-Agenturen", also Kreativ-Unternehmen, die ihren Kunden alles aus einer Hand bieten, von der Konzeption bis zur Realisierung einer Kampagne. Bevor eine Zusammenarbeit entstehen kann, müssen erst die richtigen Partner gefunden werden. Diese werden oft über Wettbewerbe ausgewählt, aber auch persönliche Empfehlungen führen zu Kooperationen.

Die Auswahl der möglichen Partner orientiert sich in der Regel an einer ganz banalen Grundsatzfrage: Was ist die Aufgabe? In der Antwort steckt zumeist auch schon die Strategie für mögliche Partnerschaftsmodelle. Dabei stehen grundsätzlich drei Konstellationen zur Diskussion: die Zusammenarbeit mit einer Agentur (Full-Service), mit einer „Lead-Agentur" oder mit einem reinen Agentur-Netzwerk. Weitere Parameter, die bei der Auswahl der Partner hilfreich sein können, sind die Zielgruppen, die Komplexität und die Kanäle des Projekts oder auch das angestrebte Niveau. Übrigens: Laut einer Umfrage 2006 hat das Modell Agentur-Netzwerk bereits eine satte Mehrheit hinter sich.

In dieser Form der Kooperation vergibt der Auftraggeber das gesamte Projekt an eine externe Partneragentur zur Abwicklung. Das bedeutet, dass alle Entscheidungen und Prozesse zwischen dem Marketingverantwortlichen eines Unternehmens und

WO SETZT KREATIVITÄT AN ?
WAS IST SIE WERT?

WERTE VON GESTALTUNG

Kann man einen hässlichen, geschmacklosen Pudding besser verkaufen, wenn man ihn mit rosa Zuckerguss überzieht? In Kreativprojekten entstehen unterschiedliche Werte, die sich in zwei große Gruppen unterteilen lassen: Zum einen sind die effektiven Geldwerte eines Unternehmens gemeint, die über eine Marke und somit durch deren Gestaltung entstehen. Zum anderen sind diejenigen „persönlichen" Werte gemeint, die über die Markenkommunikation gestaltet werden.

MARKENWERTE

Die Grundleistung eines Unternehmens, also die Produkte, sind immer schwieriger durch technische Daten, Leistungsfähigkeit oder Nutzungsmöglichkeit von anderen Produkten zu unterscheiden. Konsumenten sind heute bereit, für Markenprodukte wesentlich mehr Geld auszugeben als für andere. Wieso? Marken besitzen Identität und schaffen Vertrauen. Ein Produkt, egal ob Schmerzmittel oder Schokolade, schafft mehr Vertrauen, je stabiler es ist und je besser die Werte vermittelt werden. Folglich kommt der Art, Dinge zu produzieren und zu kommunizieren, eine immer bedeutendere Rolle zu, um einen relevanten, für den Konsumenten spürbaren Unterschied zur Konkurrenz zu schaffen. Entscheidend ist nicht, was gemacht wird, sondern wie es gesteuert wird. Dieser emotionale Nutzen, das „Wie", wird über die Werte gesteuert. Durch die bewusste Definition der Werte erreichen Unternehmensmarken Identität und Unterscheidbarkeit. Das wird benötigt, um vom Konsument erkannt zu werden und erfolgreich am Markt zu sein. Um diese Werte wahrnehmen und vermitteln zu

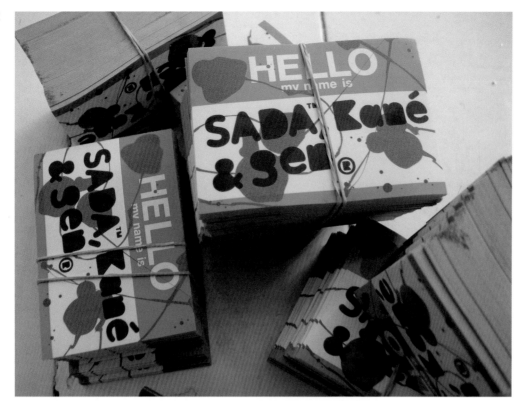

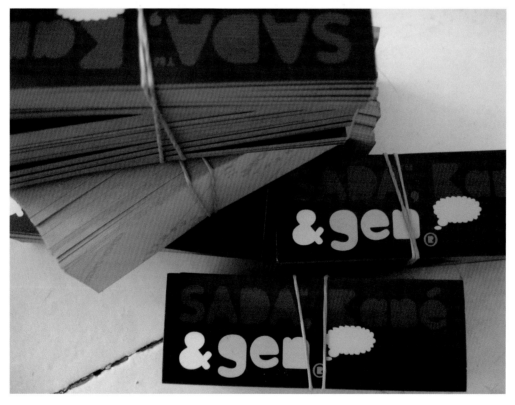

Gen Sadakane

Title : Poststicker
Country : Germany

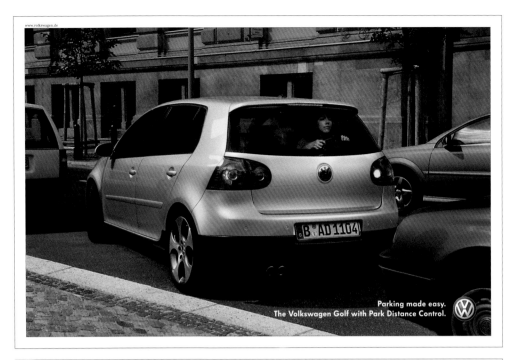

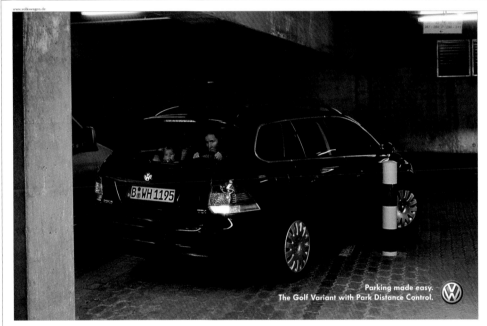

Gen Sadakane

Title : Print Ads for Volkswagen
Country : Germany

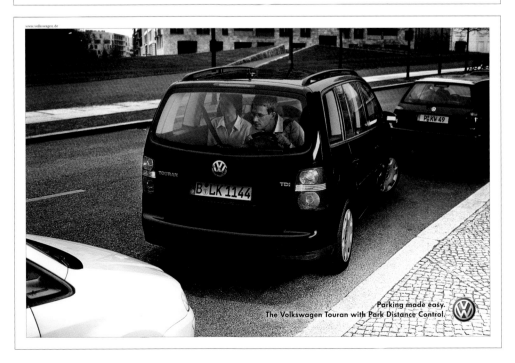

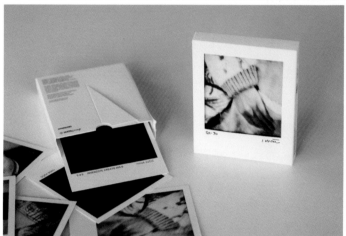

Laboratorium

Title : SX-70
Design : Ivana Vucic, Orsat Frankovic
Photography : Ivana Vucic
Country : Croatia

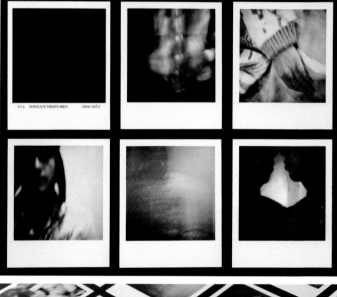

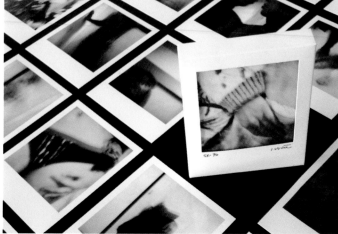

Laboratorum

Title: Aromarium
Art Director: Orsat Frankovic,
Ivana Vucic, Ana Vickovic
Design: Ana Vickovic
Country: Croatia

Laboratorum

Title : Kristian Kozul
Creative Director : Ivana Vucic, Orsat Frankovic
Art Director : Ivana Vucic, Orsat Frankovic
Design : Ivana Vucic, Orsat Frankovic, Sasa Stubicar
Photography : Tomisiav J.Kacunic, Ivana Vucic, etc
Illustration : Kristian Kozul
Country : Croatia

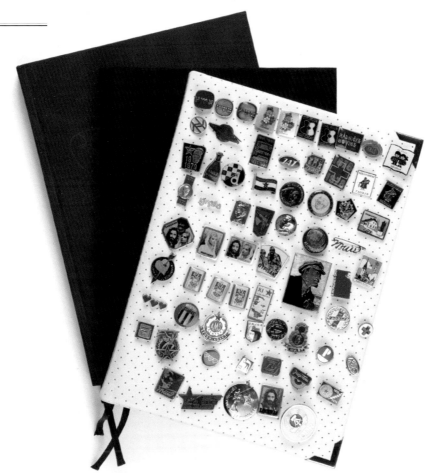

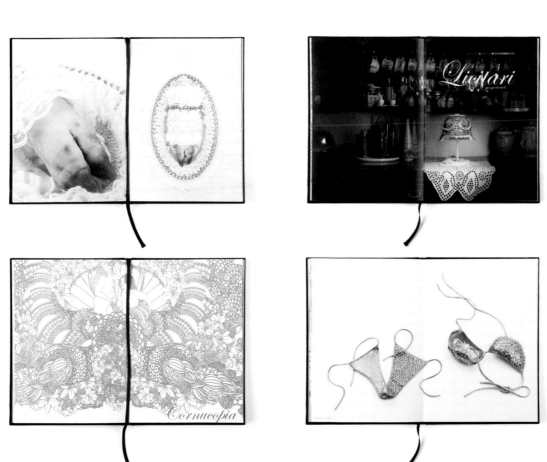

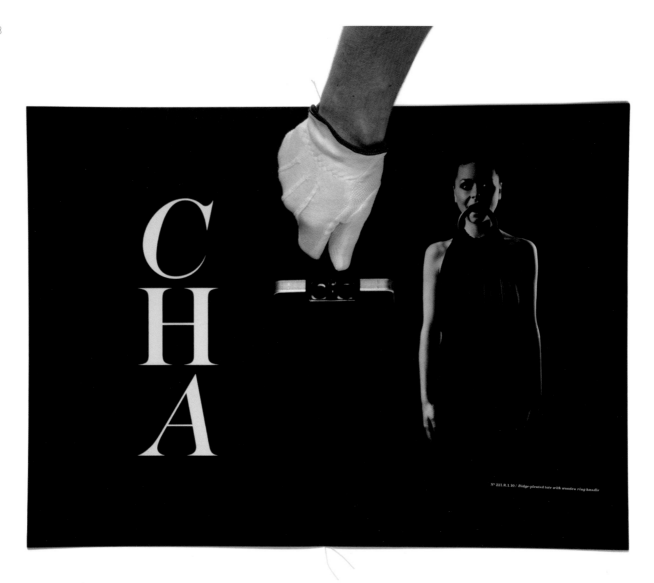

N° 221.8.1.10 / *Ridge-pleated tote with wooden ring handle*

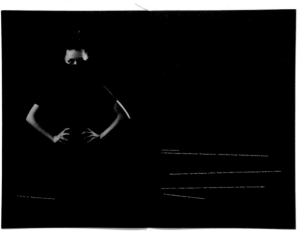

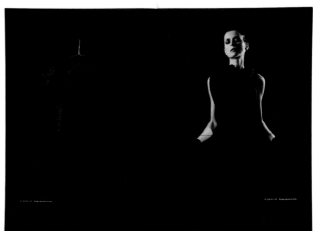

Ohlsonsmith

Title : Van Deurs Image Catalogue
Design : Ohlsonsmith
Country : Sweden

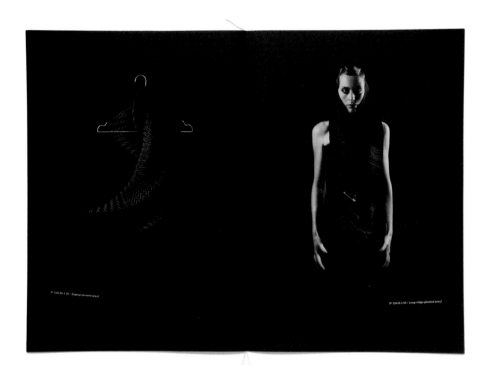

N° 258.22.1.10 / *Zigzag-pleated scarf*

N° 258.8.1.20 / *Long ridge-pleated scarf*

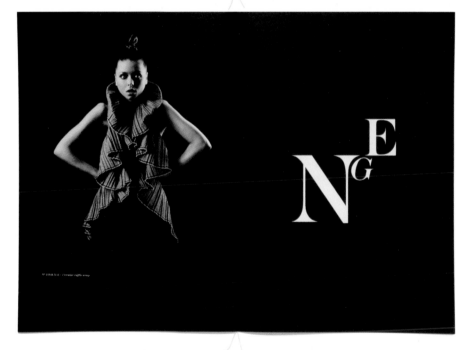

N° 258.8.3.11 / *Circular ruffle scarf*

N **E** **G**

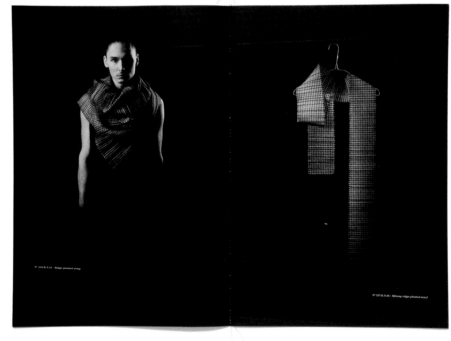

N° 258.8.3.14 / *Ridge-pleated wrap*

N° 258.8.3.20 / *Skinny ridge-pleated scarf*

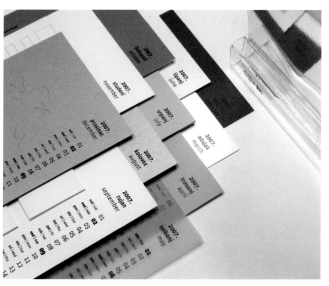

Tridvajedan Market Communication Ltd.

Title : Combis-Gadgets Calendar
Creative Director : Jelena Gvozdanovic, Izvorka Juric
Art Director : Izvorka Juric
Design : Natalija Najjar
Copywriter : Jelena Gvozdanovic
Country : Croatia

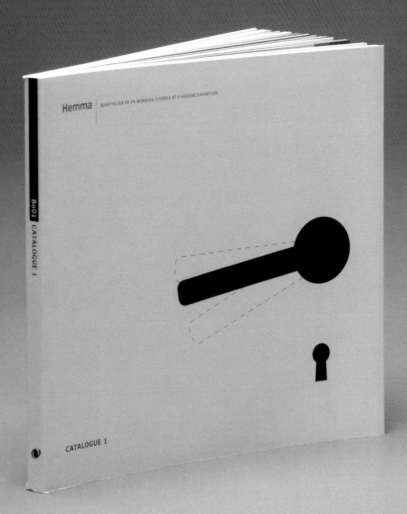

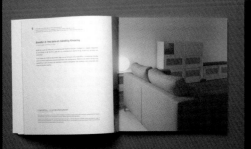

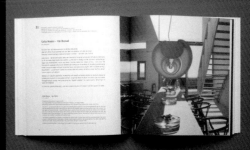

Naroska Design

Title : Naroska Design-House Advertising
Country : Germany

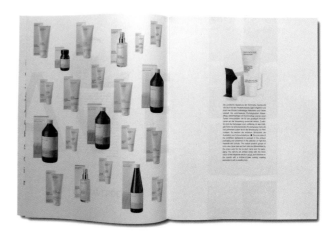

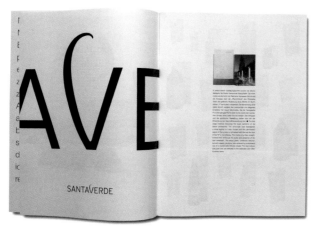

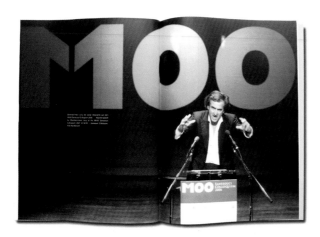

Naroska Design hat Verpackungen entworfen, Erscheinungsbilder konzipiert, mit Modedesignern gearbeitet, Plakate für Veranstaltungen und Ausstellungen gestaltet, Broschüren, Kataloge und Bücher gelayoutet, Logos gezeichnet, Websites konzipiert, Strategien entwickelt und Kultur unterstützt. Wir wollen dabei keine Philosophie entwickeln – aber eine Haltung, die haben wir: Wir verwenden viel Zeit darauf, nachzudenken und tragende Ideen als Grundlage für ausdrucksvolles und starkes Design zu entwickeln. Die Ergebnisse dieser Haltung finden Sie auf den folgenden Seiten: Ausgewählte Projekte eines erfolgreichen Jahres 2006. ■ In 2006 we designed packaging and images, worked with fashion designers, made posters for events and exhibitions, laid out brochures, catalogues and books, developed logos, websites and strategies, and supported the arts in general. We do not have a philosophy, but we do have attitude. We invest a lot of energy into thinking and developing convincing ideas that can carry a strong design. Look through the following pages and see the results of this attitude. Selected projects from a successful 2006 .

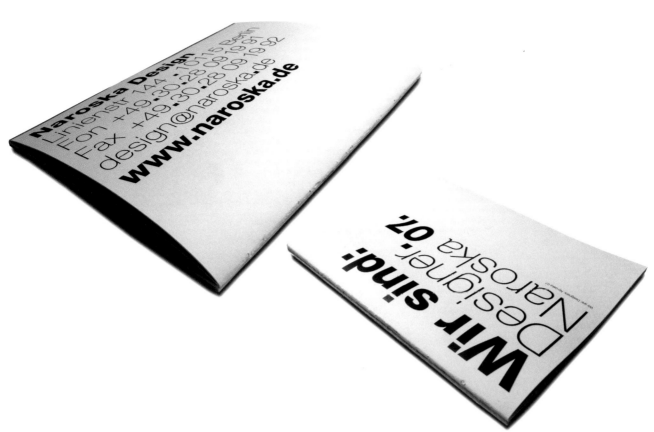

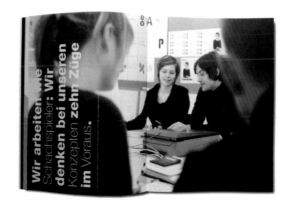

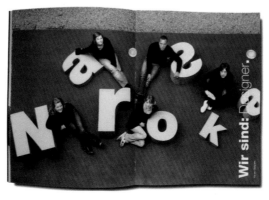

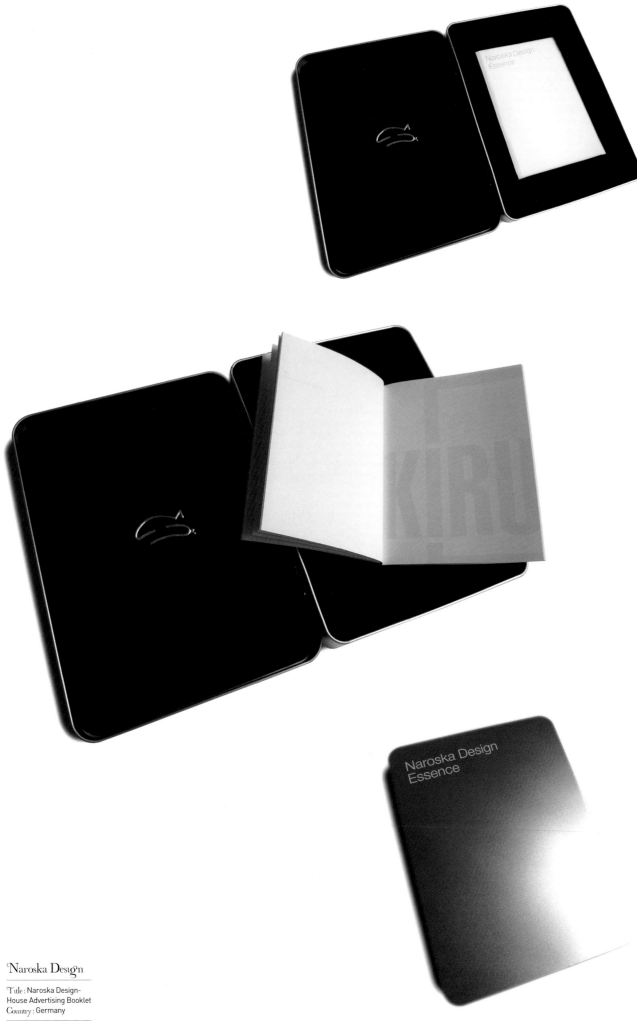

Naroska Design

Title : Naroska Design-
House Advertising Booklet
Country : Germany

Tridvajedan Market Communication Ltd.

Title : Miraculous Heat - Christmas Card
Creative Director : Jelena Gvozdanovic
Art Director : Izvorka Juric
Design : Matej Korlaet
Copywriter : Jelena Gvozdanovic
Country : Croatia

Tridvajedan Market Communication Ltd.

Title : Ericsson Nikola Tesla-Annual Report 2006
Creative Director : Izvorka Juric
Art Director : Izvorka Juric
Design : Izvorka Juric, Tin Kadoic
Copywriter : Jelena Gvozdanovic
Country : Croatia

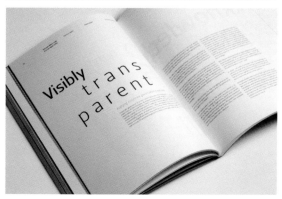

Hörður Lárusson

Title : Flag Report
Country : Iceland

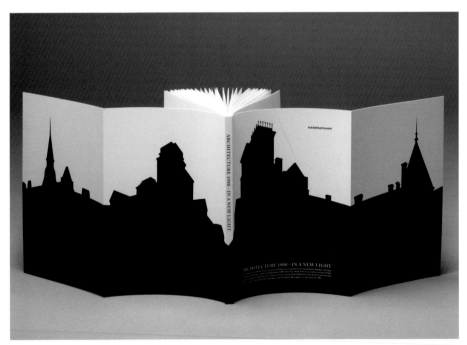

Formgivare Anna Larsson

Title : Architecture
Design : Anna Larsson
Country : Sweden

Formgivare Anna Larsson

Title : Arkitekturmuseet
Design : Anna Larsson
Country : Sweden

Formgivare Anna Larsson

Title : Florabyr Linné
Design : Anna Larsson
Country : Sweden

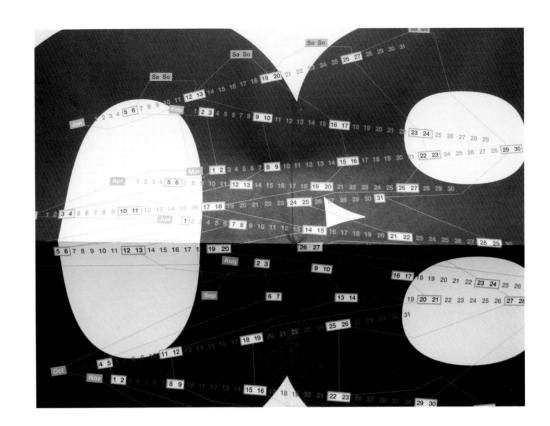

Naroska Design

Title : Naroska Design Christmas Card
Country : Germany

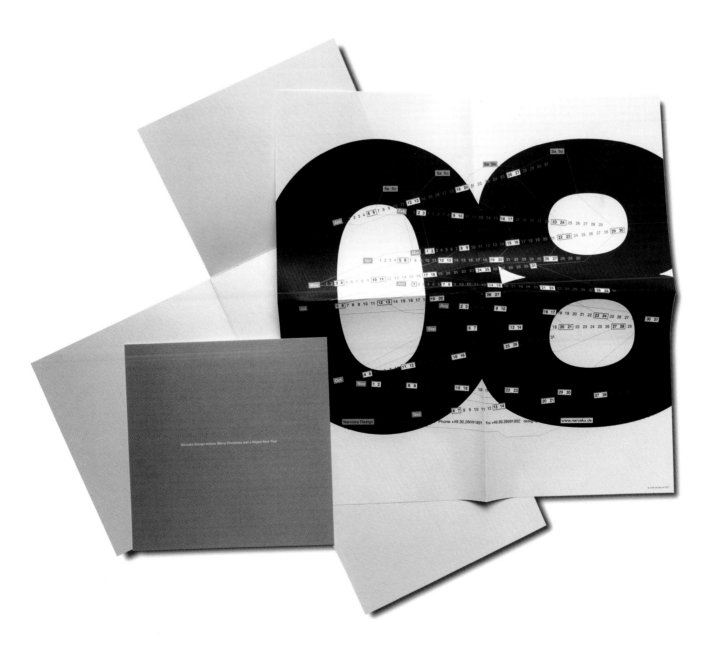

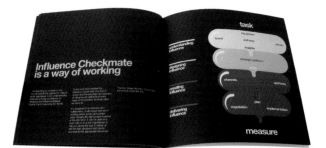

Mark Richardson
Graphic Design

Title : Influence Checkmate
Design : Mark Richardson
Country : Britain

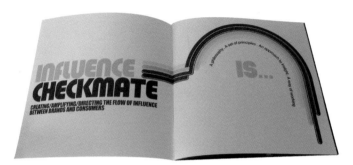

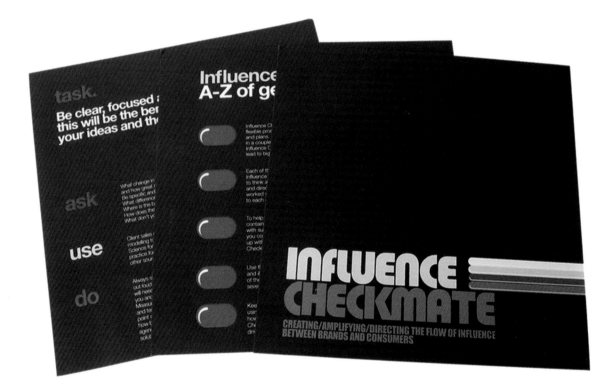

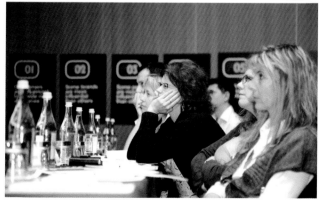

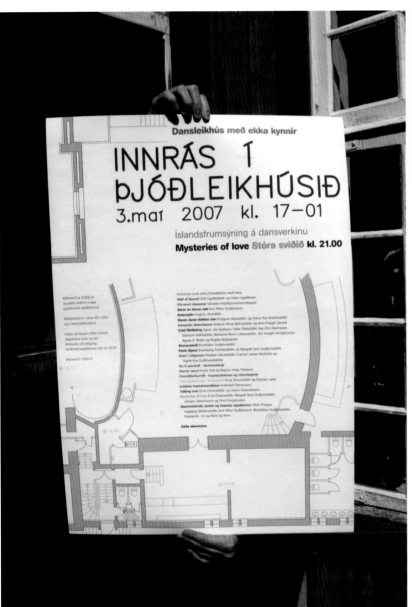

Hörður Lárusson

Title : Innrás í Þjóðleikhúsið
Design : Mark Richardson
Country : Iceland

Český komiks

Czech Comics

EXPOSIÇÃO DE BD CHECA
DE 24 DE FEVEREIRO A 15 DE ABRIL

Lisboa

BEDETECA DE LISBOA
PALÁCIO DO CONTADOR-MOR

RUA CIDADE DE LOBITO
OLIVAIS SUL

TEL.: 21 853 66 76
FAX: 21 853 21 68
E-MAIL: bedeteca@cm-lisboa.pt

www.bedeteca.com

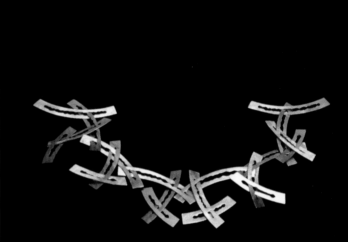

cortina de bambu

> **cortina de bambu, peitoral, 2001
prata texturada recortada.
150 X 250 X 0.7

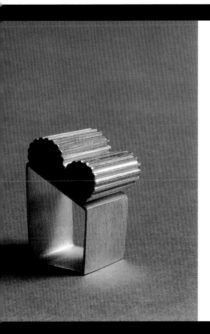

acervo

< *acervo*, anel, 1996
prata e ouro ondulado.
30 X 20 X 20

^ **acervo*, anel, 1996
prata e ouro ondulado.
30 X 20 X 20

^ > **acervo*, anel, 1996
prata e ouro ondulado.
30 X 27 X 20

^ > > **acervo*, anel, 1996
prata e ouro ondulado.
30 X 20 X 20

^ > > **acervo*, anel, 1996
prata e ouro ondulado.
30 X 20 X 20

Instalação
Estratos de Inquietude
1190 X 730

JÓIAS DE DULCE FERRAZ
Rui Afonso Santos*

Dulce Ferraz é uma destacada criadora que faz parte da novíssima [e crescentemente
internacionalizada] terceira geração da joalharia contemporânea portuguesa. Aluna
do consagrado membro da primeira geração Filomeno Pereira de Sousa, em cuja escola
de joalharia *Contacto Directo* se formou, Dulce Ferraz contava já com uma vasta
experiência cultural que foi da Licenciatura em História na Faculdade de Letras de
Lisboa a cursos de *Rattan Art* e de *Shiraki*, directamente ministrados por mestres
japoneses em Tóquio, cidade onde Dulce Ferraz viveu.
O interesse pelas ciências humanas e a estadia no Japão revelar-se-iam determinantes
no percurso de Dulce Ferraz, grande admiradora e conhecedora da cultura e arte
nipónicas. Posteriormente, diversos cursos de especialização em ourivesaria e
joalharia, ministrados por personalidades que vão do grande joalheiro Otto Kunzli a
Robert Smit e Sabine Hauss, apuraram conceptualmente o trabalho de Dulce Ferraz
e afinaram as suas jóias num aceto internacional que muito deve, evidentemente,
à sua forte marca autoral.

Das primeiras jóias em prata, subtilmente polivalentes e articuladas, semelhantes
a tiras de papéis dobrados e entrelaçados, à série *Acervo* (1996), evocadora na
sua extrema delicadeza da ancestral técnica do *Origami* japonês, o trabalho de
Dulce Ferraz evidencia uma marca nipónica rarissima na joalharia contemporânea
portuguesa.
Uma natural qualidade minimal, evidente na economia formal e na preferência
pela mono ou bicromia dada pelos materiais e técnicas nobres [ouro, prata, pérolas
negras, laca japonesa] marcaram a produção inicial [exposta na marcante exposição
Pot Pourri [1992], promovida na Galeria *Reverso*] que, em 2003, se maturou na série
Sulcos, [das em prata, ouro e alumínio minuciosamente recortados e sobrepostos,
delineando acidentes geográficos, montanhas e vales, paisagens inteiras até!
Expostas no Museu Nacional do Traje, estas jóias impressionam pela novidade
da sua proposta - seriam aquelas paisagens uma topografia natural, resultantes

das acidentais erupções e erosão terrestres, ou pelo contrário, resultariam da
paciente acção humana, como sucede nas ancestrais culturas em socalcos, do chá
no Oriente aos vinhos do Douro e da Madeira?
O equilíbrio entre os mundos natural e humano subjaz conceptualmente ao trabalho
de Dulce Ferraz, que transpõe a própria paisagem para as suas jóias, sobrepondo
eixos naturais a metas nobres por ela trabalhados.
Uma natureza sempre subtilmente entendida, tal como Dulce Ferraz, na sequência
do seu trabalho iniciado em 2000, apresentou publicamente no Verão de 2005:
a situação internacional agravava-se no Iraque, o País era devastado por incêndios,
Lisboa vivia a euforia da *ExperimentaDesign* e algumas montras de lojas destacadas
do Chiado surgiam oportunamente intervencionadas por artistas inseridos
no Simpósio *Ars Ornata Europeana*. De todas elas, foi a de Dulce Ferraz na loja
de *Design* português *Alma Lusa* a que mais me impressionou. As delicadas jóias de
Dulce Ferraz surgiam agora, transportas para a instalação, convertidas em copas em
corrça natural de dezenas de micro-sobreiros, numa paisagem tridimensional que
apelava ao regresso e ao respeito pela natureza, num discurso de consciencialização
cívica e ecológica de extrema subtileza e actualidade
Continuamos sem saber se estes Territórios de Dulce Ferraz são naturais ou
humanos, mas são certamente o resultado do equilíbrio entre ambos! Mas ainda,
neles há sempre a busca da perfeição da Forma, de uma forma arquetípica a que
acrescentam detalhes em laca - poderá ser a natureza que, generosa, se abre
e descobre maravilhas de verdes ou de água potável; ou, antes, a Natureza perfeita
que sangra pelas constantes agressões a que é quotidianamente sujeita?
Busque cada qual a sua resposta, ou aguarde pelo desenvolvimento do trabalho
de Dulce Ferraz.

*Historiador de Arte e Design.

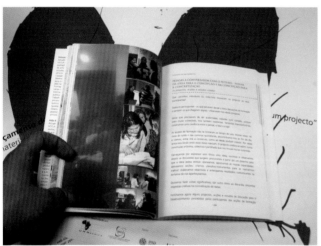

Ivo Valadares

Title : Imateacal, Possivel, Imaginations
Country : Portugal

Title : LGKM
Design : Kalle Mattsson
Country : The Netherlands

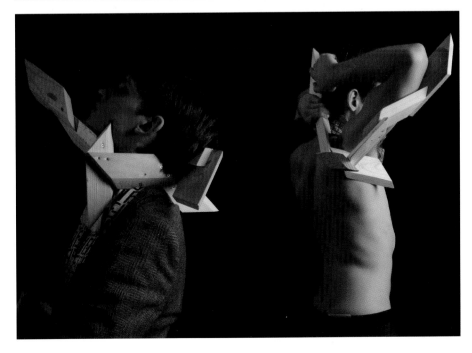

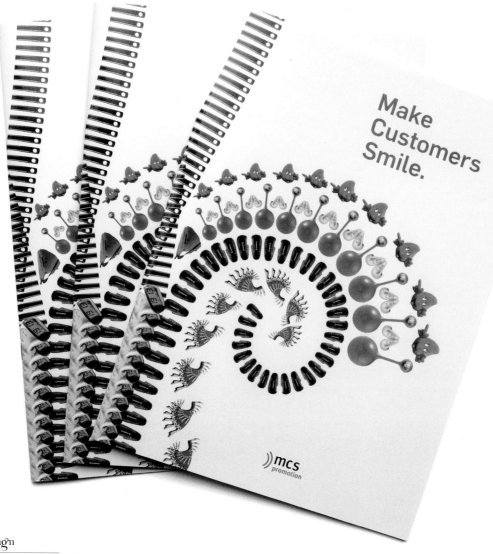

Hesse Design

Title : MCS Image Brochure
Creative Director : Christine Hesse
Art Director : Christine Eielke
Design : Benjamin Schulte
Country : Germany

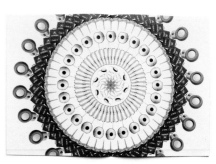

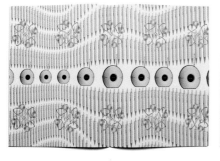

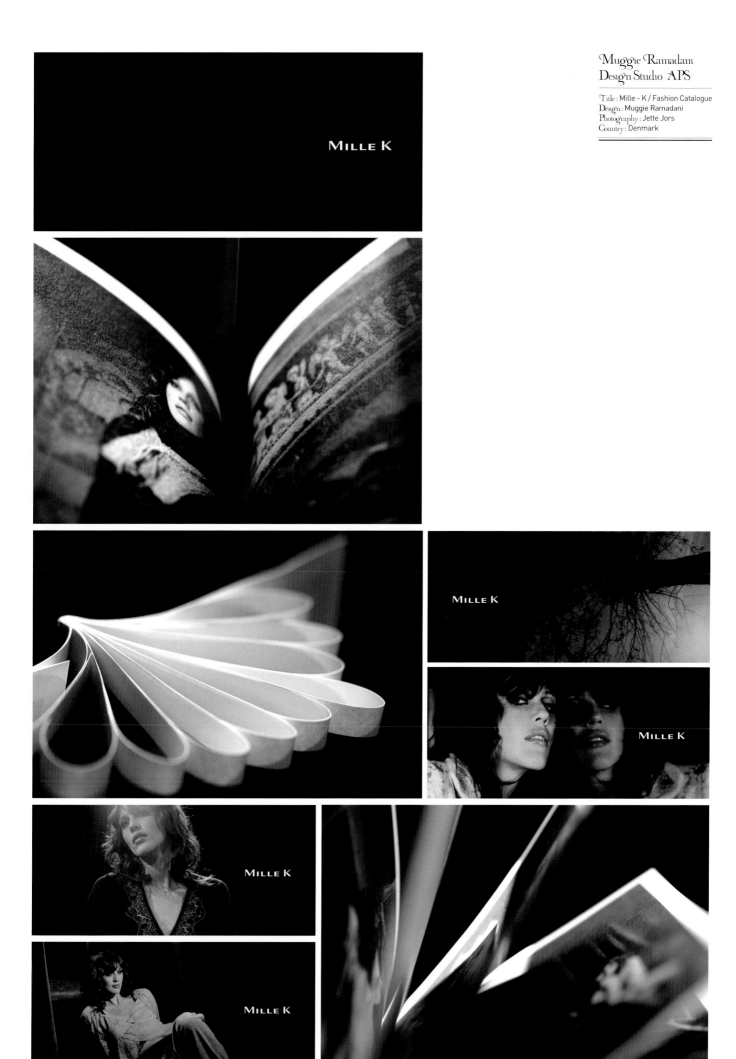

Muggie Ramadani
Design Studio APS

Title : Mille - K / Fashion Catalogue
Design : Muggie Ramadani
Photography : Jette Jors
Country : Denmark

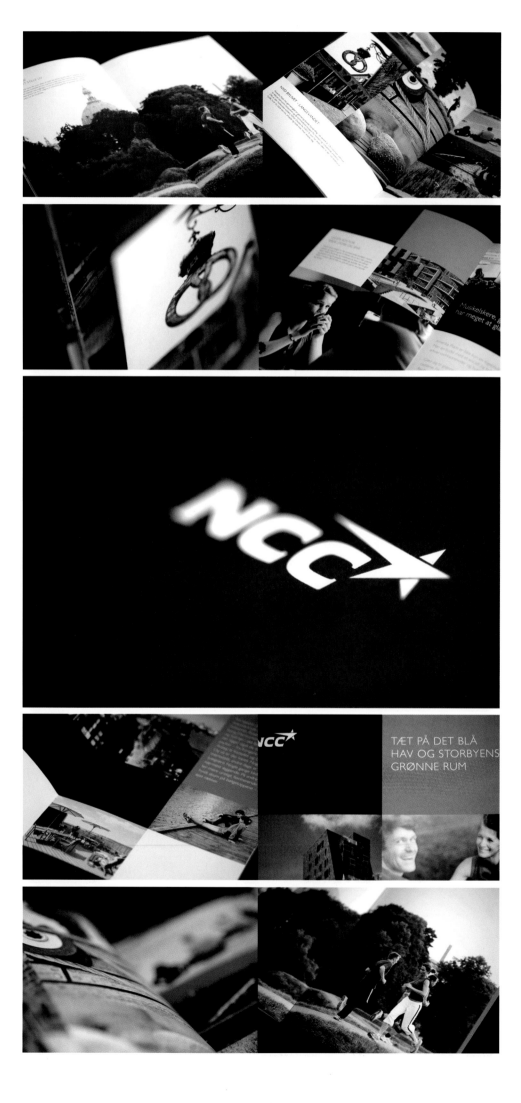

Title : NCC Boligshop / Catalogue
Design : Muggie Ramadani
Design Assistant : Jacob Darfelt
Country : Denmark

Muggie Ramadani
Design Studio APS

Title : NCC Boligshop / Catalogue
Design : Muggie Ramadani
Design Assistant : Jacob Darfelt
Photography : Mikkel Bache
Country : Denmark

100%

Hijack Your Life

Title : SVMK
Design : Kalle Mattsson
Country : The Netherlands

Hörður Lárusson
Title : Svona gerðum Uið
Country : Iceland

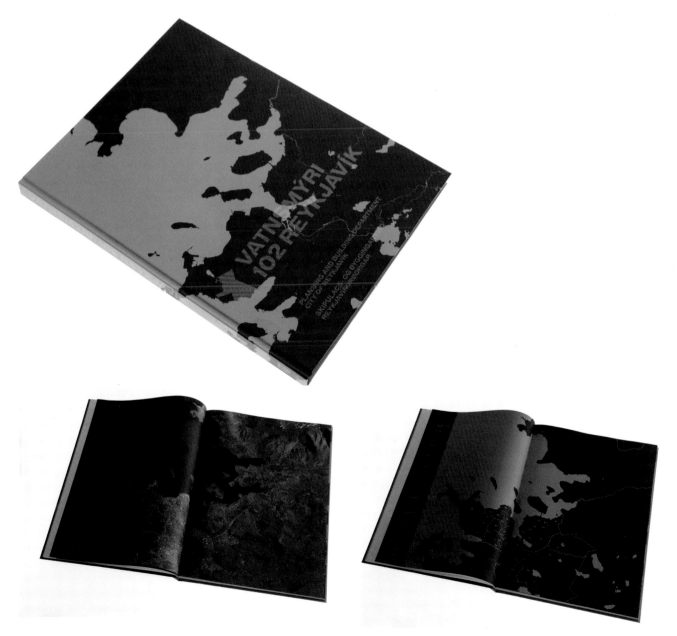

100%

The challenge is to create a spatial atmosphere in which a functional or intellectual concept can be experienced.

**Bernd Bess
07 Projects**

01 Art Pavilion
Contemporary art gallery for the
Ursula-Blickle-Foundation in Kreichtal
completed 2004

02 Kunsthalle
Vertical extension to the Kunsthalle Bremen
adding a new contemporary art gallery
competition 2005

03 Museum Lounge
Lounge for the Sprengel Museum Hannover
transforming the exhibition logo into space
completed 2007

04 Summer Pavilion
Sculptural form as an external living space,
Kreichtal
completed 2006

05 Installation
Installation for presenting research by the
German Historic Institute in Rome
commissioned 2007

06 Public Square
Design for the Spielbudenplatz in Hamburg
St. Pauli, collaboration with Stefan Kern
competition 2004

07 Exhibition
Exhibition design "Forced Migration in Europe",
Kronprinzenpalais Berlin
completed 2007

Bernd Bess established his Berlin office for architecture and exhibition design in 2002.

He has taught and lectured at various European universities and was awarded the Villa Massimo Fellowship, 2006.

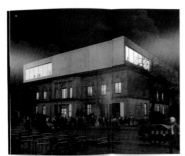

123 buero

Title : Bernd Bess
Designer : Timo Gaessner
Copywriter : 123buero
Country : Germany

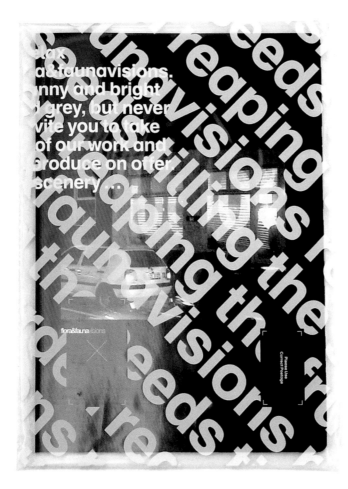

123 buero

Title : Flora & Fauna Visions/
Breath Deeply & Relax
Designer : Timo Gaessner
Copywriter : 123buero
Country : Germany

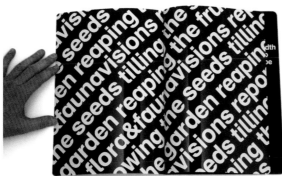

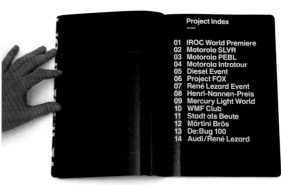

Project Index

01 IROC World Premiere
02 Motorola SLVR
03 Motorola PEBL
04 Motorola Introtour
05 Diesel Event
06 Project FOX
07 René Lezard Event
08 Henri-Nannen-Preis
09 Mercury Light World
10 WMF Club
11 Stadt als Beute
12 Märtini Brös
13 De:Bug 100
14 Audi/René Lezard

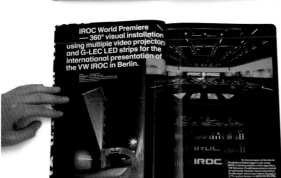

IROC World Premiere
— 360° visual installation
using multiple video projectors
and G-LEC LED strips for the
international presentation of
the VW IROC in Berlin.

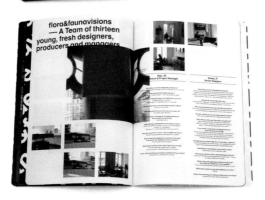

flora&faunavisions
— A Team of thirteen
young, fresh designers,
producers and managers

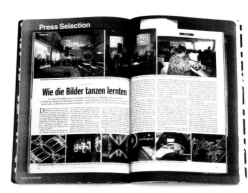

Press Selection

Wie die Bilder tanzen lernten

Lava

Title : Annual Report of the Dutch Filmfunds
Creative Director : Hans Wolbers
Design : Leon Dijkstra
Copywriter : Mark Fekkes
Photography : Joost van den Broek
Country : The Netherlands

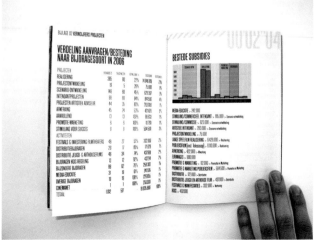

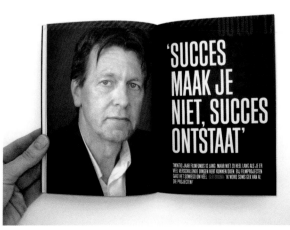

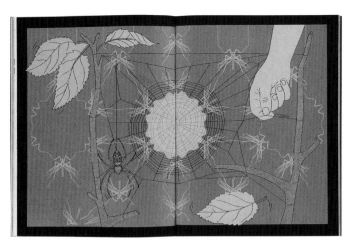

Lava

Title : Grafisch Nederland - Een nieuwe tijd
Creative Director : Hans Wolbers
Design / Photography / Illustration : Noortje Boer, Elspeth
Diederix, Paul Faassen, Rene Knip, Harmen Liemburg,
Bouwe van der Molen, Hans Muller, Rauser, Vittorio
Roerade, Typophonics
Copywriter : Toon Tellegen
Country : The Nertherlands

228

Lava

Title : Vitae - Ode to the New Professional
Creative Director : Hans Wolbers
Design : Jorgen Koolwijk, Leon Dijkstra
Country : The Netherlands

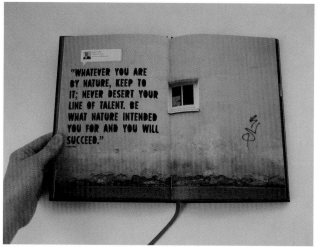

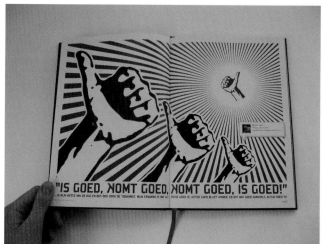

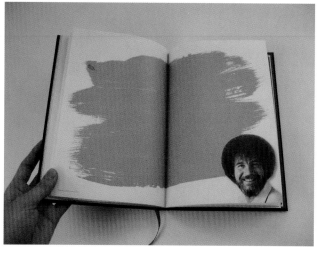

123 buero

Title : Wild Capital/Wildes Kapital
Designer : Timo Gaessner
Copywriter : 123buero
Country : Germany

Studio Annelys de Vet

Title : Subeurope
Designer : Annelys de Vet
Country : The Netherlands & Belgium

Erika Rennel Bjorkman
Graphic Design

Title : Svenskt Tenn
Creative Director : Erika Rennel Bjorkman
Copywriter : Svenskt Tenn
Country : Sweden

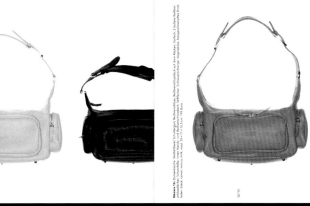

Vika 6: Damentasche. Reißverschluss; Schutzfüße; innen Handy- und Reißverschlussfach, Schlüsselschlange. Naturleder. 32 × 21 × 9,5 cm. 219 Euro.

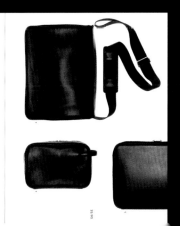

Marc Taule

Title : Marc Taule Portfolio
Country : Spain

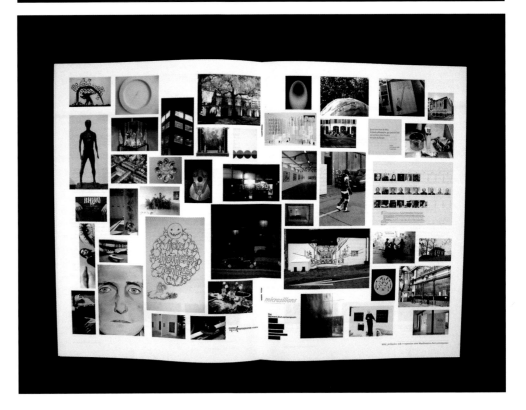

Title : Vision Praille - Acacias
Country : Switzerland

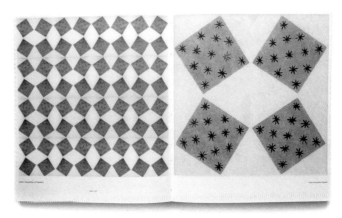

Sergio Calatroni Artroom srl

Title : 100E+ Ceramiche x il Paradiso
Creative Director : Sergio Calatroni
Art Director : Miyuki Yajima
Designer : Hisayuki Amae
Copywriter : Sergio Calatroni
Photography : Sergio Calatroni
Illustration : Sergio Calatroni Artroom srl
Country : Italy

Sergio Calatroni Artroom srl

Title : A-temporary O&A
Creative Director : Sergio Calatroni
Art Director : Miyuki Yajima, Nishino Yoshiaki
Design : Hisayuki Amae
Photography : Sergio Calatroni
Illustration : Sergio Calatroni Artroom srl
Country : Italy

Gary Fernandez

Title : Introduction to Fantastic
Girls, Future Landscapes & The
Most Beautiful Birds Ever Seen
Country : Spain

Gary Fernandez

Title : Collection 3-Rebellions
Photography : Fernando Maselli
Country : Spain

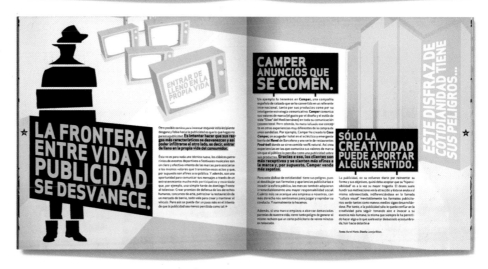

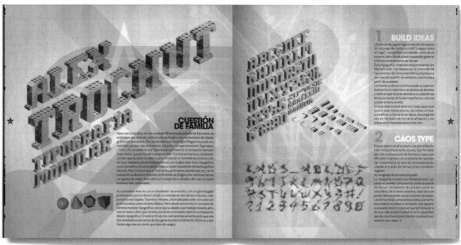

Studio Copyright

Title : Copyright Magazine
Designer : Gabriel Morales
Country : Spain

Sweden Graphics

Title : Label System for Divided Denim
Country : Sweden

L
long length
DIVIDED
wide cut

M
regular length
DIVIDED
extreme flared

S
long length
DIVIDED
tight fit stretch

slim western jacket

DIVIDED

extreme flared

DIVIDED

western jacket

DIVIDED

silver slim cut

flared leg

golden great cut

bronze boot cut

extreme flared

super low waist

authentic

low cut

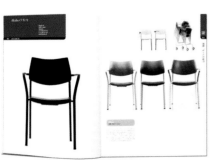

Graciela Artiga

Title : Guia del Diseno Espanol; 50 Disenadores
Espanoles (Japan and Russia)
Creative Director : Pierluigi Cattermole
Art Director : Graciela Artiga
Design : Graciela Artiga
Copywriter : Experimenta-ICEX
Illustration : Carrio, Sanchez, Lacasta(Spanish
Cover); Graciela Artiga(Interiors)
Country : Spain

Graciela Artiga

Title : Guia del Habitat; Experimenta
Creative Director : Pierluigi Cattermole
Art Director : Graciela Artiga
Design : Graciela Artiga
Copywriter : Experimenta-ICEX
Illustration : Estudio Manuel Estrada (Cover);
Graciela Artiga, Anja Eneroth (Interiors)
Country : Spain

colegio
oficial de
ingenieros
químicos
comunitat
valenciana

dossier informativo

coiq
cv

Modos Disseny Grafic S.L.

Title : Dossier Informativo COIQcv
Designer : Carolina Gimeno Lopez
Country : Spain

Picnic Oficina de creación

Title : Cuadernos de trabajo para niños y niñas con VIH
de 6 a 11 años (Etapa de comunicación del diagnóstico)
Designer : Annelys de Vet
Country : Spain

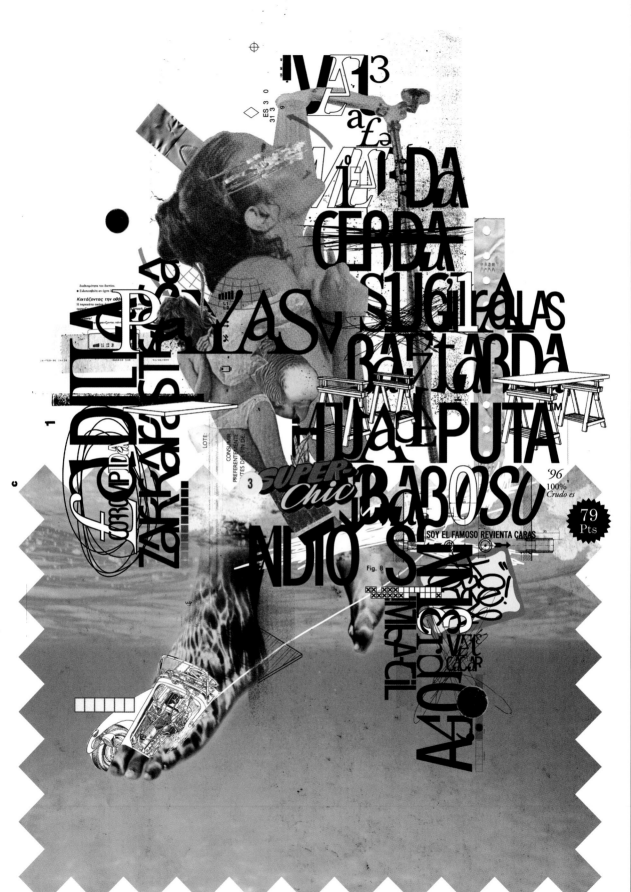

Picnic Oficina de creación

Title : AAAA Book
Country : Spain

Studio Copyright

Title : Sony Life Style
Design : Gabriel Morales
Country : Spain

Sweden Graphics

Title: Sexton Texter om Mode
Country: Sweden

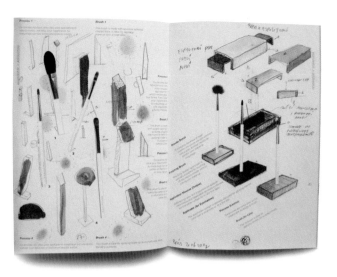

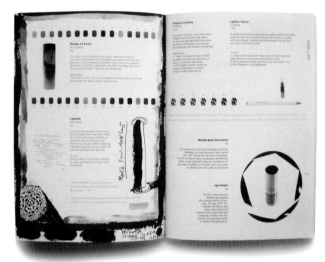

Sergio Calatroni Artroom srl

Title : Untied
Creative Director : Sergio Calatroni
Art Director : Sergio Calatroni, Miyuki Yajima
Design : Hisayuki Amae
Photography : Sergio Calatroni
Country : Italy

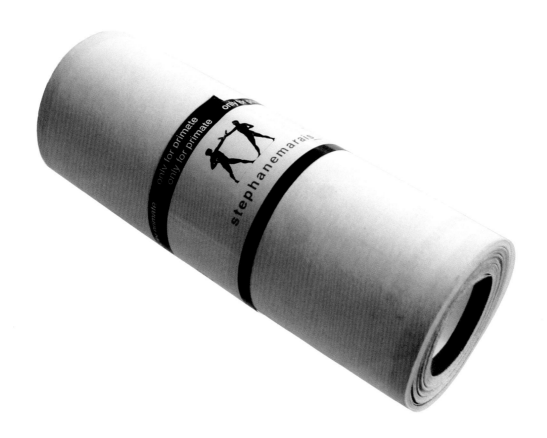

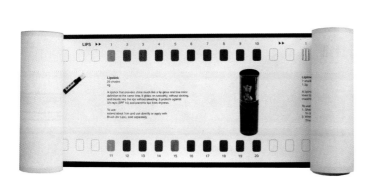

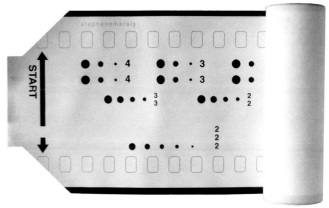

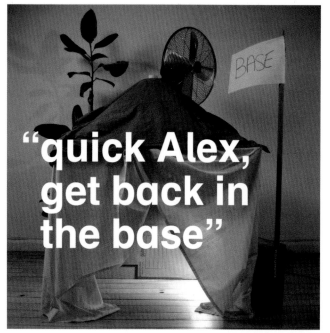

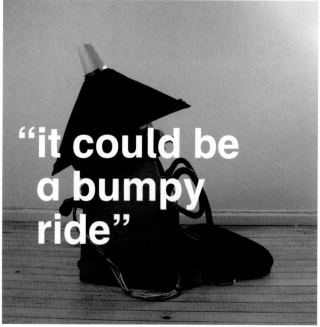

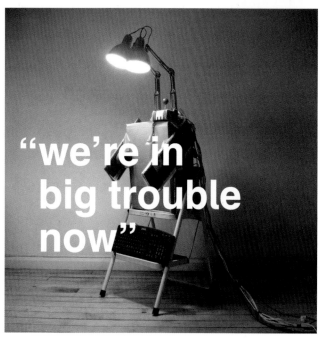

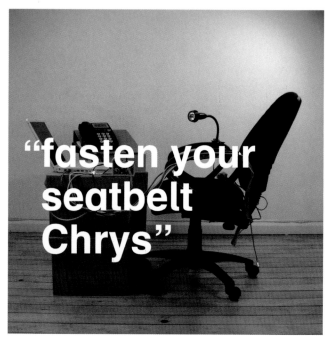

Campany

Title : Image
Design : Alex Swain & Chrysostomos Naselos
Country : Britain

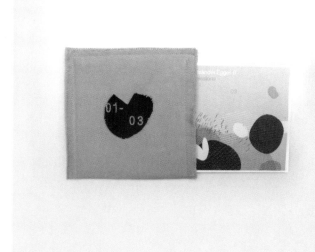

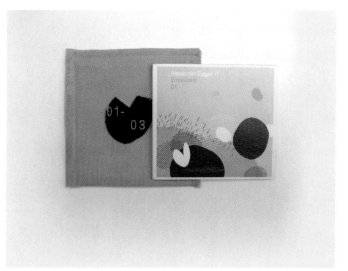

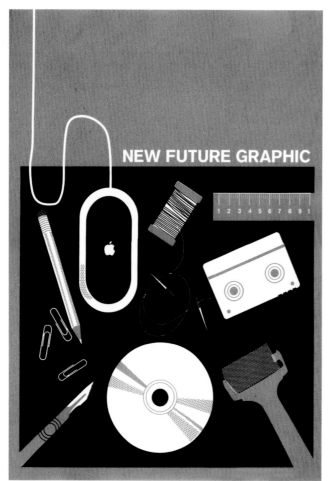

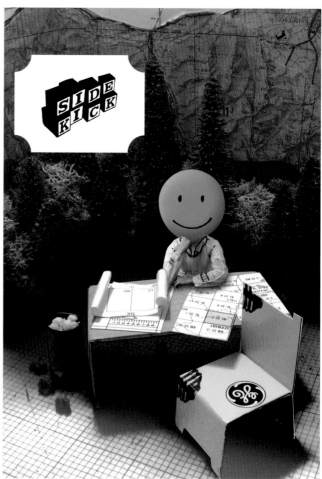

New Future Graphic

Title : Pot Noodle
Country : Britain

L'Energia è un frutto della terra

Contribuiamo allo sviluppo della produzione energetica da fonti rinnovabili con centrali idroelettriche nell'arco alpino e impianti eolici installati dalla Norvegia alla Sicilia. Oggi, con l'Energia da Fonte Rinnovabile garantita dal gruppo EGL, puoi qualificare la tua impresa dando un valido contributo alla riduzione dell'impatto ambientale. EGL, il gruppo che mette in relazione le migliori energie.

www.egl-business.it

NETWORKING ENERGIES

L'Energia secondo EGL

Da 50 anni Qualità, Innovazione e Rispetto guidano le nostre scelte nel mercato dell'energia in 15 paesi europei. Oggi, con 19 miliardi di KWh di energia, forniamo grandi gruppi industriali e tante piccole e medie imprese italiane. EGL, il gruppo europeo che mette in relazione le migliori energie.

www.egl-business.it

NETWORKING ENERGIES

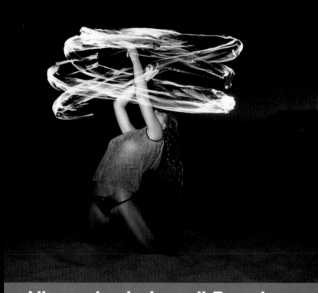

Libera circolazione di Energia

Certi che la libertà di scegliere sia per ogni azienda un'opportunità da cogliere, abbiamo intrapreso nuove iniziative commerciali e ambiziosi progetti industriali. Oggi, con 19 miliardi di KWh di energia, forniamo grandi gruppi industriali e migliaia di piccole e medie imprese italiane. Libera la tua energia.

www.egl-business.it
Numero Verde 800 199 979

NETWORKING ENERGIES

2007

V4 *El Giuan e la Luisa*
In: *Questo quaderno* (▶2007. V1), pp. 39-45.
Dialogo teatrale in milanese, manoscritto e parzialmente dattiloscritto, legato agli anni e ai personaggi de "I segreti di Milano" (▶1958. V1).

V5 *La mostarda di Cremona*
In: *Questo quaderno* (▶2007. V1), pp. 53-57.
Soggetto dattiloscritto, non datato, per un film risalente agli anni de "I segreti di Milano" (▶1958. V1) e mai realizzato.

V6 *Appendix Oraziana. Poema tafanario*

In: *Questo quaderno* (▶2007. V1), pp. 113-116.
Dialogo immaginario tra i due animali della Natività. Manoscritto, databile all'epoca della stesura dei saggi per *Gli artisti del legno* (▶1985. V18).

V9 [*Lettera a Giovanni Scheiwiller*]
In: *Giovanni Testori Bibliografia*, a cura di D. Dall'Ombra, Milano, Associazione Giovanni Testori-Scalpendi, pp. 2-3.
Riproduzione di una lettera manoscritta datata "Sormano, 12 giugno 1939" all'editore Scheiwiller. Testori ringrazia per alcuni libri pubblicati dalla casa editrice All'Insegna del Pesce d'Oro, inviatigli dallo stesso editore. Si tratta del più antico scritto testoriano a noi noto: Testori aveva sedici anni.

16 marzo 2007

continua su
www.archiviotestori.it

352

1941

IN PERIODICO

P1 *Segantini*
In: «Via Consolare», Forlì, II, 1, gennaio, R: Galleria inedita dell'800, p. 15.
Prima e unica uscita di una rubrica dedicata a opere d'arte inedite dell'Ottocento italiano; viene presentato uno studio preparatorio per *Alpe di maggio* di Giovanni Segantini.

Giovanni Testori Bibliografia

Scalpendi Associazione Giovanni Testori

Intervento in occasione della mostra alla Galleria Corrente di Milano. Il sottotitolo della rivista compare con il n. 4 (aprile 1941).
▶2002. R6, pp. 69-72.

P4 *Incanti di Guidi*
In: «Via Consolare. Mensile di politica e d'arte», Forlì, II, 6, giugno, p. 18.
Intervento in occasione della mostra alla Galleria del Milione di Milano.

P5 *La III Mostra del Sindacato Fascista Belle Arti*
In: «Via Consolare» (▶1941. P4), pp. 23-25.
Intervento in occasione della mostra al Palazzo dell'Arte - Triennale di Milano.

P6 *Scipione*
In: «Architrave. Mensile di politica, letteratura e arte», Bologna, I, 8, giugno, p. 9.

P7 *Domenico Cantatore*
In: «Via Consolare. Mensile di politica e d'arte», Forlì, II, 7-8, luglio-agosto, p. 17.

5

(spine) Giovanni Testori Bibliografia

Ginette Caron Communication Design

Title: Giovanni Testori Bibliografia
Design: Ginette Caron
Country: Italy

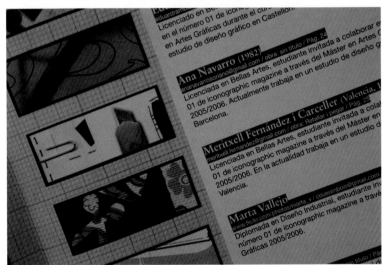

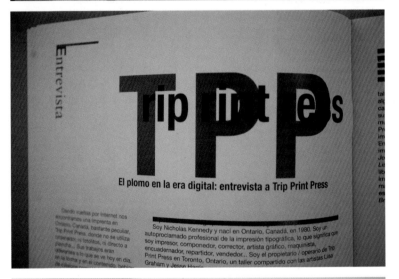

256

Iconosraphic Magazine

Title : Iconosraphic Magazine
Design : Rvben Arnal, Ainhoa Fernandez, Ricaroopena, Elena Vegvccas
Country : Spain

100%

Illustration

258

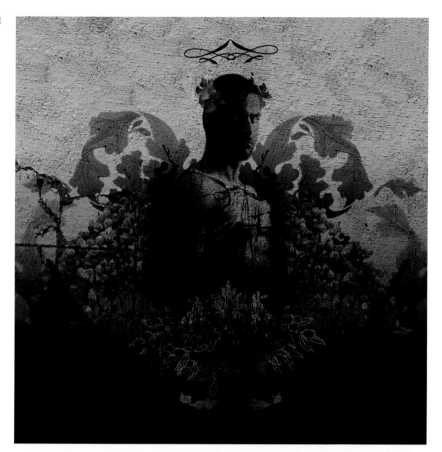

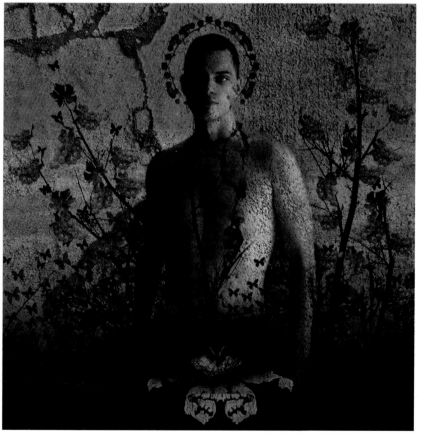

Vladimir Svorcan

Title : Tasting the Nectar of the Gods
Designer : Vladimir Svorcan
Country : Serbia

Design as publishing. The Jan van Eyck Design department wishes to contribute to the international design climate by organizing conferences and public events both in and out of Maastricht, both in the Netherlands and abroad. Together with partner institutions and companies, it initiates and conceives both printed and online publications for its research project

typo-manias

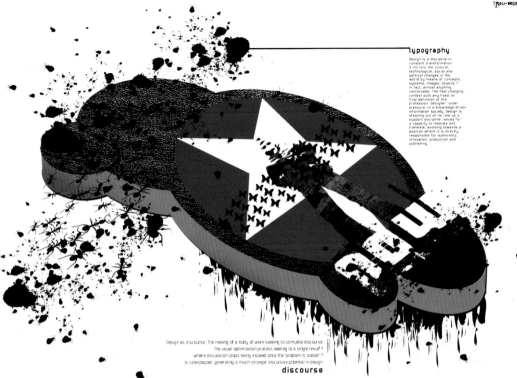

typography

Design is a discipline in constant transformation. It mirrors the cultural, technological, social and political changes in the world by means of concepts, systems, images, objects ? In fact, almost anything conceivable. The fast-changing context puts any fixed, or final definition of the profession 'designer' under pressure. In a knowledge-driven information society, design is stepping out of its role as a 'support discipline' valued for a capacity to mediate and translate, evolving towards a position where it is directly responsible for authorship, innovation, production and publishing.

Design as discourse. The making of a body of work seeking to stimulate discourse. The usual optimization process leading to a single result ? where discussion stops being invoked once the 'problem is solved' ? is sidestepped, generating a much stronger discursive potential in design.

discourse

design research implies that designers s hould visualize and formulate questions rather than answers, problems rather than solutions. This is not, as it may seem, contradictory to pursuing formal or aesthetical goals.

Vladimir Svorcan

Title : Typo-maniac
Country : Serbia

Design as discourse. The making of a body of work seeking to stimulate discourse.

Design as research. Design research implies that designers should visualize and formulate questions rather than answers, problems rather than solutions. This is not, as it may seem, contradictory to pursuing formal or aesthetical goals.

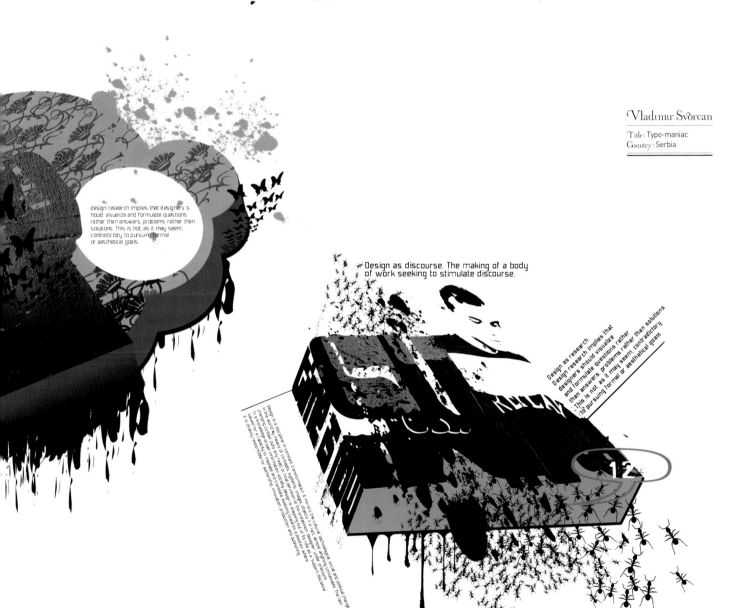

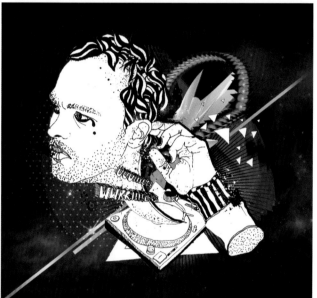

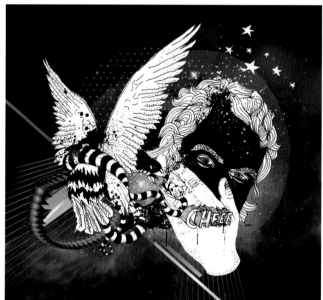

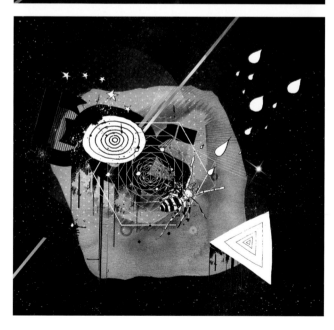

In Graphics We Trust

Title : Dos-Artwork for Michael Fakesch's
(Founder of Funkstorung) Solo Album
Designer : Sebastian Onufszak
Country : Germany

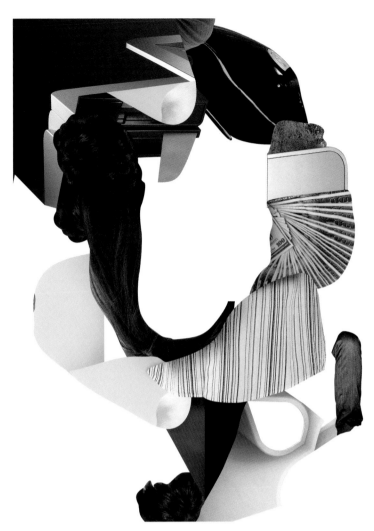

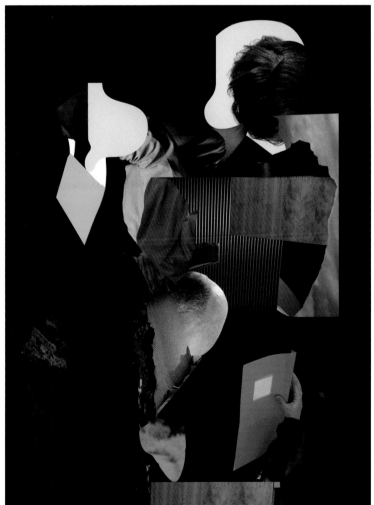

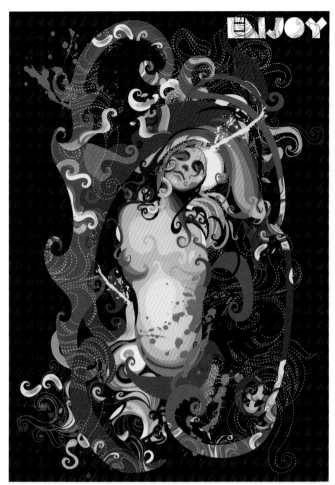

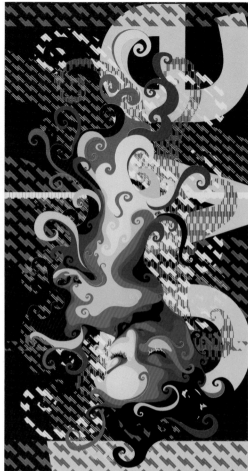

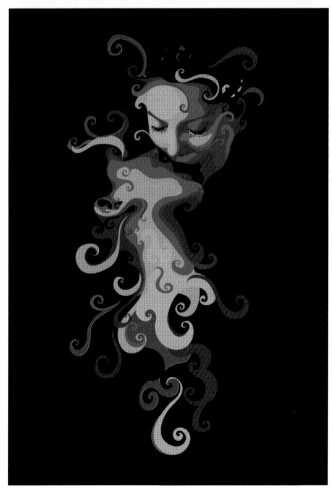

Alessandro Pautasso
aka Kaneda

Title : Madonna Rmx
Country : Italy

Alessandro Pautasso
aka Kaneda

Title : Love
Country : Italy

Alessandro Pautasso
aka Kaneda

Title : The Long Kiss Goodnight
Country : Italy

Alessandro Pautasso
aka Kaneda

Title : Enjoy
Country : Italy

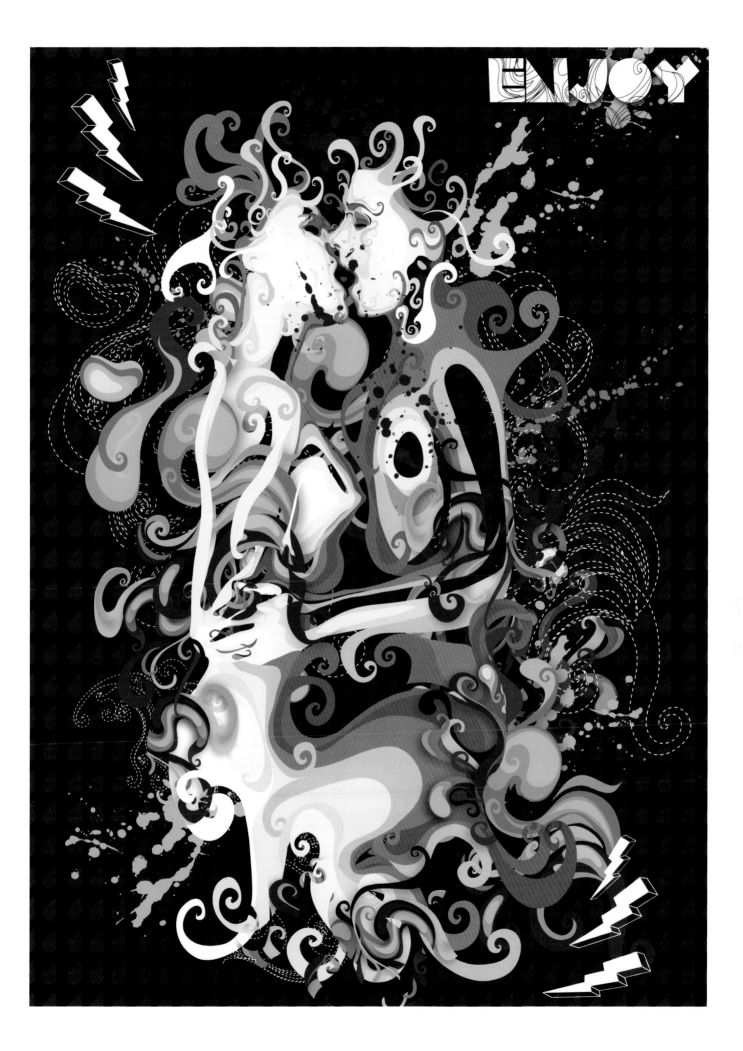

Yonoh

Title : RSFS-T-shirt Design for the
Guiarussafa's Presentation
Design : Alex Selma
Country : Spain

Yonoh

Title : RSFS-T-shirt Design for the
Guiarussafa's Presentation
Design : Alex Selma
Country : Spain

ORIGINAL COLOR ARTISTS'S CHOICE

Bard Hole Standal

Title : Atlanta Game's
HelloBard Shoe Line
Country : Norway

Bard Hole Standal

Title : Stupid Devil T-shirts
Country : Norway

Bard Hole Standal

Title : Stupid Tank
Country : Norway

RED MAGIC STYLE

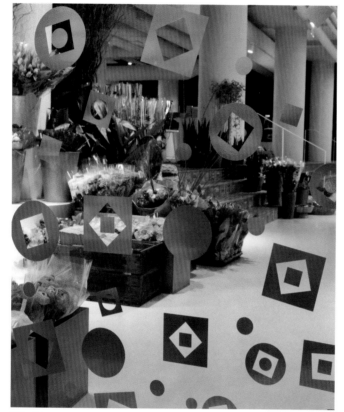

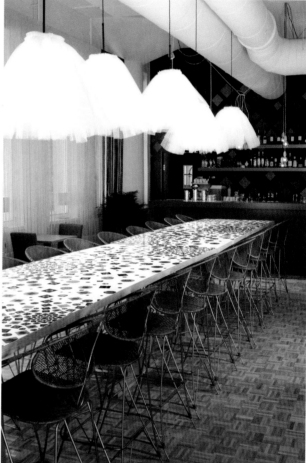

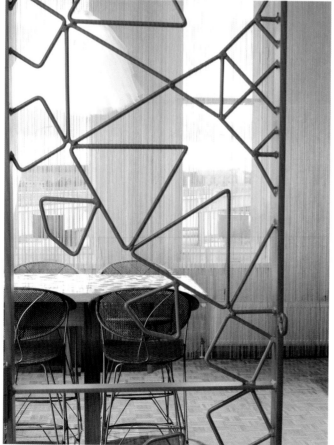

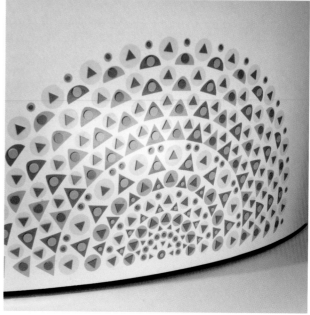

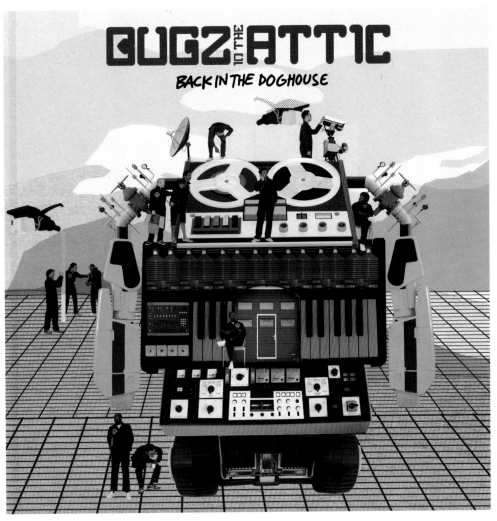

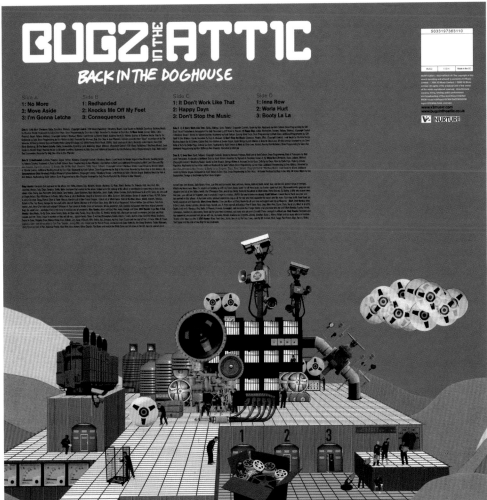

New Future Graphic

Title : Bugz In the Attic
Creative Director : Marcus Walters
& Gareth White
Country : Britain

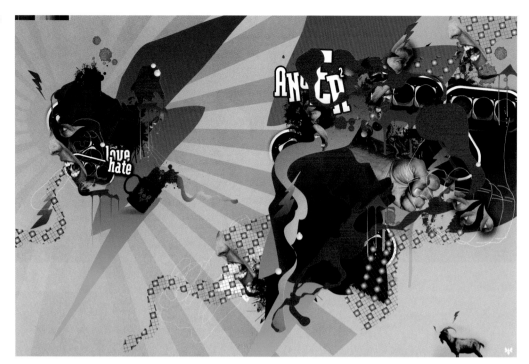

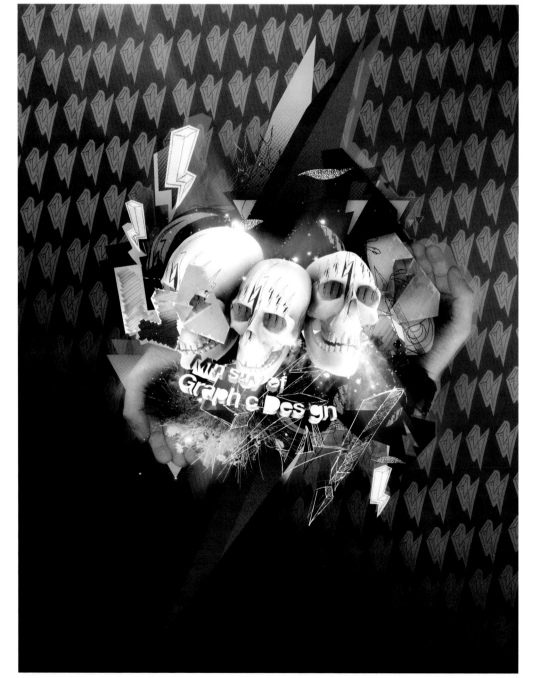

Lysergrid

Title : Anger
Design : Sattler Loïc
Country : France

Lysergrid

Title : LSD
Design : Sattler Loïc
Country : France

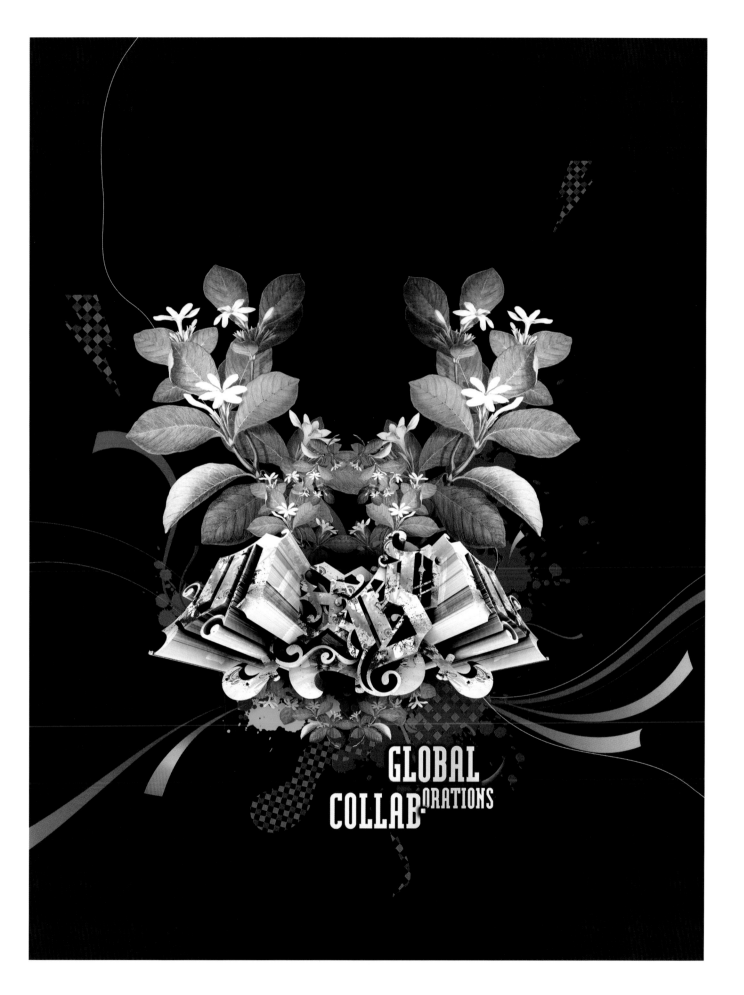

Lysergid

Title : Global Collaborations
Design : Sattler Loïc
Country : France

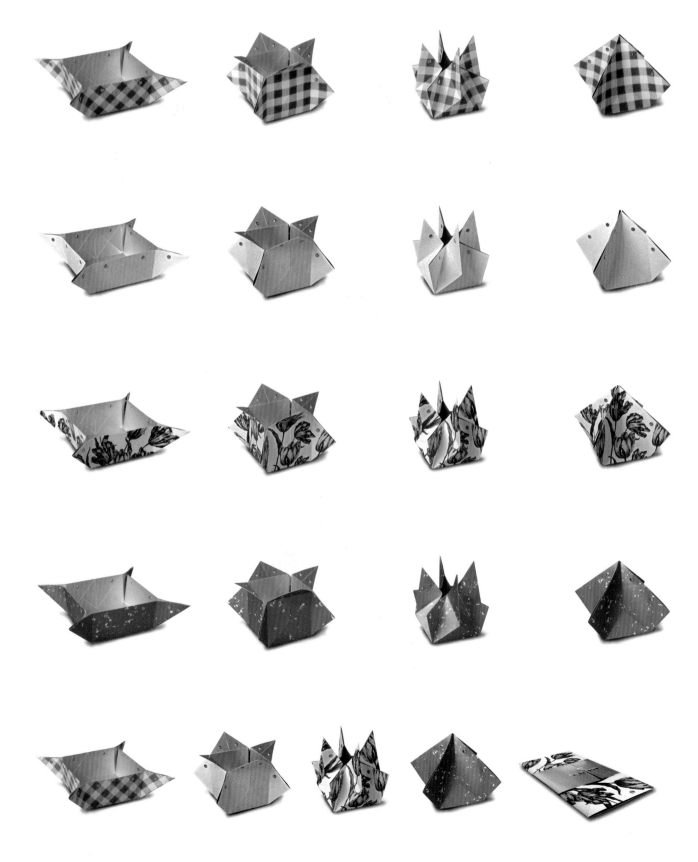

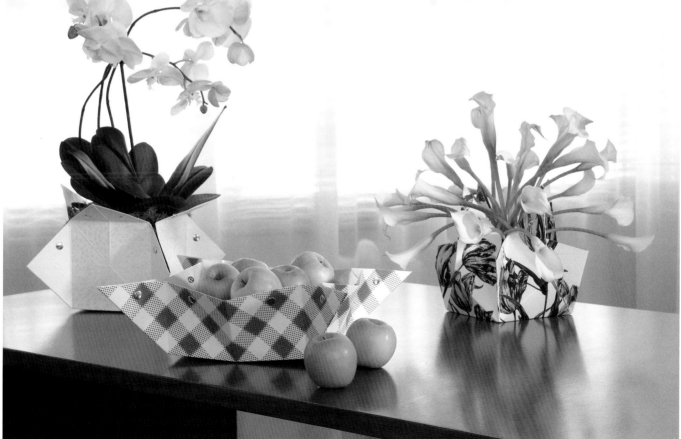

COEN!

Title : Media Academie
Design : Coen van Ham
Country : The Netherlands

ZUU

Title : ZUU VS ABT Cap
Illustration : Rui Parada
Country : Portugal

ZUU

Title : ZUU "Galo de Barcelos"
Illustration : Rui Parada
Country : Portugal

274

ZUU

Title : ZUU Cap
Illustration : Rui Parada
Country : Portugal

ZUU

Title : ZUU Toy
Illustration : Rui Parada
Country : Portugal

ZUU

Title : ZUU Painting
Illustration : Rui Parada
Country : Portugal

ZUU

Title : ZUU Painting
Illustration : Rui Parada
Country : Portugal

ZUU

Title : ZUU Sneakers
Illustration : Rui Parada
Country : Portugal

ZUU

Title : ZUU Prototank
Illustration : Rui Parada
Country : Portugal

ZUU

Title : ZUU Exhibition
Illustration : Rui Parada
Country : Portugal

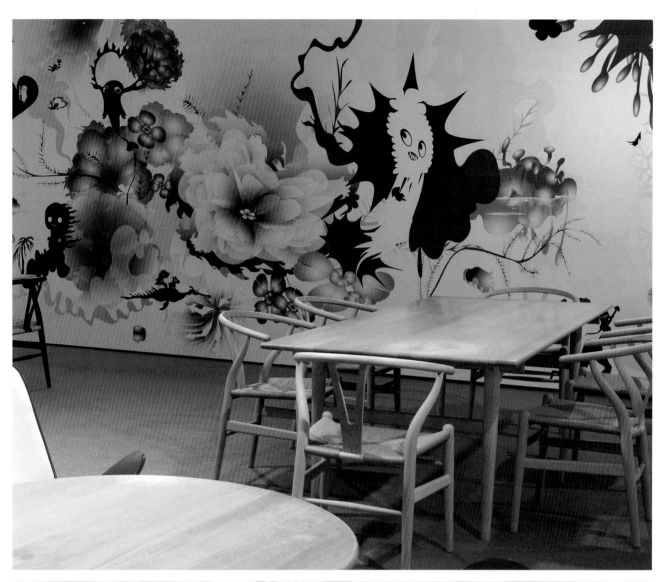

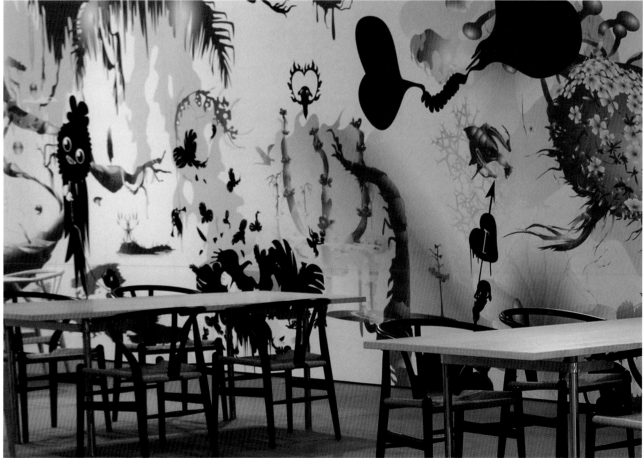

100% TOKYO

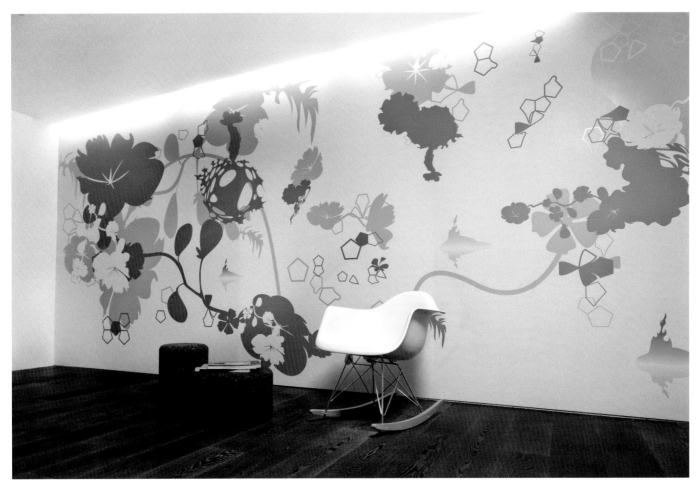

Katrin Olina Ltd.

Title : Love - Mural
Illustration : Katrin Olina
Country : Iceland

Katrin Olina Ltd.

Title : Parki, Environmental Graphics
Illustration : Katrin Olina
Photography : Jonas Valtysson
Country : Iceland

Katrin Olina Ltd.

Title : Port, Wallpaper
Creative Director : Katrin Olina
Country : Iceland

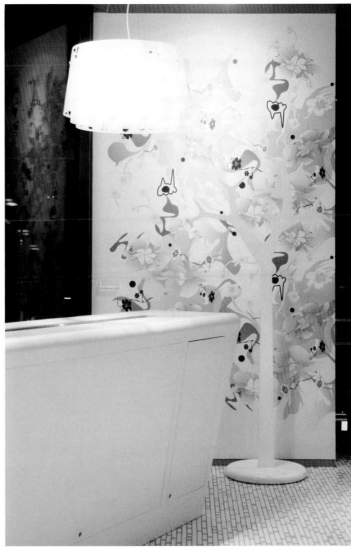

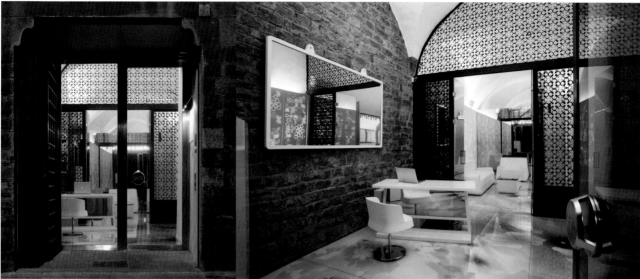

Katrin Olina Ltd /
Michael Young Ltd

Title : Skin, Graphic Art for an Interior
Creative Director: Katrin Olina
Interior Design: Michael Young
Copywriter : Katrin Olina
Photography : Carlo Lavatory
Illustration : Katrin Olina
Country : Iceland

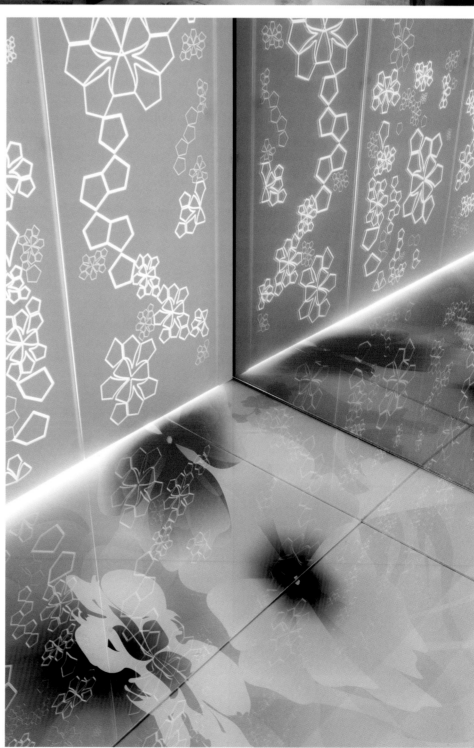

Proyecto Limon

Title : Panda
Design : Luis Miguel Munilla Gamo
Country : Spain

Josh Butcher

Title : Boom Barbers
Country : Britain

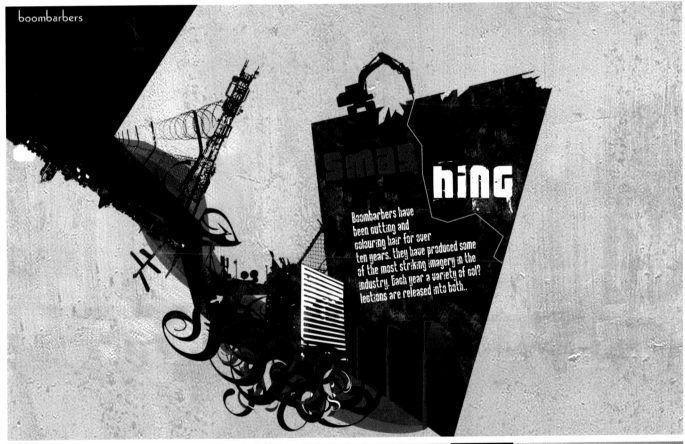

Hörður Lárusson

Title : Bullseye
Country : Iceland

Hahmo Design Ltd

Title : Stamp to Commenmorate the
400th Anniversary of City of Vaasa
Design : Pekka Piippo
Country : Finland

Hahmo Design Ltd

Title : Stamp to Honor The
National Library of Finland
Design : Pekka Piippo
Country : Finland

Hashka

Title : Dirty Angelz
Country : France

Hashka

Title : Tire-ailleurs!
Country : France

Hashka

Title : Tromz
Country : France

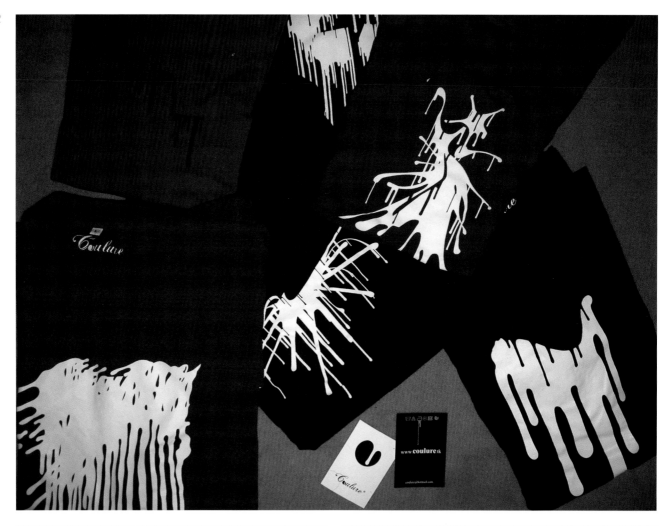

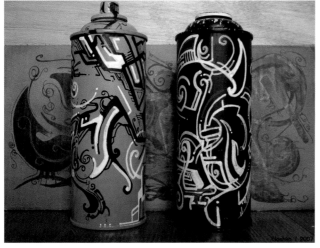

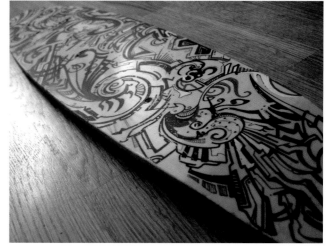

Hashka

Title : Coulure
Country : France

Hashka

Title : Two Bombz
Country : France

Hashka

Title : Grafikaboardz
Country : France

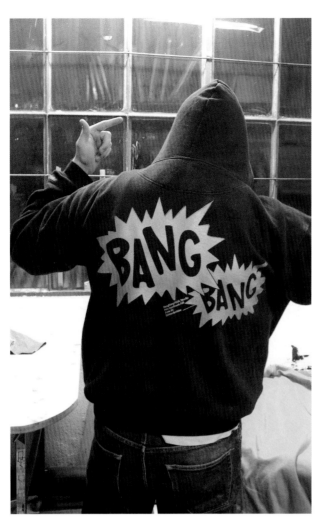

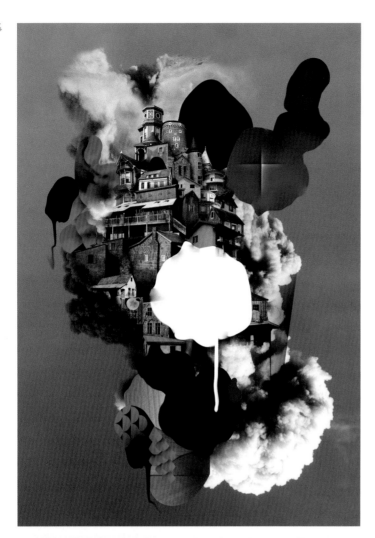

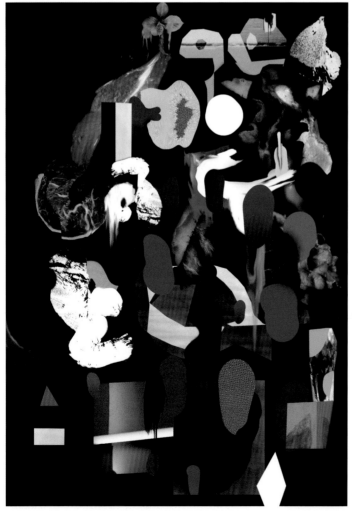

Hijack Your Life

Title : Visual Experiments
Design : Kalle Mattsson
Country : The Netherlands

Hijack Your Life

Title : T-shirt
Design : Kalle Mattsson
Country : The Netherland

Katrin Olina Ltd

Title : Limited Edition Graphics
on Snowboards and Helmets
Design : Katrin Olina
Country : Iceland

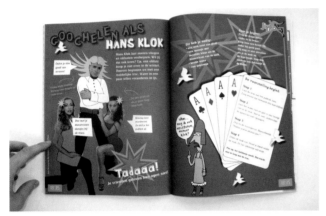

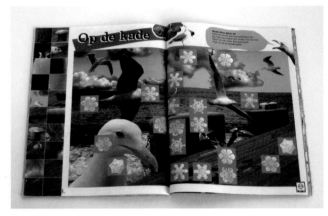

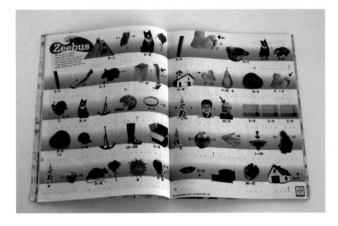

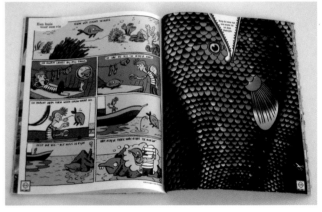

Lava

Title : Jippo Winterbook and Jippo Summerbook
Creative Director : Hans Wolbers
Design : Noortje Boer, Celine Lamee, Bouwe van der Molen
Illustration : Noortje Boer, Celine Lamee, Bouwe van der Molen
Country : The Netherlands

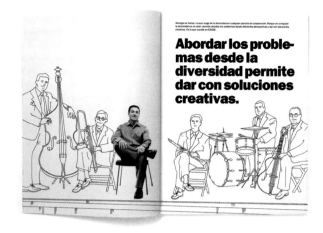

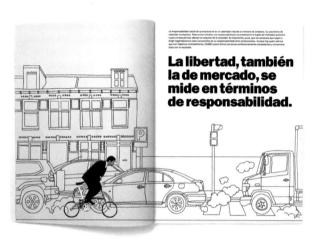

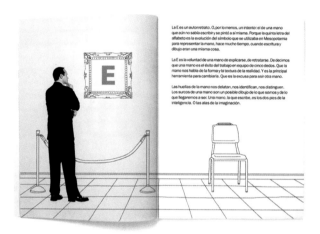

BAG.Disseny

Title : Report ESADE Association Pupils
Creative Director : Xavi Mora
Art Director : Sandra Compte
Photography : BAG
Country : Spain

Modos Disseny Grafic S.L.

Title : Cabretes, T-shirt Design
Design : Daniel Gramage Asensi
Country : Spain

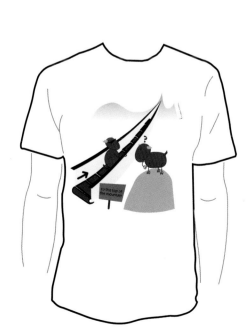

MUNROE EFFECT

HELLO TERRORIST

1- THE DEATH OF JAMES JOELL
2- LITTLE COMBINATIONS
3- SHARPEN YOUR TEETH
4- EAT YOUR DAMAGE
5- GOD CREATED MONSTERS

Recorded & mixed by Richard Worrall
All songs written & produced by munroe effect
Artwork & Design by Nazario Graziano @ ngdesign.it
The band would like to thank:
David Waterman, Nazario Graziano and John & Alison Hazell
@ Birchope Byre Farmhouse.

band website: www.munroeeffect.co.uk
band email: band@munroeeffect.co.uk
graphic: www.ngdesign.it

© 2006 munroe effect

please visit: ilovepasta.it

PASTA

ITALIAN TASTE

WEAR MAKING REVOLUTION

Sweden Graphics

Title : Illustrated Short Novel
Country : Sweden

BeetRoot design group

Title : Aesop Fables Calendar
Creative Director : Yiannis Charalambopoulos,
Alexis Nikou, Vagelis Liakos
Illustration : Alexis Nikou, Ilias Pantikakis
Country : Greece

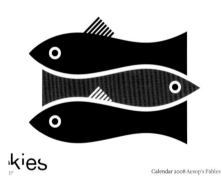

Calendar 2008 Aesop's Fables

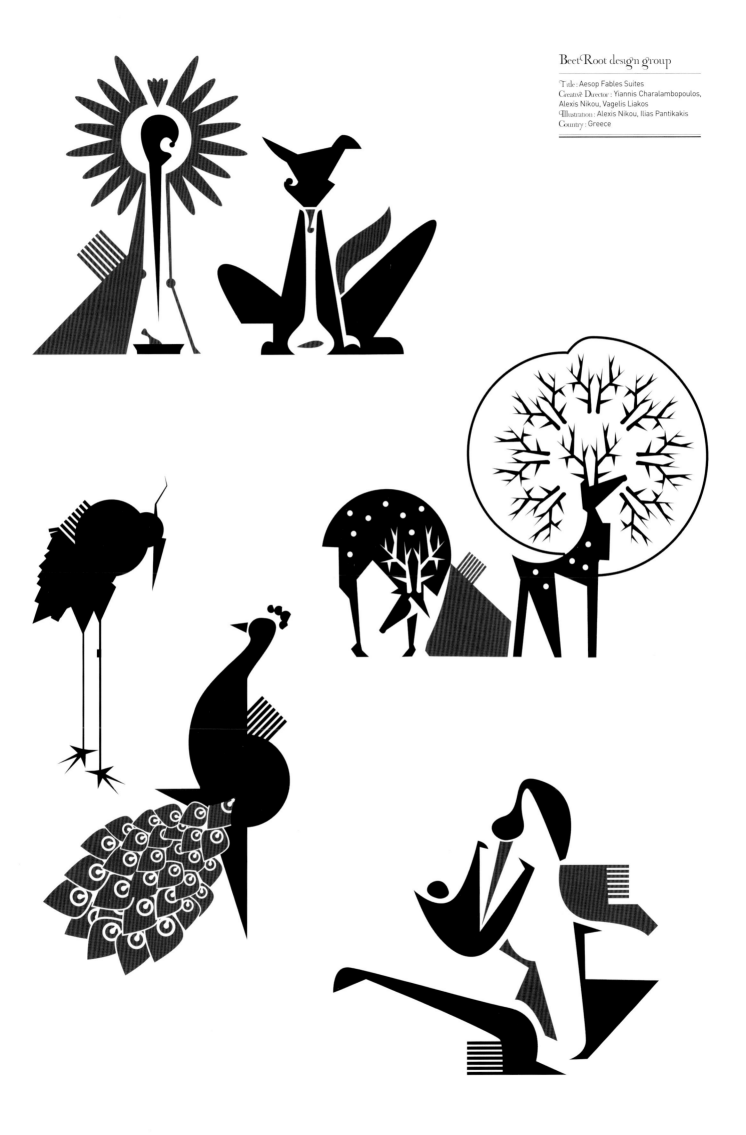

BeetRoot design group

Title : Aesop Fables Suites
Creative Director : Yiannis Charalambopoulos,
Alexis Nikou, Vagelis Liakos
Illustration : Alexis Nikou, Ilias Pantikakis
Country : Greece

Studio Copyright

Title : Cirsa Illustrations System
Creative Director : Joel Lozano
Design : Joel Lozano, Laura Alejo, Cristina Belles
Country : Spain

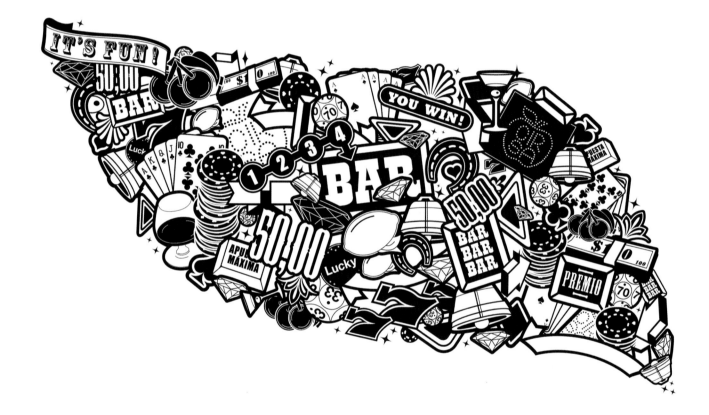

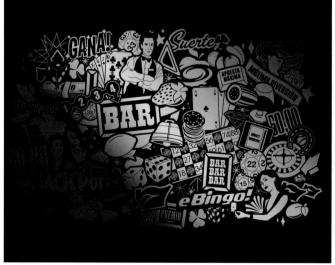

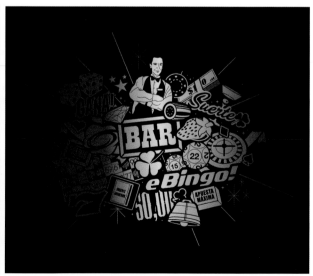

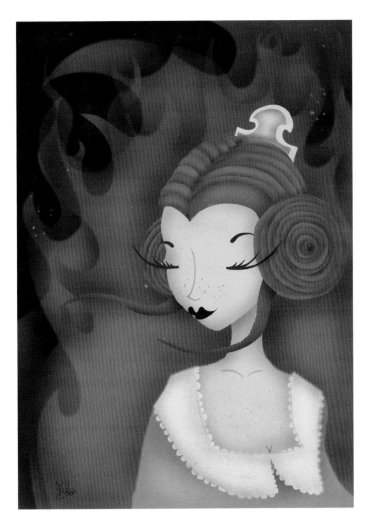

Angel De Franganillo

Title : Fallera
Country : Spain

Angel De Franganillo

Title : Ococ
Country : Spain

Angel De Franganillo

Title : A Bunny for Le Toy
Country : Spain

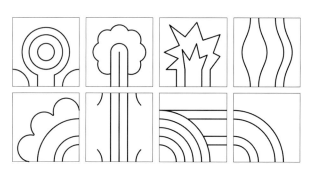

Sweden Graphics

Title : Gooh1 Floor Tiles
Country : Sweden

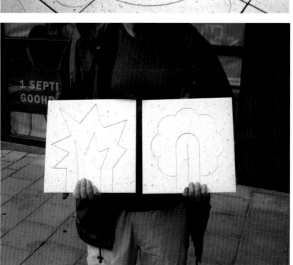

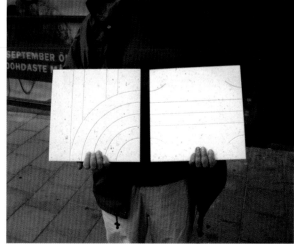

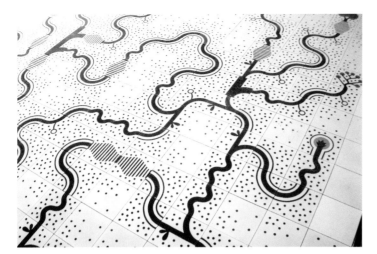

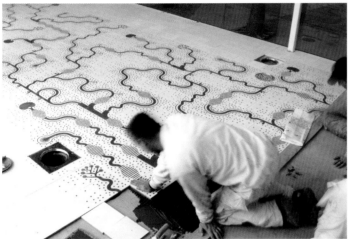

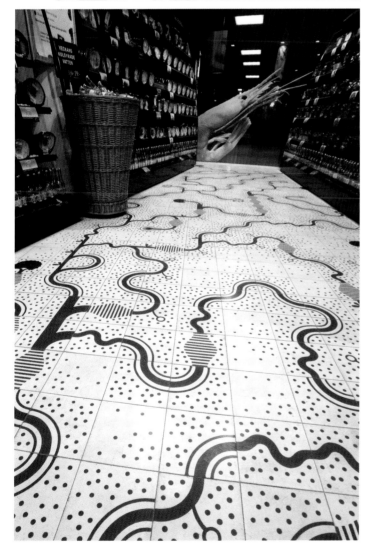

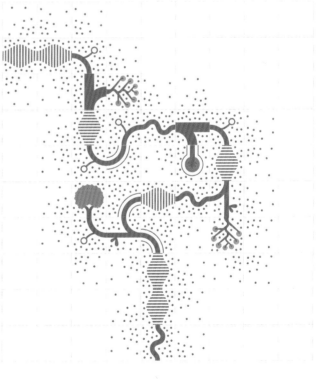

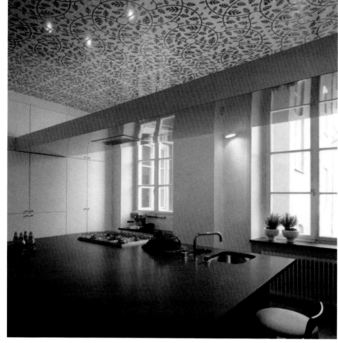

Sweden Graphics

Title : "Unitile" One Tile Design for Multiple
Pattern Construction Possibilities
Country : Sweden

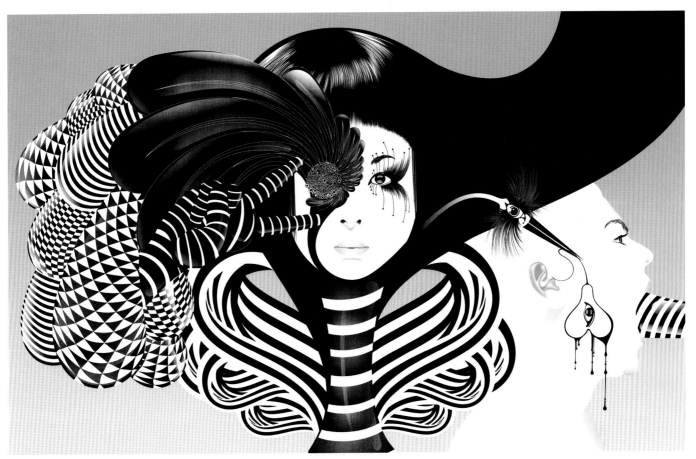

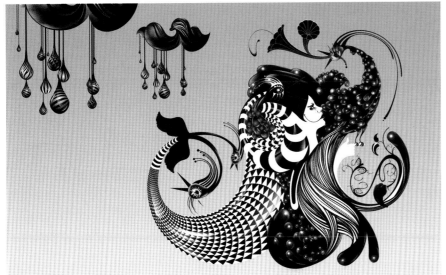

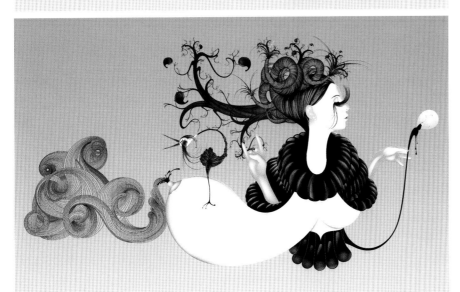

Gary Fernández

Title : Introduction to Fantastic Girls, Future
Landscapes & The Most Beautiful Birds Ever Seen.
Country : Spain

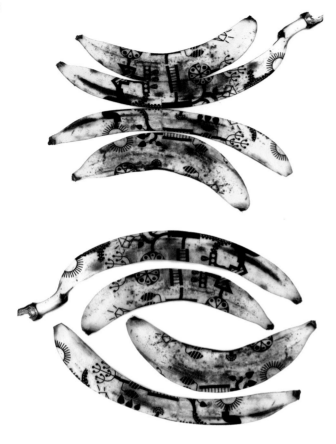

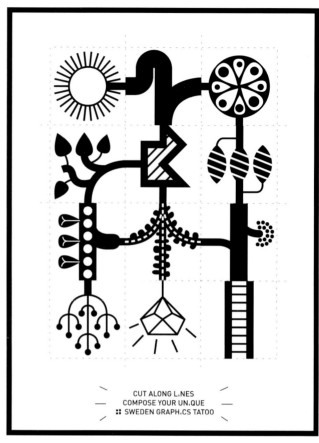

Sweden Graphics

Title : Bananas
Country : Sweden

CUT ALONG L.NES
COMPOSE YOUR UN.QUE
▪▪ SWEDEN GRAPH.CS TATOO

Sweden Graphics

Title : IDN T-shirts
Country : Sweden

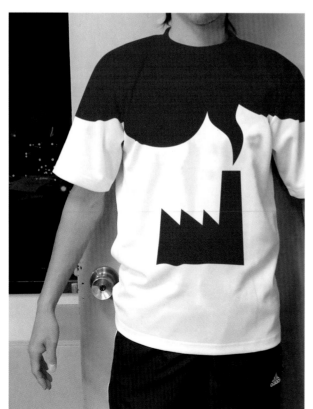

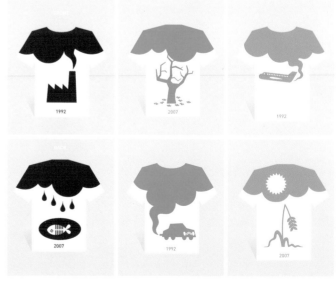

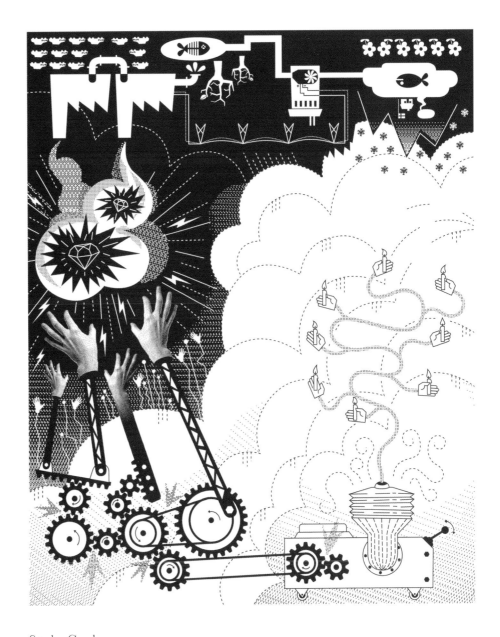

Sweden Graphics

Title : Table Cloth
Country : Sweden

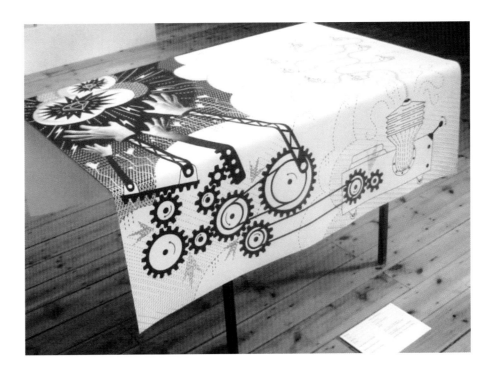

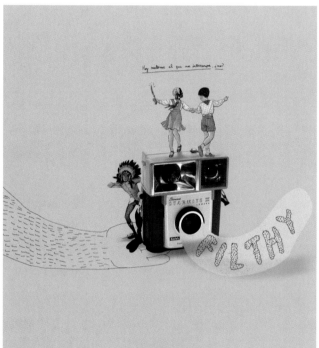

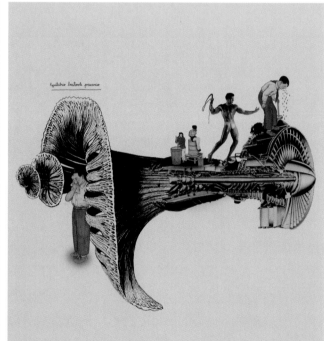

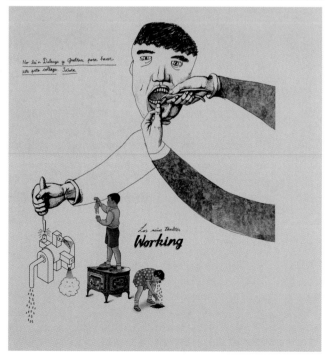

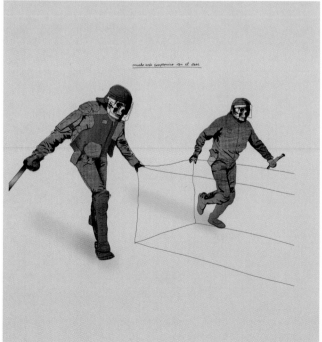

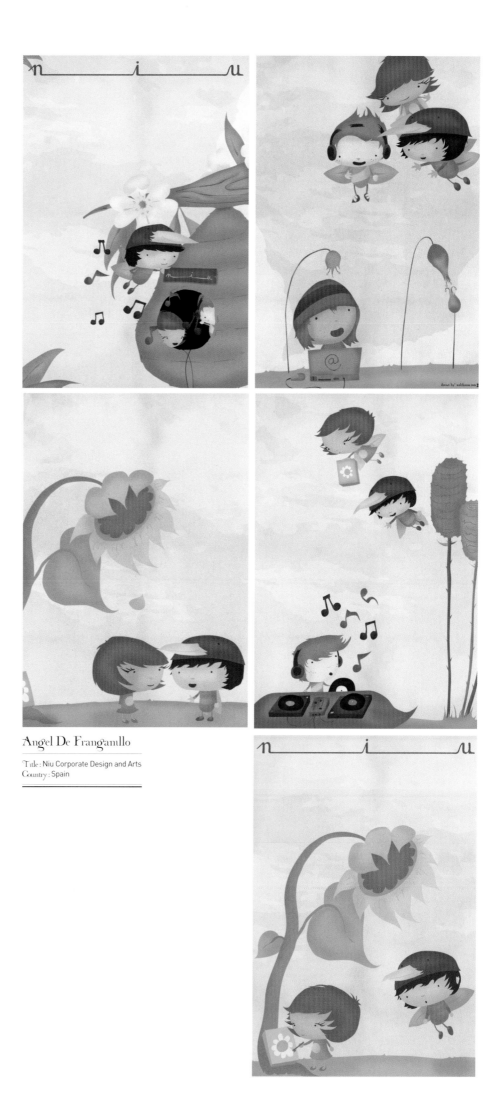

Angel De Franganillo

Title : Niu Corporate Design and Arts
Country : Spain

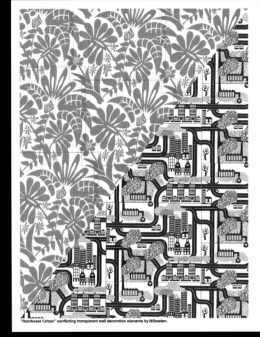

"Rainforest/Urban" conflicting transparent wall decoration elements by ▪▪Sweden.

This will be the design room.

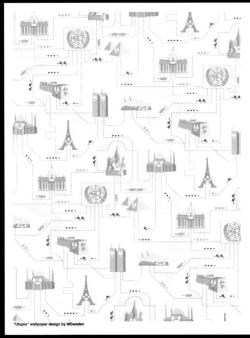

"Utopia" wallpaper design by ▪▪Sweden

This will be a corner of the design room.

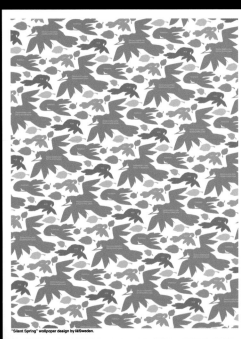

"Silent Spring" wallpaper design by ▪▪Sweden.

This will be the dining room.

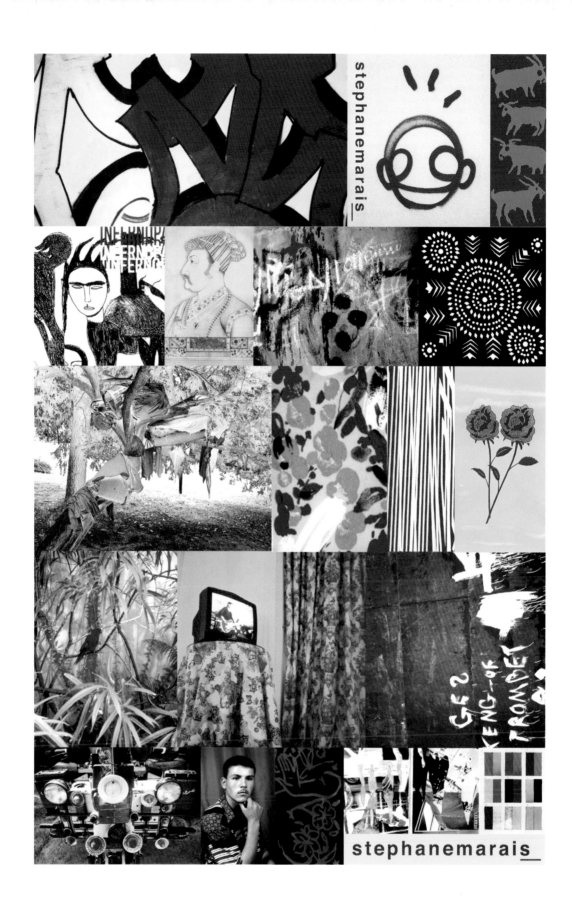

Sergio Calatroni Artroom srl

Title : Untied
Creative Director : Sergio Calatroni
Art Director : Sergio Calatroni, Miyuki Yajima
Design : Hisayuki Amae,
Photography : Sergio Calatroni
Country : Italy

Sweden Graphics

Title : Brain
Country : Sweden

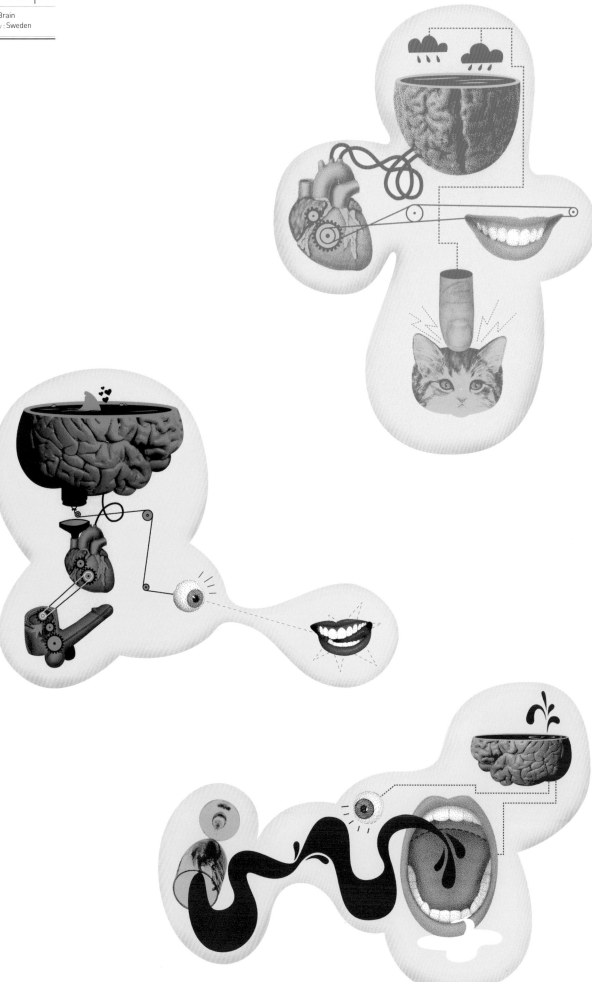

Sweden Graphics

Title : To Creative Review
Country : Sweden

100%

Chris Bolton

Title : l&pt Reinterpretations
Country : Finland

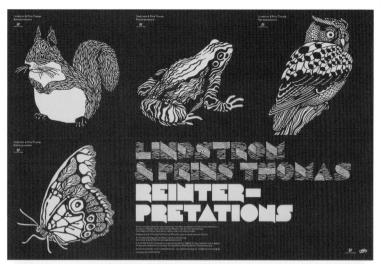

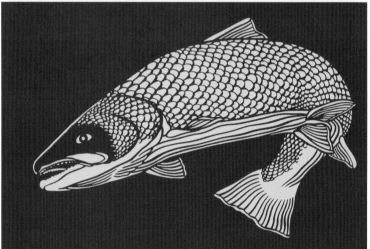

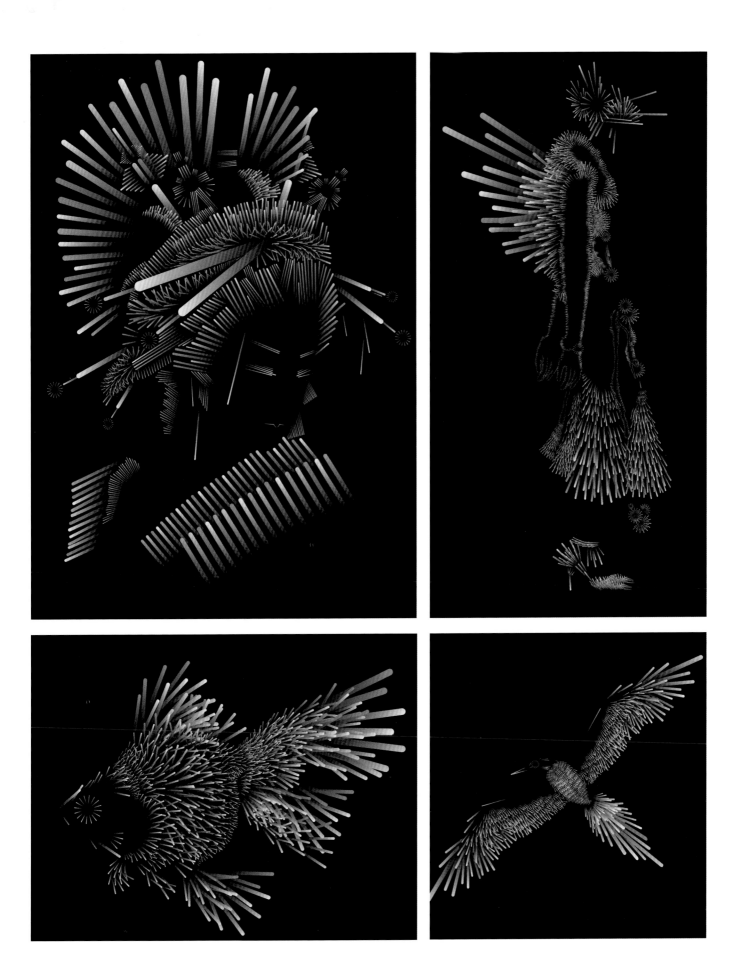

BeetRoot Design Group

Title : Zen Mascaro
Creative Director : Yiannis Charalambopoulos,
Alexis Nikou, Vagelis Liakos
Illustration : Ilias Pantikakis
Country : Greece

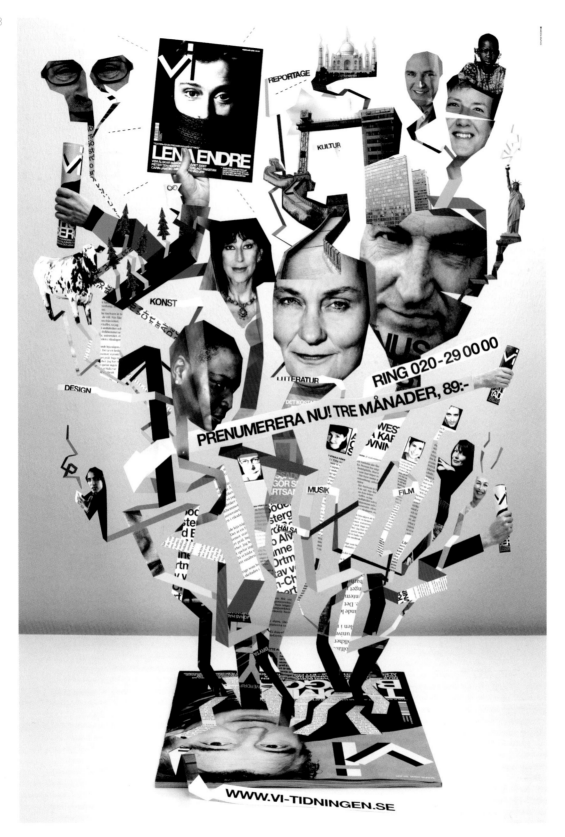

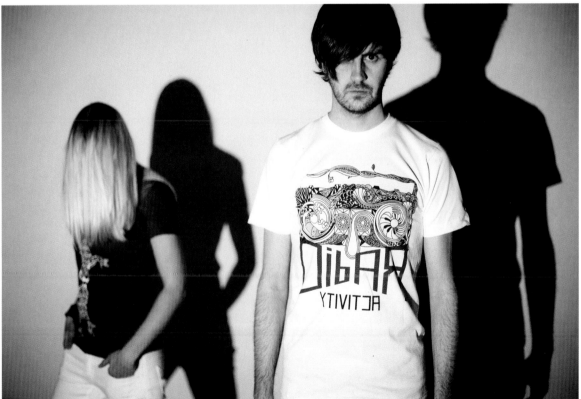

Gary Fernández

Title : Rebellions
Photography : Fernando Maselli
Country : Spain

tunefisch
jewel

Alexander Egger

Title : Tunefish
Country : Italy

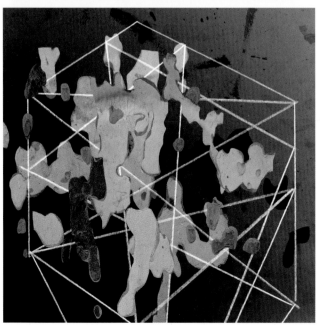

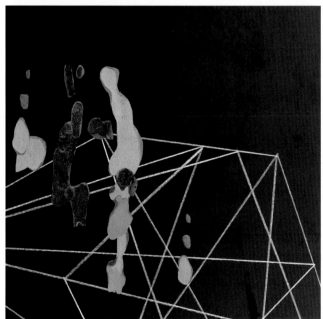

Katrin Olina Ltd.

Title : Silk Scarf
Design : Katrin Olina
Country : Iceland

Katrin Olina Ltd.

Title : Porcelain
Design : Katrin Olina
Country : Iceland

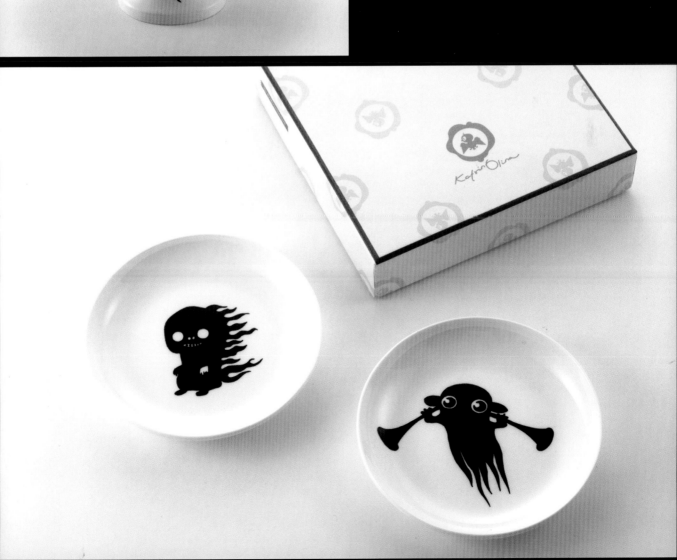

Hypnotis

Title : Mint Earthlabs / DJ Booth Illustration
Designer : Teis Albers
Country : The Netherlands

Hypnotis

Title : Wegener / Illustration for an Article
Design : Teis Albers
Country : The Netherlands

Hypnotis

Title : Catalogue / Book Illustration
Design : Teis Albers
Country : The Netherlands

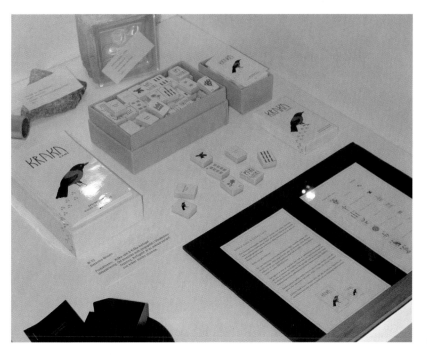

KRAKA
GAME

Based on the traditional
Chinese game Mah-jong

Flowers	TUS	VIN	SN				NORR TULL	SKANS TULL	ROSLAGS TULL
Red Dragon / Red Elk		SOM	BLÅ				NORR TULL	SKANS TULL	ROSLAGS TULL
Bamboo 7 / Log 7		VR	TUS				NORR TULL	SKANS TULL	ROSLAGS TULL
Sign 4		HS	TUL				NORR TULL	SKANS TULL	ROSLAGS TULL
Circle 1 / Crown 1									
Winds / Toll ways	SKANS TULL								
Bamboo 1 / Log 1									
Seasons	HS								

wasTeshirt

name

address

phone no. contact person

meeTshirt

name

sex status (free/occupied) attracted to

age weight height phone no.

wish for

LosTshirt

name

age address

phone no. contact person / adult

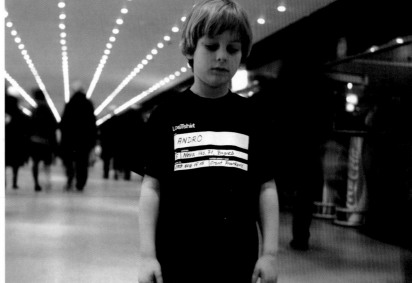

Laboratorium

Title : BLABLAB T-shirts Black Collection
Design : Orsat Frankovic, Ivana Vucic
Country : Croatia

Poster

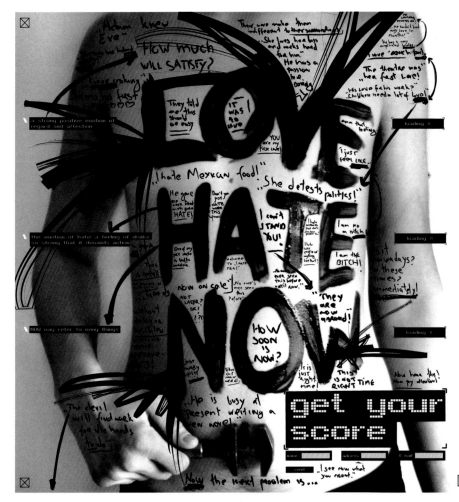

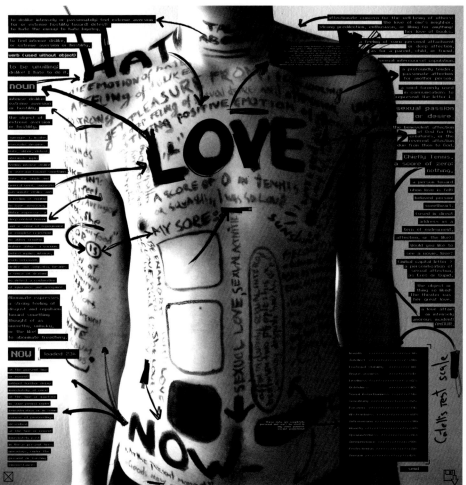

Vladimir Svorcan

Title: Score
Country: Serbia

New Future Graphic

Title : Margin Trade Show
Creative Director : Marcus Walters
& Gareth White
Country : Britain

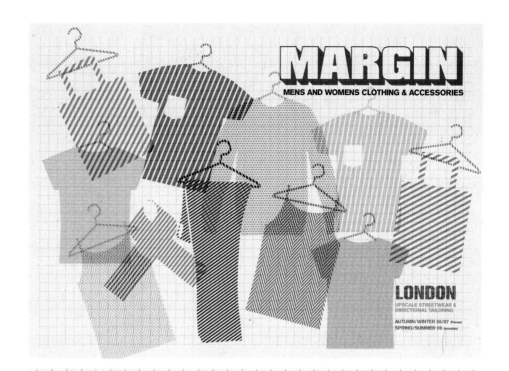

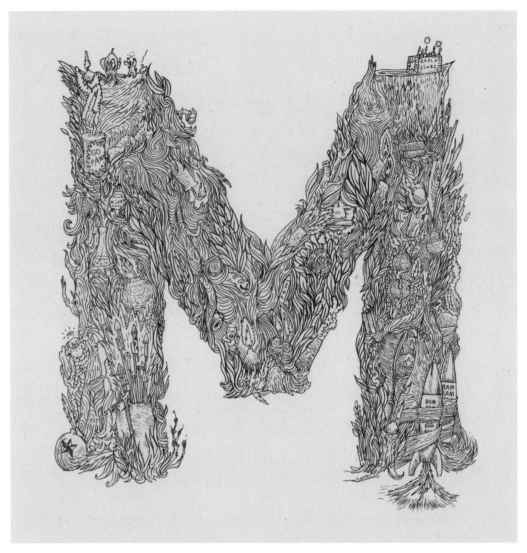

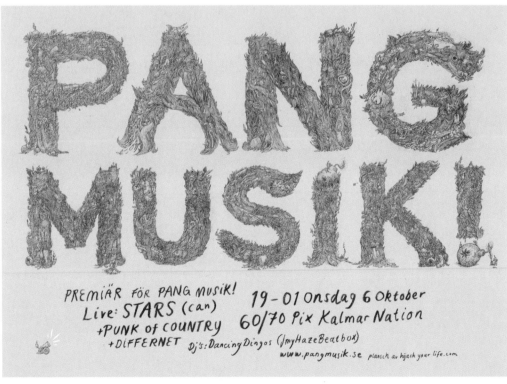

Hijack Your Life

Title : Pang Musik
Design : Kalle Mattsson
Country : The Netherlands

AT BRANCA LEONE

LUNEDÌ 16.04.07

PRESENTATO DA: FIREWATER www.firewater.it · SNOB PRODUCTION · B

UNICA DATA IN ITALIA

AMON TOBIN

NINJA TUNE RECORDS UK
ARTWORK FROM THE ALBUM FOLEY ROOM

SURROUND SOUND DJ SET

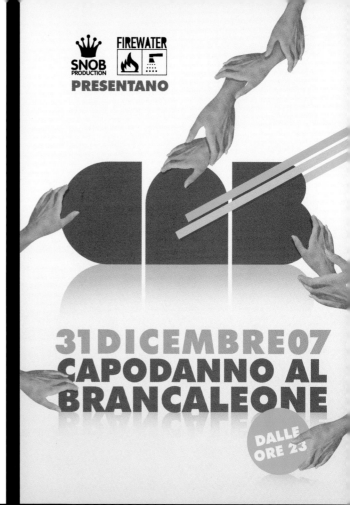

SNOB PRODUCTION · FIREWATER

PRESENTANO

31 DICEMBRE 07 CAPODANNO AL BRANCALEONE

DALLE ORE 23

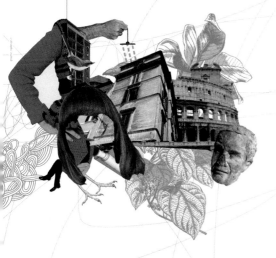

AT BRANCA LEONE

04.10.06 LAYO & BUSHWACKA!

FIREWATER · B

 REDSAND · Porn Star · **FIREWATER.IT**

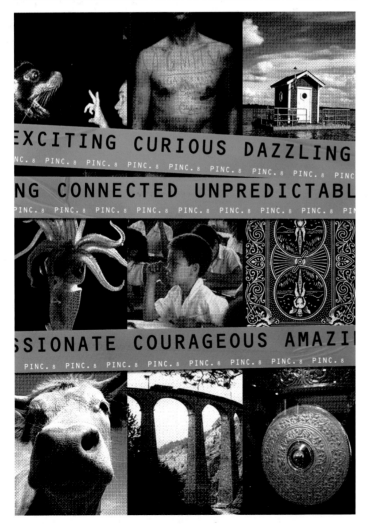

Lava

Title : Pinc Conference 9
Creative Director : Hans Wolbers
Design : Daan Hornstra
Country : The Netherlands

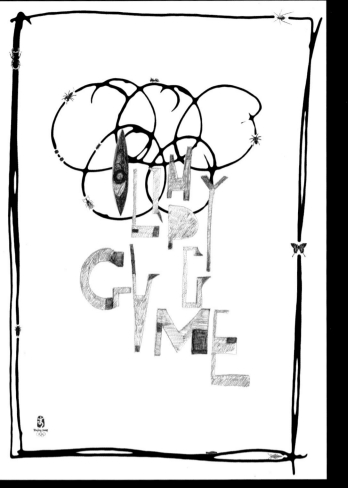

Sergio Calatroni Artroom srl

Title : Poster for Olympic, Namoc, Beijing
Creative Director : Sergio Calatroni
Art Director : Miyuki Yajima,
Design : Hisayuki Arnae
Illustration : Sergio Calatroni Artroom srl
Country : Italy

New Future Graphic

Title: Institute of Physics
Creative Director: Marcus Walters
& Gareth White
Country: Britain

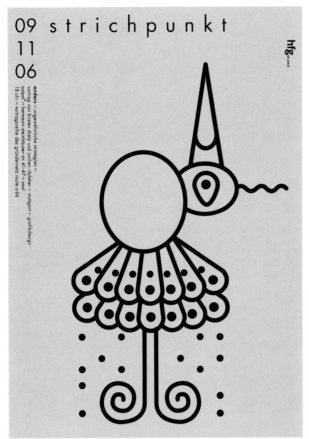

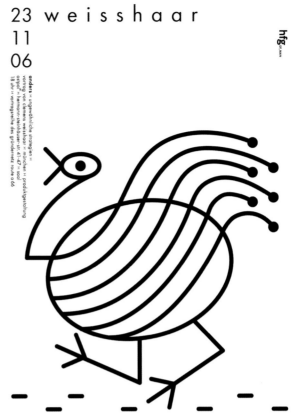

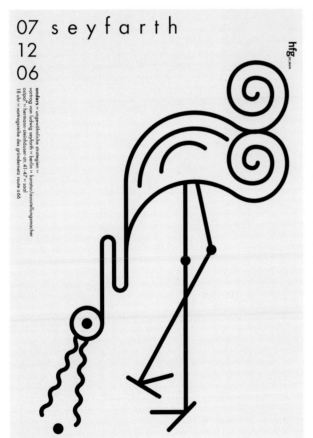

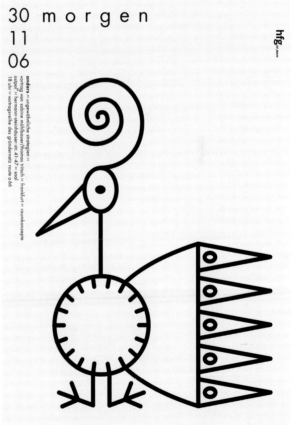

Hesse Design

Title: Strange Birds
Design: Klaus Hesse
Country: Germany

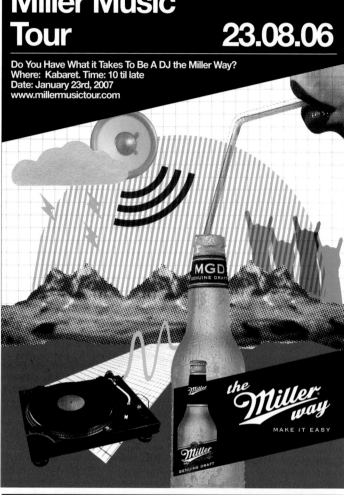

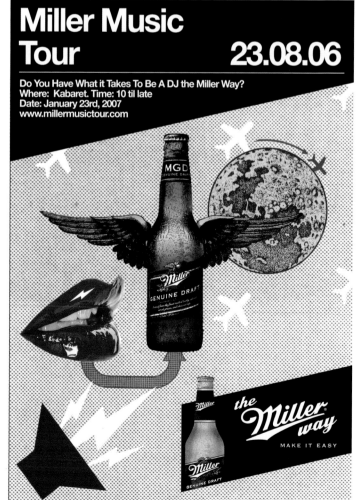

SUIVI PAR LA SOIRÉE

FOREVER
FOOTBALL

DJS:
DIXON (SONARKOLLEKTIV, BERLIN)
BLUE DOG (RADIO FG)
P-O, MISTER J & LULLABIES (MISSIVE)
GWEN MAZE (BATOFAR)

AU BATOFAR
SAMEDILE 24-05-2003
DOORS OPEN : 22H00
FACE AU 11, QUAI FRANÇOIS MAURIAC
75013, PARIS
ENTRÉE : 8 EURO

BALONY CUP 2003 ENTRÉE GRATUITE
 BAR SUR PLACE
SAMEDILE 24-05-2003
DOORS OPEN : 12H00
KICK OFF : 13H00
FINAL : 18H30

THIS
IS
NO
COMPETITION

AVEC :
FC MAGNET MITTE BERLIN
WADTEAM
FG ELECTRONIC SOCCER
MISSIVE
BATOFAR AU STADE CHARLÉTY
 SALLE PIERRE CHAPPY
 99, BOULEVARD KELLERMANN
AC BALONY 75013 PARIS – RER CITÉ UNIVERSITAIRE

DJS DE CHAQUEE QUPE :
DIXON (SONARKOLLEKTIV, BERLIN)
STEVEN REDAN (WAD)
BLUE DOG (RADIO FG)
P-O, MISTER J & LULLABIES (MISSIVE)
GWEN MAZE (BATOFAR)
JOSS DANJEAN (BALONY)

CONTACT : BRICE@BALONYMEDIA.COM
ARTWORK : 123BUERO // TINO GIESSNER

BALONY CUP 2003 ENTRÉE GRATUITE
 BAR SUR PLACE
SAMEDILE 24-05-2003
DOORS OPEN : 12H00
KICK OFF : 13H00
FINAL : 18H30

THIS
IS
NO
AWARD

AVEC :
FC MAGNET MITTE BERLIN
WADTEAM
FG ELECTRONIC SOCCER
MISSIVE
BATOFAR AU STADE CHARLÉTY
 SALLE PIERRE CHAPPY
 99, BOULEVARD KELLERMANN
AC BALONY 75013 PARIS – RER CITÉ UNIVERSITAIRE

DJS DE CHAQUEE QUPE :
DIXON (SONARKOLLEKTIV, BERLIN)
STEVEN REDAN (WAD)
BLUE DOG (RADIO FG)
P-O, MISTER J & LULLABIES (MISSIVE)
GWEN MAZE (BATOFAR)
JOSS DANJEAN (BALONY)

CONTACT : BRICE@BALONYMEDIA.COM
ARTWORK : 123BUERO // TINO GIESSNER

BALONY CUP 2003 ENTRÉE GRATUITE
 BAR SUR PLACE
SAMEDILE 24-05-2003
DOORS OPEN : 12H00
KICK OFF : 13H00
FINAL : 18H30

THIS
IS
NO
OFFENCE

AVEC :
FC MAGNET MITTE BERLIN
WADTEAM
FG ELECTRONIC SOCCER
MISSIVE
BATOFAR AU STADE CHARLÉTY
 SALLE PIERRE CHAPPY
 99, BOULEVARD KELLERMANN
AC BALONY 75013 PARIS – RER CITÉ UNIVERSITAIRE

DJS DE CHAQUEE QUPE :
DIXON (SONARKOLLEKTIV, BERLIN)
STEVEN REDAN (WAD)
BLUE DOG (RADIO FG)
P-O, MISTER J & LULLABIES (MISSIVE)
GWEN MAZE (BATOFAR)
JOSS DANJEAN (BALONY)

CONTACT : BRICE@BALONYMEDIA.COM
ARTWORK : 123BUERO // TINO GIESSNER

G*VA Studio

Title: The International Center of Percussion in Geneva
Country: Switzerland

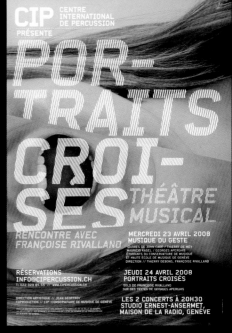

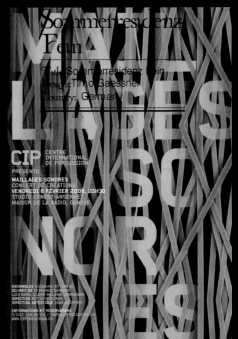

Sommerresidenz
Fein

Title: Sommerresidenz Fein
Design: Timo Gaessner
Country: Germany

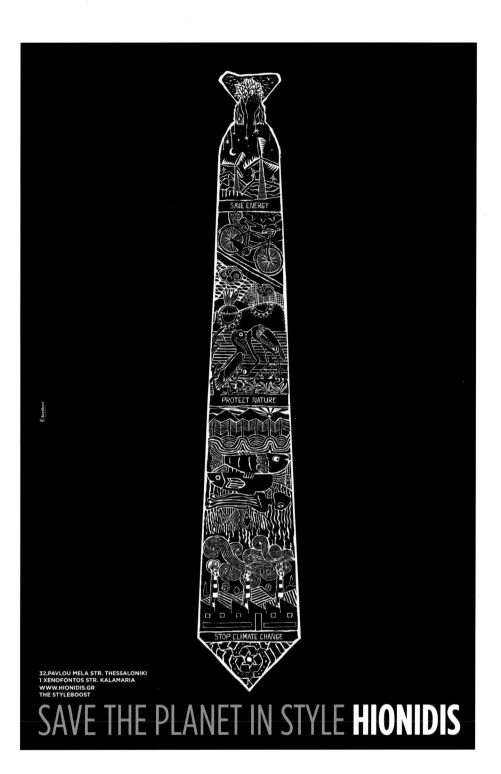

Beet Root design group

Title : Save the Planet in Style
Creative Director : Yiannis
Charalambopoulos, Alexis Nikou,
Vagelis Liakos
Illustration : Alexis Nikou
Country : Greece

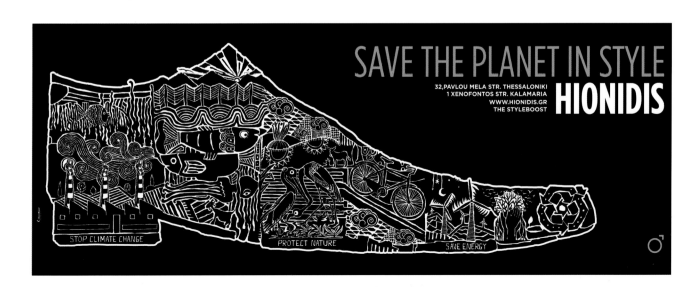

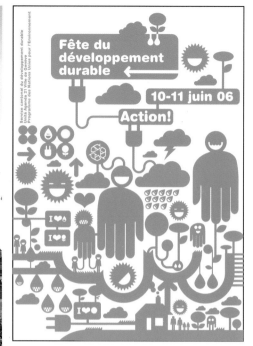
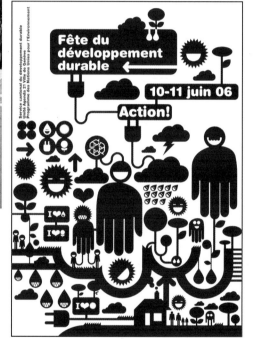
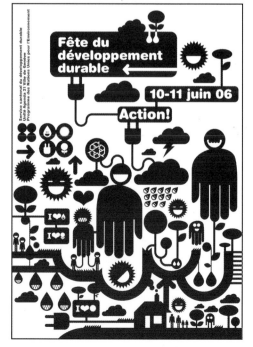

GVA Studio

Title : Project for the Festival of the
Durable Development of Geneva
Cuontry : Switzerland

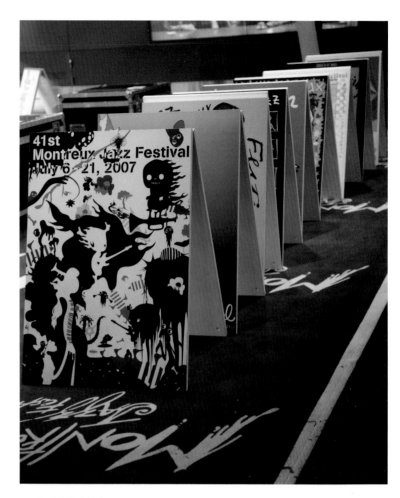

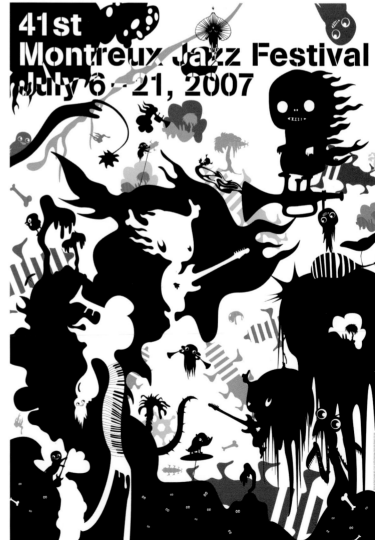

Katrin Olina Ltd

Title : 41st Montreux Jazz Festival Poster
Design : Katrin Olina
Country : Iceland

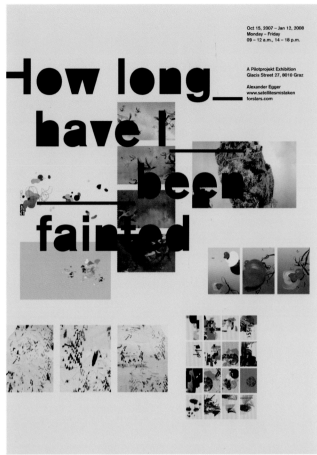

Alexander Egger

Title : Exhibition Posters-How Long
Have I Been Fainted
Country : Italy

Studio Dumbar

Title : Poster Series for the Dutch
orchestra, Amsterdam Sinfonietta
Country : The Netherlands

332

Making IMPAKT!

We are looking for you.

Get involved with the Impakt Festival 2008 / Your Space and be part of a program with film, video, visual arts, music and new media. If you want to volunteer for Impakt, phone us at **030-29 444 93** or send an email to **making@impakt.nl**. For more information and an application form check **www.impakt.nl/volunteers**. Meld je aan als vrijwilliger!

Impakt Festival 2008 / Your Space van 7 t/m 11 mei in Theater Kikker, Filmtheater 't Hoogt en diverse andere locaties in Utrecht.

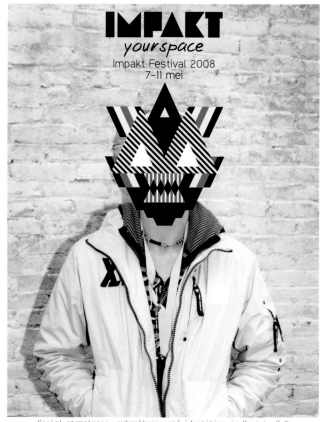

IMPAKT
yourspace
Impakt Festival 2008
7-11 mei

Social structures, subcultures and identities in Society 2.0

Theater Kikker en Filmtheater 't Hoogt, Utrecht
Meer informatie op www.impakt.nl en via 030-2944493

NUEVA COLECCIÓN

Lava

Title : Poster Impakt Festival 2008
Creative Director : Hans Wolbers
Art Director : Ruben Pater
Design : Ryan Cole
Country : The Netherlands

Proyecto Limon

Title : Poster Nueva Coleccion
Design : Luis Miguel Munilla Gamo
Country : Spain

Typography

Chris Bolton

Title : Hiem "Popscene Clubscene"
Country : Finland

Chris Bolton

Title : L.S.B. 'Original Highway Delight' &
'FOG' 12 inch Sleeve Designs
Country : Finland

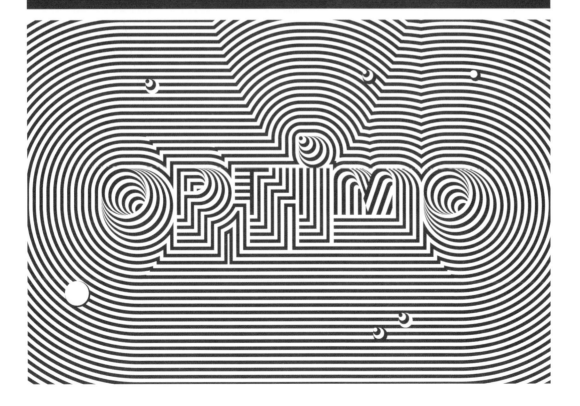

Chris Bolton

Title : Optimo Presents Psyche Out
12Inch Cover & Fold Out CD Poster
Country : Finland

CLUB ESCALATOR
DJ Sampler EP Part 1
(ESCD042P12 Pt1)

CLUB ESCALATOR
DJ Sampler EP Part 2
(ESCD042P12 Pt2)

Chris Bolton
Title : Club Escalator Part 1 &
Part 2 12 inch Sleeve Designs
Country : Finland

Chris Bolton

Title : Radio Slave 'Creature of the Night'
Country : Finland

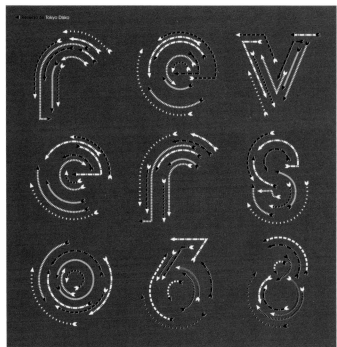

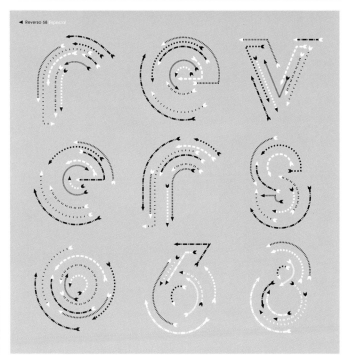

Chris Bolton

Title : Reverso 68 'Tokyo
Disko' & 'Especial'
Country : Finland

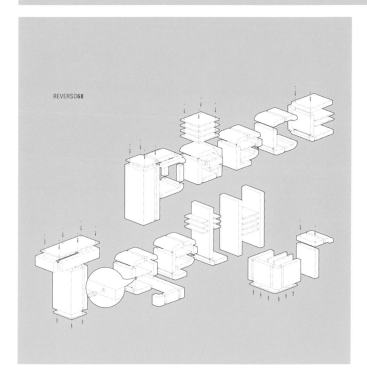

SIDE A
PART TWO
SIDE B
**TODD TERJE
SPINNING
STAR MIX**

WRITTEN & PRODUCED BY
P. HERBERT / P. MISON
MIXED BY R.TWELFTREE
PUBLISHED BY WESTBURY MUSIC
REMIX AND ADDITIONAL
PRODUCTION BY TODD TERJE

WWW.NEWSDISTRIBUTION.BE
WWW.NEWSRECORDS.BE
WWW.ESKIMORECORDINGS.BE

DESIGN BY CHRIS BOLTON
WWW.CHRISBOLTON.ORG

(P) & (C) 2007 N.E.W.S
SABAM. ALL RIGHTS RESERVED.
MADE IN BELGIUM.

CATALOGUE NUMBER 541416 501841

eskimo recordings

REVERSO**68**

Chris Bolton

Title : Reverso 68 "Piece
Together"
Country : Finland

Hörður Lárusson

Title : Albingi
Art Director : Atli Hilmarsson
Country : Iceland

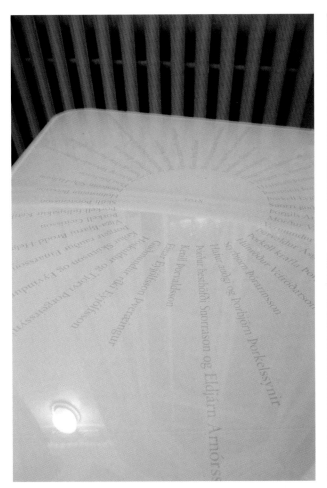

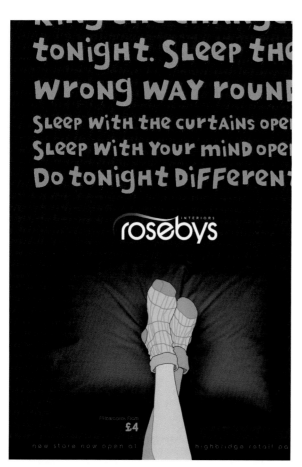

BJL

Title : Different
Country : Britain

BJL

Title : Personality
Country : Britain

BJL

Title : New
Country : Britain

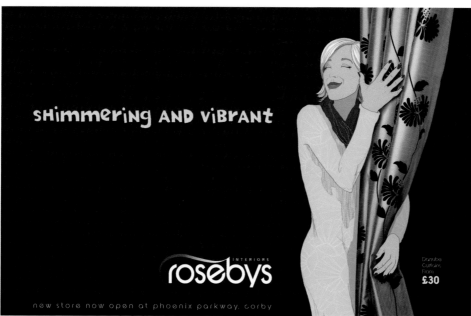

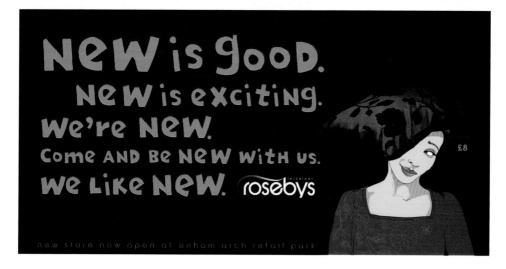

Designaside

Title : Big Circle
Art Director : Mauro Caramella
Photography : Sonia Solka
Country : Italy

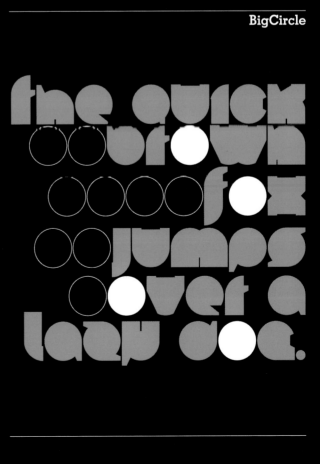

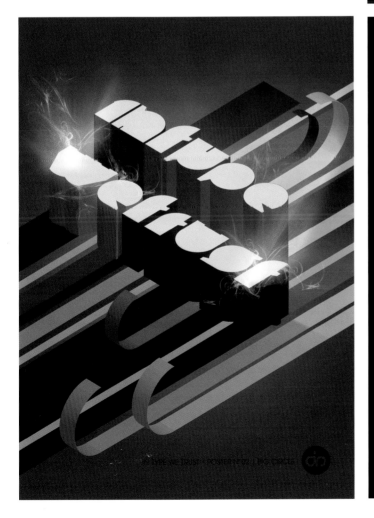

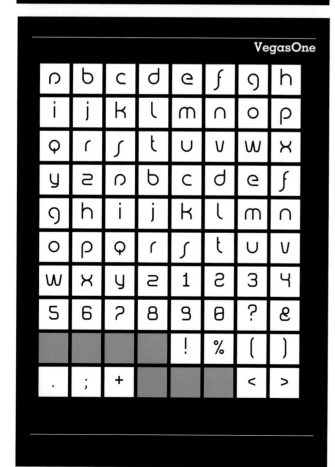

Designaside

Title: In Type We Trust
Art Director: Mauro Caramella
Photography: Sonia Solka
Country: Italy

IN TYPE WE TRUST • POSTER N°02 | VEGAS ONE

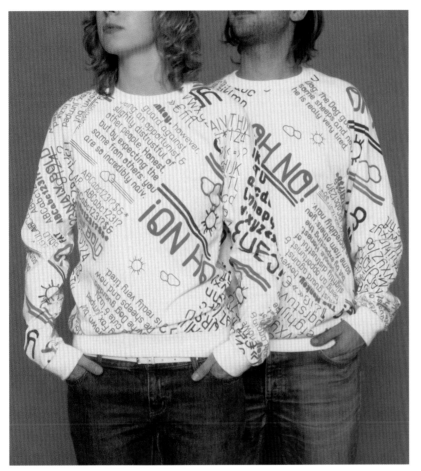

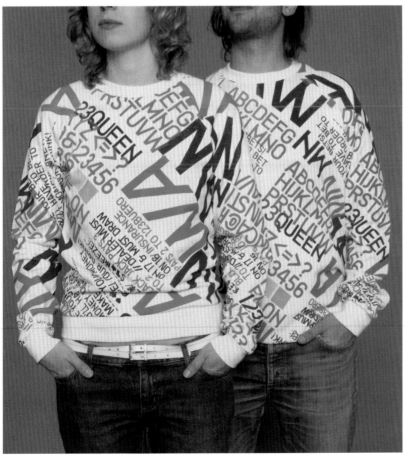

123 Buero

Title : 123sweater
Designer : Timo Gaessner
CopyWriter : 123 buero
Country : Germany

My amazing Holidays

The huge brown, but very nasty Fox, jumped over the cute & lazy Dog. The Dog guarded some sheeps and now he is realy very tired.

The Monkey. however,
must guard against being an opportunist & slightly distrustful of other people. **Honest,** but by expecting the same from others: you are so incredibly naiv.

THIN ABCabc123!?$&*
REGULAR ABCabc123!?
BOLD ABCabc123!?$&
FAT ABCabc123!?$&*

!„#$%&'()*+,-./01234567899;;<=>?ABCDE
FGHIJKLMNOPQRSTUVWXYZ^_`abcdefghij
klmnopqrstuvwxyz~ÄÖÜäöü•¶ß¿ı≈«»…--
""''€<>fifl·„!„#$%&'()*+,-./01234567899;
;<=>?ABCDEFGHIJKLMNOPQRSTUVWXYZ^
_`abcdefghijklmnopqrstuvwxyz~ÄÖÜäö
ü•¶ß¿ı≈«» …--""''€<>fifl·„!„#$%&'()*+,-.
/01234567899;;<=>?ABCDEFGHIJKLMN
OPQRSTUVWXYZ^_`abcdefghijklmnopq
rstuvwxyz~ÄÖÜäöü•¶ß¿ı≈«» …--""''€<>
fifl·„

The quick brown Fox jumps over the lazy Dog. A slow red Horse diggs under the wired Sentense. **The bold rounded 123naiv finaly stops amazing the bored Viewer in the end.**

123 Buero

Title: 123naiv
Designer: Timo Gaessner
Copyright: 123 Buero
Country: Germany

Studio Copyright

Title : 40 Movil Type
Creative Director : Joel Lozano
Design : Joel Lozano
Country : Spain

CHUCHES FONT

Laura Millán
Title: Chuches Font
Country : Spain

Studio Copyright

Title : Moto Type
Creative Director : Joel Lozano
Design : Joel Lozano, Robin Frank
Country : Spain

TIPOGRAFÍA
MODULAR
WORKSHOP CON ANDREU BALIUS
ABCaBC
ROBIN FRANK Y JOEL LOZANO
MOTO TYPE
COPYRIGHT FONTS
ABCDEFGHIJKLMNÑOPQRSTUVWXYZ@123456789
abcdefghijklmnñopqrstuvwxyz@123456789

MOTO
TYPE

Picnic Oficina de creacion
Title: Crazy, crazy, crazy
Country: Spain

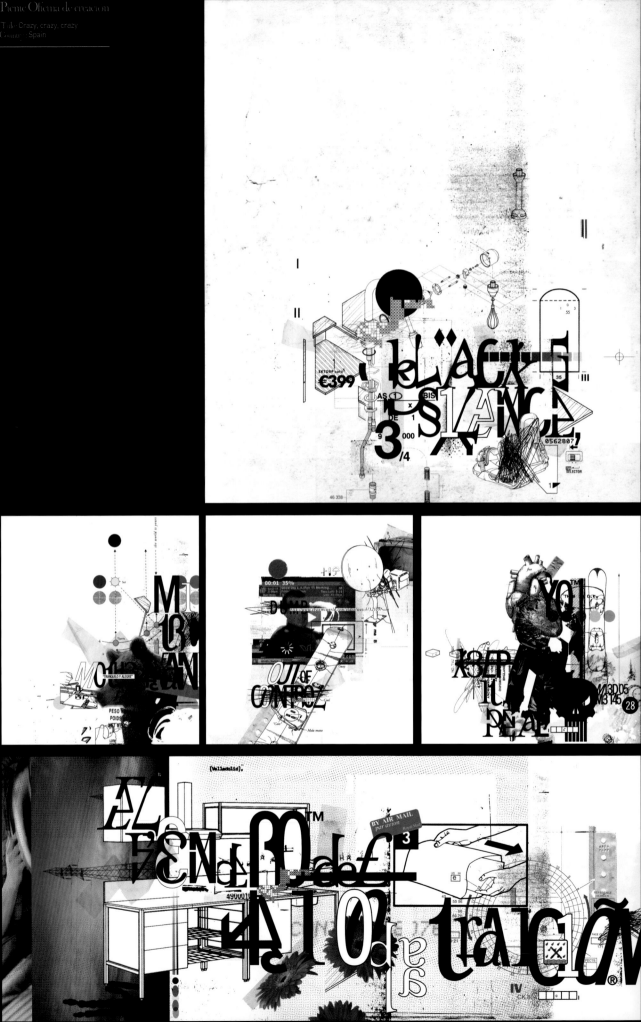

352

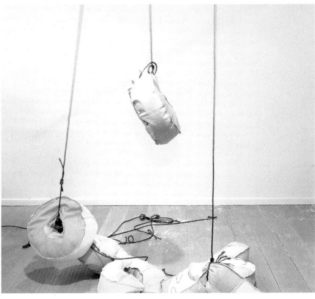

Sweden Graphics

Title : Oddjob
Country : Sweden

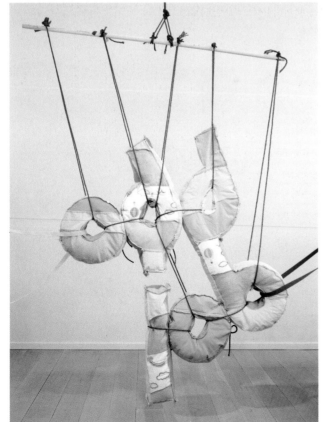

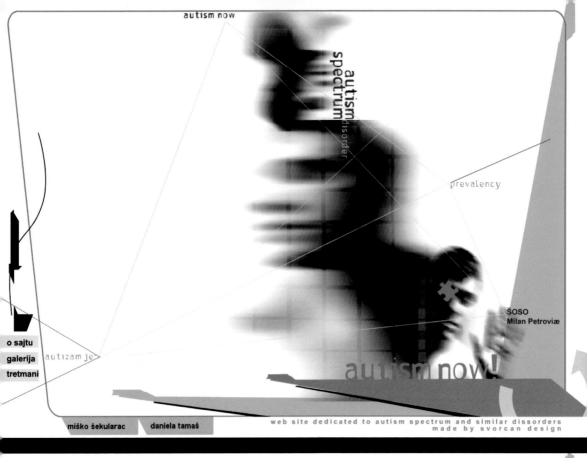

GRAPHIC
DESIGN
PORTFOLIO
VLADIMIR SVORCAN
..

PORTFOLIO

BIOGRAPHY

this site is dedicated to graphic communications, on this page you can find
links for the galleries with works from different areas of graphic design.
Site and all its visual elements are made by Vladimir Svorcan

GALLERIES WITH POSTERS VISUAL IDENTITY ILLUSTRATIONS TYPOGRAPHY PUBLICATIONS ✉

POSTERS
TYPOGRAPHY
PUBLICATIONS
VISUAL IDENTITY
PORTFOLIO
..

this page contains links for the galleries with works from diferent
arias of graphic design, some of the works are just projects,
some of them are published and some are experimental work
that explores and I hope moves some edges of graphic design
and visual arts in generaly.

IDENTITY

POSTERS

PUBLICATIONS

TYPOGRAPHY

ILLUSTRATIONS

HOME

VLADIMIR SVORCAN GRAPHIC DESIGN GALLERIES ✉

Vladimir Svorcan

Title : Svorcan Design www.svorcan-design.com
Country : Serbia

Tank Design

Title: Motlys Film
Creative Director: Ina Brantenberg
Art Director: Hans Christian Oren
Design: Tank
Country: Norway

stop:contact

stop:contact

stop:contact

Verminder uw sluipverbruik
en voorkom CO² uitstoot.

Doe mee >

Studio Dumbar

Title: Essent Online public campaign 'Stop Contact'
Country: The Netherlands

stop:contact

essent

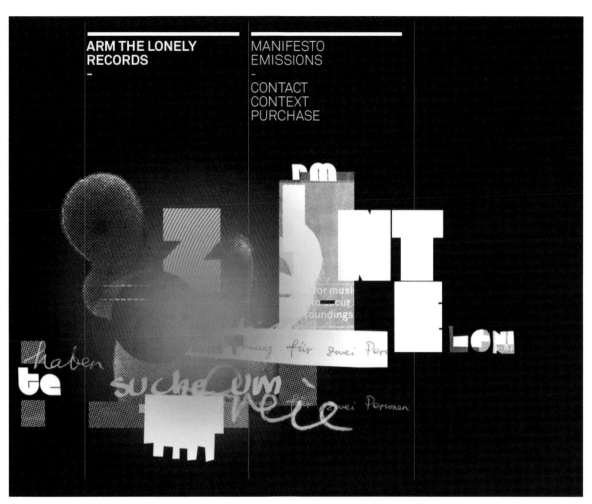

iaia filiberti

ita eng

Alexander Egger

Title : Arm the Lonely
Country : Italy

Ginette Caron Communication Design

Title : Iaia Filiberti
Design : Ginette Caron
Country : Italy

Peter Raczko

Title : Frans Vos
Country : The Netherlands

Peter Raczko
Title: Werkgroep Herkenning
Country: The Netherlands

Digital ∧ map

click to
view

TV ∧ map

Welcome to BJL.
We are an
independent
advertising
agency based
in Manchester.

Please take a
look around,
if you like what
you see, call us.

Home ∧ map

80s
Barrington Johnson
Lorains opens in 1987
with 3 employees and
2 clients. In no time,
Prestons, Pifco, Boots
and Swinton Insurance
all join the agency.

use
arrow
keys
↑
↓

servizi chi siamo contatti

servizi chi siamo contatti

Cacao Design

Title: Midax Website
Creative Director: Mauro Pastore, Masa
Magnoni, Alessandro Floridia

BJL

Title : www.friendsreignited.co.uk
Art Director : Chris Gaffey
Design : Neil Boote
Copywriter : Marcus Leigh
Photography : Christian Mcgowan
Illustration : Andy O' Snavgnessey
Country : Britain

BJL

Title : www.versuscancer.org
Art Director : Richard Pearson
Design : Neil Boote, Ian
Patterson, Caroline Marsdew
Copywriter : Harinder Bajwa
Country : Britain

123 Buero

Title: Tomas Bende
Designer: Timo Gaes
Copywriter: 123buero
Country: Germany

123 Buero

Title: Maak Roberts
Designer: Timo Gaes
Copywriter: 123buero
Country: Germany

123 Buero

Title: Dr. Med Seide
Designer: Timo Gaes
Copywriter: 123buero
Country: Germany

Sweden Graphics

Title : Smith and Jones Films
Country : Sweden

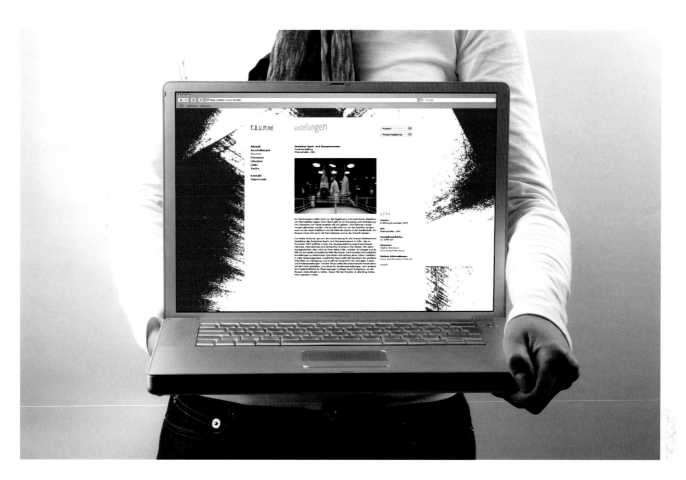

Rotbraun Informationsgestaltung

Title : r.a.u.m.net
Design : Nora Bilz, Pia Schneider
Country : Germany

Marc Taule

Title : Mirton Website (www.mirton.com)
Country : Spain

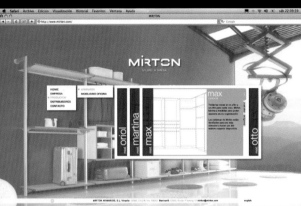

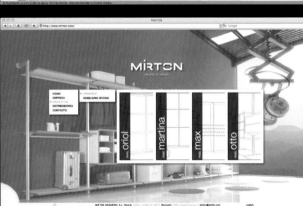

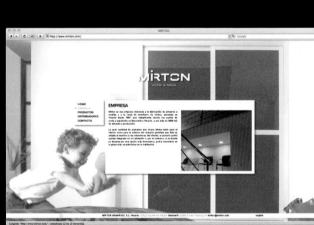

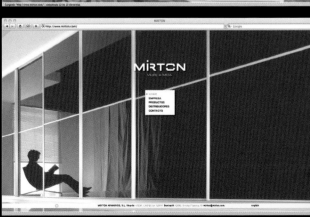

Sergio Calatroni Artroom srl

Title : www.fabriziosclavi.it
Creative Director : Fabrizio Sclavi,
Art Director : Sergio Calatroni, Miyuki Yajima
Design : Hisayuki Amae, Teru Takeda
Photography : Sergio Calatroni Artroom srl
Illustration : Fabrizio Sclavi
Country : Italy

Sergio Calatroni Artroom srl

Title : www.galleriarossanaorlandi.com
Creative Director : Sergio Calatroni
Art Director : Miyuki Yajima
Design : Hisayuki Amae, Teru Takeda
Copywriter : Sergio Calatroni Artroom srl
Illustration : Sergio Calatroni Artroom srl
Country : Italy

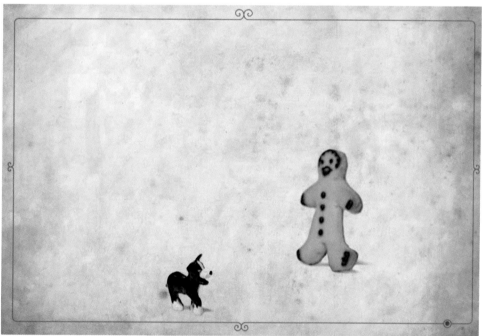

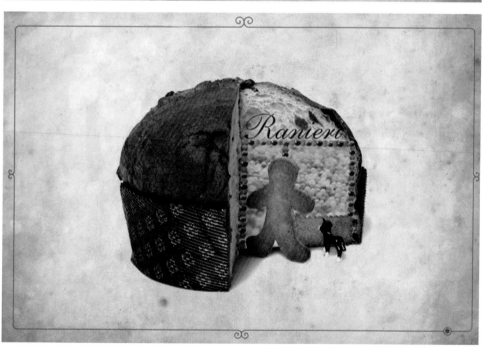

Pasticceria Ranieri

- open • mon - sat 7h30 - 19h30
- close • sunday afternoon

via moscova 7 20121 milano
T.+39.02.6595308
P.iva / c.f 07056000156

RANIERI

NEWS • 2

Ranieri prepara per vostra Pasqua.

Torte

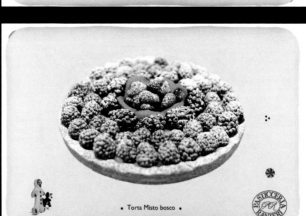

• Torta Misto bosco •

378 Sergio Calatroni Artroom srl

Title : www.pellux.it
Creative Director : Sergio Calatroni
Art Director : Miyuki Yajima
Design : Hisayuki Amae, Teru Takeda
Copywriter : Sergio Calatroni Artroom
Illustration : Sergio Calatroni Artroom
Country : Italy

100%

Sergio Calatroni Artroom srl

Title : www.sergiocalatroni.com
Creative Director : Sergio Calatroni
Art Director : Miyuki Yajima
Design : Hisayuki Amae, Teru Takeda
Copywriter : Sergio Calatroni Artroom srl
Photography : Sergio Calatroni Artroom srl
Illustration : Sergio Calatroni Artroom srl
Country : Italy

FAUSTO SANTINI

Sergio Calatroni Shiseido Untied • Packaging Giappone Japan 1996 Packaging and Display

-2 Modelli Models

-1 Collezione Ser Shiseido Untied -3 Composizione Composition

ART

SEXY DESIGN

Sergio Calatroni Ritratti Portrait 1990 - 2004 Fotografia Photograph

Sergio Calatroni Tappeto Carpet • Italia Italy 1990 Design

Tappeto della Meditazione

Disegnato da Sergio Calatroni
Casmir, India, 1990.
Produzione Atrocity
Lana tinta con colori vegetali.
Ricamato al piccolo punto.
192 x 192cm
Foto: Ernest Levi

Carpet of Meditation

Designed by Sergio Calatroni
Casmir, India 1990
Production Sisal
Plain wool with vegetables colors.
Embroieded in small point.
192 x 192cm
Photo: Ernest Levi

Sergio Calatroni Artroom srl

Title : www.eclecticshop.ch
Creative Director : Sergio Calatroni,
Art Director : Miyuki Yajima
Design : Hisayuki Amae, Teru Takeda
Photography : Sergio Calatroni Artroom srl
Illustration : Sergio Calatronni Artroom srl
Country : Italy

Logo

Title : MAK
Designer : Chris Boltoon
Country : Finland

RAUM.FILM

Title : Raumfilm
Design Agency : Lichtwitz-Buro fur Visuelle Kommunikation
Country : Austria
Award : Eulda 2007

PIAS

Title : Pias
Designer : Chris Boolton
Country : Finland

TEXTURA

Title: Textura
Designer Agency : Muamer Adilovic
Country : Bosnia-Herzegovina
Award : Eulda 2007

seos

Title : S.E.O.S
Designer : Chris Boltoon
Country : Finland

ADU

Title : Academy of Dramatic Art logo
Designer Agency : Laboratorium
Country : Croatia
Award : Eulda 2007

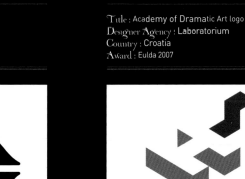

Title : Make-up
Designer : Chris Boltoon
Country : Finland

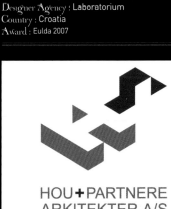

HOU+PARTNERE
ARKITEKTER A/S

Title : Architectural firm Hou+Partnere Arkitekter A/S
Designer Agency : Super Duper Graphics
Country : Denmark
Award : Eulda 2007

Title : Moor
Designer Agency : Hahmo Design Oy
Country : Finland
Award : Eulda 2007

Title : 'Mn'
Designer Agency : Chris Trivizas I Design
Country : Greece
Award : Eulda 2007

Title : Logo for the Consumer Society and citizen
Networks(Ukraine)
Design Agency : Jovan Rocanov (Serbia) for Kaffeine
Communications(Kiey, Ukraine)
Country : Serbia
Award : Eulda 2007

Title : Redesign Traffic Signs
Designer Agency : Deka Design Stúdió
Country : Hungary
Award : Eulda 2007

Title : The Association of Albanian Publishers
Designer Agency : Eggra
Country : Former Yugoslav Repubilc Of Macedonia
Award : Eulda 2007

Title : Food of Angels
Designer Agency : Orn Smári slf
Country : Iceland
Award : Eulda 2007

Title : Monopol
Designer Agency : KITA™ Berlin I Visual Playground
Country : Germany
Award : Eulda 2007

Title : Luttrellstown Castle Resort
Designer Agency : First Impression
Country : Lreland
Award : Eulda 2007

Title : Logo for the italian volontary association of blood donors
Designer Agency : Tangram Strategic Design
Country : Italy
Award : Eulda 2007

Title : Teho
Designer Agency : Bleed
Country : Norway
Award : Eulda 2007

MÁDARA™
ecocosmetics

Title : MÁDARA
Designer : Liene Drazniece
Country : Latvia
Award : Eulda 2007

MOUSTACHE FILM

Title : Moustache Film
Designer Agency : Juice
Country : Poland
Award : Eulda 2007

urban chic

Title : Urban Chic
Designer Agency : Vidale - Gloesener
Country : Luxembourg
Award : Eulda 2007

GALERIA
HELIOS

Title : Galeria Helios
Designer Agency : X3 Studios
Country : Romania
Award : Eulda 2007

EFFENAAR

Title : Effenaar
Designer Agency : Fabrique Communications and Design
Country : The Netherlands
Award : Eulda 2007

Title : Public youth social organization of anti-drag cation
Designer Agency : Y-design.ru
Country : Russian Federation
Award : Eulda 2007

Title : International Visegrad Fund
Designer Agency : International Visegrad Fund
Country : Slovakia
Award : Eulda 2007

Title : Torch
Designer Agency : El Paso, Galeria de Comunicacion
Country : Spain
Award : Eulda 2007

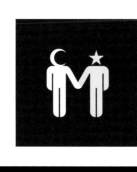

Title : An identity for a Picnic Service Provider
Designer Agency : Armada
Country : Slovenia
Award : Eulda 2007

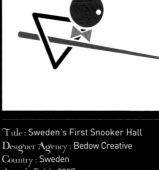

Title : Sweden's First Snooker Hall
Designer Agency : Bedow Creative
Country : Sweden
Award : Eulda 2007

Title : Symbol for the Turkey and European Union
Publications Relationship
Designer Agency : MYRA
Country : Turkey
Award : Eulda 2007

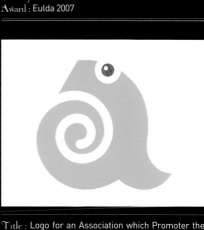

Title : Logo for an Association which Promoter the
Respect for Nature to Children
Designer Agency : Mottaz Design
Country : Switzerland
Award : Eulda 2007

Title : Logo for Eight
Designer Agency : Shift design
Country : Portugal
Award : Eulda 2007

Title : Brightlines Translation
Designer Agency : Mytton Williams
Country : Britain
Award : Eulda 2007

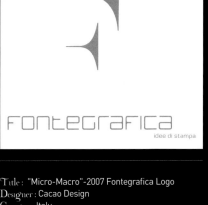

Title : "Micro-Macro"-2007 Fontegrafica Logo
Designer : Cacao Design
Country : Italy

Title : Lovely Lily
Designer : Peter Raczko
Country : The Netherlands

Title : Midax Logo
Design Agency : Cacao Design
Country : Italy

Title : Niet Tevreden
Designer : Peter Raczko
Country : The Netherlands

Title : Wolda
Design Agency : Cacao Design
Country : Italy

Title : Nika Horseproducts
Designer : Peter Raczko
Country : The Netherlands

Title : Black Mountain
Design Agency : Lysergid
Country : France

Title : Black Couture
Design Agency : Lysergid
Country : France

Title : Mass Mechanics
Design Agency : Lysergid
Country : France

Title : Shu, God of Wind
Design Agency : Cappelli Communicatio
Country : Italy

Title : Proto
Design Agency : Lysergid
Country : France

Title : ES
Design Agency : Lysergid
Country : France

Title : Pilotprojekt
Designer : Alexander Egger
Country : Italy

Title : Fubiz
Design Agency : Lysergid
Country : France

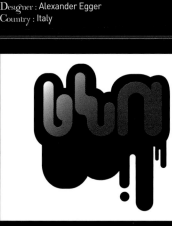

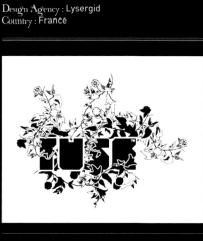

Title : Geny
Designer : Gen Sadakanen
Country : Germany

Title : Fuse
Design Agency : Lysergid
Country : France

Title : KZE IIC
Design Agency : Lysergid
Country : France

Title : Food & Beverage
Design Agency : Cappelli Communication
Country : Italy

Title : LRRL
Design Agency : Lysergid
Country : France

Title : Ars Itinerandi
Design Agency : Cappelli Communication
Country : Italy

Title : Moda Made in Italy
Design Agency : Cappelli Communication
Country : Italy

Title : Graficandesign
Design Agency : Cappelli Communication
Country : Italy

Title : Family Day
Design Agency : Cappelli Communication
Country : Italy

Title : Art Museum New Logo
Design Agency : Cappelli Communication
Country : Italy

Title : Newsletter in XXII°
Design Agency : Cappelli Communication
Country : Italy

Title : Italian Painter
Design Agency : Cappelli Communication
Country : Italy

Title : Pulp It
Design Agency : Cappelli Communication
Country : Italy

Title : Integration
Design Agency: Cappelli Communication
Country : Italy

TUTTO DALLA **A**
ALLO **ZELIG**

Title : Zelig in Summer
Design Agency : Cappelli Communication
Country : Italy

Title : Untitled
Design Agency : Gen Sadakane
Country : Germany

SURVIVAL

LOREM
IPSUM
Original™

Title : Disco on the Beach
Design Agency : Cappelli Communication
Country : Italy

Title : Loren Ipswm
Design Agency : Gen Sadakane
Country : Germany

Title : Untitled
Design Agency : Gen Sadakane
Country : Germany

Title : Untitled
Design Agency : Gen Sadakane
Country : Germany

Title : The Midnight Sun
Design Agency : Gen Sadakane
Country : Germany

Title : Adult Vision
Design Agency : Gen Sadakane
Country : Germany

Title : Sirus
Design Agency : Gen Sadakane
Country : Germany

Title : EATME
Design Agency : Gen Sadakane
Country : Germany

Title : Untitled
Design Agency : Gen Sadakane
Country : Germany

Title : Air Berlin
Design Agency : Gen Sadakane
Country : Germany

Title : Untitled
Design Agency : Gen Sadakane
Country : Germany

Title : Untitled
Design Agency : Gen Sadakane
Country : Germany

Title : Untitled
Design Agency : Gen Sadakane
Country : Germany

b·lounged

Title : b.lounged
Design Agency : Gen Sadakane
Country : Germany

Title : Untitled
Design Agency : Gen Sadakane
Country : Germany

Title : EOD
Design Agency : Gen Sadakane
Country : Germany

Title : Untitled
Design Agency : Gen Sadakane
Country : Germany

Title : Netlob
Design Agency : Gen Sadakane
Country : Germany

Title : EDEN
Design Agency : Gen Sadakane
Country : Germany

Title : International Award Winner
Design Agency : Gen Sadakane
Country : Germany

Title : Animission
Design Agency : Gen Sadakane
Country : Germany

Title : Untitled
Design Agency : Gen Sadakane
Country : Germany

Title : Untitled
Design Agency : Gen Sadakane
Country : Germany

Title : Yummy
Design Agency : Gen Sadakane
Country : Germany

Title : Jonny Lang
Design Agency : Gen Sadakane
Country : Germany

Title : Untitled
Design Agency : Gen Sadakane
Country : Germany

Title : Dior
Design Agency : Gen Sadakane
Country : Germany

Title : MAAKROBERTS
Designer Agency : 123buero
Country : Germany

Title : SAYIMSORRY
Design Agency : 123buero
Country : Germany

Title : Matteo Lampertico
Designer Agency : Ginette Caron Communication Design
Country : Italy

Title : GTP Grand Theater de Provence
Designer Agency : Ginette Caron Communication Design
Country : Italy

Title : Certo
Design : Jelena Drobac
Country : Serbia

Title : Ismaele Marrone Architects
Designer Agency: Ginette Caron Communication Design
Country : Italy

Title : Quattro Associati Architects
Designer Agency: Ginette Caron Communication Design
Country : Italy

Title : CPA
Designer Agency : Chris Trivizas Design
Country : Greece

Title : The Corfu English School
Designer Agency : Chris Trivizas Design
Country : Greece

Title : Omnis ICT
Designer Agency : Chris Trivizas Design
Country : Greece

Title : Javerdel
Designer Agency : Hahmo Design Ltd.
Country : Finland

Title : Romeo & Juliet
Designer Agency : Chris Trivizas Design
Country : Greece

Title : Labtium
Designer Agency : Hahmo Design Ltd.
Country : Finland

Title : Semeli the Hotel
Designer Agency : Chris Trivizas Design
Country : Greece

Title : Luses, The Foundation for the Promotion of Finnish Music
Designer Agency : Hahmo Design Ltd.
Country : Finland

Title : Marttiini Deco
Designer Agency : Hahmo Design Ltd.
Country : Finland

Title : Livz
Designer Agency : Eden Design & Communication
Country : The Netherlands

Title : Promaint
Designer Agency : Hahmo Design Ltd.
Country : Finland

Title : Garden Emporium
Designer : Josh Butcher
Country : Britain

AIM Amsterdamse Innovatie Motor

Title : Amsterdam Innovation Motor
Designer Agency : Eden Design & Communication
Country : The Netherlands

TV4 ANYTIME

Title : TV4 Anytime logotype/Icon
Designer Agency : Ohlsonsmith
Country : Sweden

CentiQ
Wijzer in geldzaken

Title : CentiQ logo design
Designer Agency : Eden Design & Communication
Country : The Netherlands

Title : TV4 Guld logotype
Designer Agency : Ohlsonsmith
Country : Sweden

Title : North Spirit logo
Designer Agency : Laboratorium
Country : Croatia

Title : Typorized
Designer : Marc Taule
Country : Spain

Title : Roars Not Whispers
Designer : Josh Butcher
Country : Britain

Title : High Times Logo
Designer : Marc Taule
Country : Spain

Title : Urban Republic Logo
DesignerAgency : Laboratorium
Country : Croatia

Title : Abovo
DesignerAgency : Sergio Calatroni Artroom srl
Country : Italy

Title : Culturmix
Designer Agency : Sergio Calatroni Artroom srl
Country : Italy

Title : Gioi
DesignerAgency: Sergio Calatroni Artroom srl
Country : Italy

Title : Istart
Designer Agency : Sergio Calatroni Artroom srl
Country : Italy

Title : TV4 Komedi Logotype
Designer Agency : Ohlsonsmith
Country : Sweden

Title : Alquimia
Designer : David del Olmo Gines
Country : Spain

WOO

Title : Woo
Designer : Ragnar Freyr
Country : Iceland

Title : MAAAM
Designer Agency : Sergio Calatroni Artroom srl
Country : Italy

nova
estetic

Title : Logo Nova Estetic
Designer Agency : Proyecto Limon
Country : Spain

nippon sense

Title : Nippon sense
Designer Agency : Sergio Calatroni Artroom srl
Country : Italy

GIS
Gestión
integral de
siniestros

Title : Logo Gis
Designer Agency : Proyecto Limon
Country : Spain

Title : Paolo Cecchin
Designer Agency : Sergio Calatroni Artroom srl
Country : Italy

Title : Krome
Designer Agency : Sergio Calatroni Artroom srl
Country : Italy

Title : Shikikobo
Designer Agency : Sergio Calatroni Artroom srl
Country : Italy

Title : Luciano Soprani
Designer Agency : Sergio Calatroni Artroom srl
Country : Italy

Title : Songérie
Designer Agency : Sergio Calatroni Artroom srl
Country : Italy

Title : EMLYN
Designer Agency : 123buero
Country : Germany

Title : Sergio Calatroni Artroom
Designer Agency : Sergio Calatroni Artroom srl
Country : Italy

Title : Nonsolopane
Designer Agency : Sergio Calatroni Artroom srl
Country : Italy

Title : Zingiber
Design Agency : Sergio Calatroni Artroom srl
Country : Italy

Title : Areokomunikacije
Design : Jelena Drobac
Country : Serbia

Title : Logo for Vermillion and Cinnabar
Design Agency : Warmrain
Country : Britain

Title : Balcony Magazine
Design Agency : 123buero
Country : Germany

Title : ADD Fashion
Design Agency : 123buero
Country · Germany

Title : Elystone Capital
Design Agency : Ginette Caron Communication Design
Country : Italy

Title : Architect Thomas Bendel
Design Agency : 123buero

Title : Elin, Calle, Wille, Hugo
Design Agency : Erika Rennel Bjorkman Graphic Design

Association of Dutch Designers

The Association of Dutch Designers (BNO) brings together over 2,500 individual designers, as well as 200 design agencies and design departments within companies. That makes us the most important representative organization for the design industry in the Netherlands.
The Association of Dutch Designers (BNO) promotes the business, social and cultural interest of designers in the Netherlands. Its most important task is to provide support and advice to members in performing their profession. As part of that effort, the BNO constantly seeks to deepen and broaden the design profession. On top of that, the BNO turns the national and international spotlight on the achievements of Dutch Design.

Association of Professional Graphic Designers in Finland

Grafia is an association for professional graphic designers in Finland. Established 75 years ago, it has currently over 800 members. The membership consists of persons engaged in visual communications professions: graphic designers, designers of marketing communication and electronic visual communication, illustrators, lay-out designers of magazines and books, and teachers, researchers and students in the field.

Swedish Association of Designers

The Swedish Association of Designers (Sveriges designer) is a trade organization for professional designers based in Sweden. Members of our organization are skilled designers in one or more of the following areas: Fashion Design, Furniture Design, Graphic Design, Industrial Design, Interactive Design, Product Design, Textile Design, Web design. If you encounter someone with the title mSd (member Sveriges designer) s/he is one of Swedens best designers. The Swedish Association of Designers is member of Beda and Icsid.

Wolda

Built on the success of Eulda, the European Logo Design Annual (which it replaces), Wolda is the high-profile graphic design award scheme that rewards the best logos and trademarks designed throughout the world. The winners are selected by an international three-tier jury consisting of 10 top design professionals, 10 marketing managers from major international clients and finally 10 members of the public (provided respectively by the worldwide organizations Icograda, Aquent and Consumers International).

Alessandro Paulasso aka Kaneda

Illustration and Photography

Alexander Egger

Alexander Egger is an Italian graphic designer, illustrator, conceptionist, artist, writer, publisher of zines and musician. He is working in different media on a range of cultural and commercial projects for small and big clients like Adidas, Designforum, Technisches MUSEUM Wien, BMW, Burda Medien, departure Kunst- und Kulturforderung, BIG Bundesimmobiliengesellschaft, Siemens, Sony, T-Mobile, Future house Vienna, Design Austria, Vienna City Hall, Bundesministerium fur Arbeit und Wirtschaft, Austrian Railways. Alexander Egger is currently living and working in Vienna and sometimes elsewhere.

Alberto Ghirardello

Angel De Franganillo

Angel De Franganillo was born in the city of Leon, spain in 1983, where with only 4 years of age, is gets introduced to art by his parents. From this point on, painting his home's walls and everything else around was the start of evereything. After a short period, angel starts participating in art contest and is soon called by many magazines, newspapers and different brands and companies in order to create their identitis and different illustration work for the same reason. Soon after he decides to study graphic design and moves to Barcelona after graduating where he enrolls in different video and moviemaking courses. Nowadays he works for a variety of clients in all fiels of audiovisual and interactive communication work and keeps painting everything else that is around him.

BAG Disseny

BAG is the name of a design and communication studio and it reflects both their origins and field of action. They are present in Barcelona, Andorra and Girona, hence the name BAG. They specialize in graphic design, corporate identity, publishing, graphic communication, signage, illustration, packaging and products. Each new project is unique and requires special attention so they approach it accordingly. By implementing creative solutions based on analysis and strategy BAG help their clients to both set and reach their goals.

Bard Hole Standal

Bard is a Norwegian designer and illustrator whose work has been featured in numerous design books, exhibitions, festivals and other creative projects around the world. Bard's work spans from illustration / character-design to graphic design, motion graphics, interactive design, animation and product design. He has his own line of shoes, a 9" tall vinyl toy, a series of adhesive vinyl art, a line of skateboards and a mountain of art prints that he peddles to consumers around the world. His art-label Stupid Devil functions as an umbrella for some of these products, while doubling as a vehicle of destruction that tries to drag current standards of the concept of 'art' down to a new low. Bard currently lives in Oslo where he works as an art director for a web design company by day and as an illustration maniac by night.

BeetRoot Design Group

Beetroot is a design studio based in Thessaloniki/Greece, founded in September 2000 by V. Ligkos, A. Nikoy and Y.Haralambopoulos. Beetroot now counts 8 employees and offers quality services in every aspect of design.

BJL

BJL is the most successful independent advertising agency in the North of England. The success is rooted in their ability to make a tangible and lasting difference to our clients business. That's why they have achieved more IPA Effectiveness Awards than any other independent agency. They are guided by one simple principle: out-thinking. Out-thinking means

out-manouvering the competition by being smarter. It means getting to the very nub of a problem or opportunity. It means big ideas, irrespective of budget. It means doing things differently. Areas of expertise include marketing and brand consultancy, integrated communications planning to cover all aspects of advertising, sales promotion, direct marketing, on-line and design.

Blackandgold

Founded in 1990, Blackandgold has gained a strong reputation over 15 years of close collaboration with some of the greatest food and beverage brands (Coca-Cola, Kellogg's, Badoit, Evian, Lu, President, Panzani, Lustucru, Yoplait, Twinings…), along with some of the main luxury and personal care players (Guerlain, L'Oréal, Lancaster, Lever Fabergé, Henkel, Dim…). Its expertise was awarded in 2007 by two Pent Awards: Gold for the creation of the « Smart » functional drink brand and its whole range, and Silver for the Evian Brumisateur revamp. Blackandgold is now actively extending its activities. First, it recently implants in China, thanks to the integration of « Nexteo », a long-established agency with knowledge of the local market. Second, through the development of a proprietary, image-oriented and participative innovation process, it now launch for companies such as Altadis (Gauloises, Gitanes, Fortuna, News, Fine and Royale tobacco brands) and Heineken.

Büro Uebele Visuelle Kommunikation

büro uebele studied architecture and urban planning at the university of stuttgart, and graphic design at the stuttgart state academy of art and design. Since 1995, he has managed his own visual communications agency in stuttgart, and since 1998 has been a professor for communications design at düssel-dorf university of applied sciences. andreas uebele is also a member of the agi, alliance graphique internationale, the type directors club of new york, the art directors club of new york, the art directors club deutschland and the german design council. The agency is active in all areas of visual communications. Projects are handled by small interdisciplinary teams comprising communications designers, media engineers and architects. The focus is on cd/ci, signage and wayfinding systems, corporate communications and exhibitions. the work of the office was awarded with over 120 international awards.

Cacao Design

Cacao Design, found in January 2004 by masa magnoni, alessandro floridia and mauro pastore, is not an all-round communication agency: it's a small studio that specializes in branding (naming, logo, stationery, corporate brochures and other elements of the visual identity of a brand), web design and below the line (point-of-sale material, product brochures, catalogues etc.)

Kempertrautmann

Chris Bolton

Chris Bolton, born 1975, is a British/Canadian educated graphic designer, based in Helsinki. He is working on music, retail, fashion, architecture, advertising and publishing projects worldwide. His thought-provoking work delivers a clear and relevant result, regardless of scale or budget. Recent clients include Nokia (Finland), Skanno (Finland) and Eskimo Recordings (Belgium). He has also worked with Comme Des Garcons (Japan), Escalator Records (Japan) and A-lehdet (Finland) to mention a few.

Chris Trivizas Design

Born in Ctheirfu, Chris Trivizas has studied Programming and Analysis, 3D Animation and Graphic Arts at AKTO (Athenian Artistic and Technological Group), and finalized his studies in 2001 with a Master of Arts from Middlesex University. Having worked in several Advertising companies, as a commercial artist & Creative Director, he also worked with the IMAKO Group in image processing & morph. He established his own creative studio in Athens, 2003. From 2004 to 2006, he has been nominated and won several awards in many events such as the Greek Graphic Design & Illustration Awards (EBGE), EULDA (European logo design annual) and Ermis Awards under categories of corporate ID, logotypes, and Ermis Design etc. He now is also a Member of GGDA (Greek graphic designers association).

COEN!

Coen van Ham (1971) is a Dutch conceptual designer, architectural designer and stheirce of creative inspiration. He has studied at Sint Lucas in Boxtel as well as at the renowned Design Academy in Eindhoven. His design agency COEN! is one of the leading agencies in the Netherlands due to its innovative concepts, much talked about designs and inspiring workshops.
COEN! shapes and guards over clients' most important possession: the identity of their enterprise. The designs for corporate identity, product and interior are all based on one consistent and poTheyrful concept.
COEN! also develops and presents inspiring workshops and individual coaching sessions.

Company

Company is a graphic design studio based in London. Working across a variety of media and formats, they create brand identity and visual communication. Company's approach is to formulate simple yet strong ideas, which work on multiple levels to deliver clear and effective solutions. Combining hand-crafted with attention to detail, they take a holistic approach to contemporary design to ensure that strong concepts are integrated with commercial context. They believe thought-provoking ideas with a playful twist are the most successful.
Company works with a diverse mix of local and European clients, mainly in the arts and cultural, and creative industries. They are committed to providing bespoke ideas with a personal service, no matter how ambitious or low-budget the project. Their work has been shown at BFI Southbank, the ICA, European Design Awards, and the Royal College of Art.

David Torrents

Freelance designer and illustrator from Valencia, Spain (1982). Technical engineer in industrial design by the ETSID of the Universidad Politécnica of Valencia. He has worked in Florence (Italy) and Shanghai (China) as in the illustration and the corporate design sector as in video edition. Versatile and creative, this young designer is up to everything.

Designaside

Designaside is a community that has been active since 2001 and concerns itself with graphics, web design, design, photography and art. Nowadays Designaside is one of the more prominent independent realities of the Italian scene, and each day it makes available to hundreds of users constantly updated news, an index with the best national and

international achievements, information about books, resources, awards and events.

Dew Gibbons Ltd.

Dew Gibbons is one of UK's leading creative design consultancies. They look at strategy with designers' eyes and apply their imagination with intelligence. Whether they're creating or caring for brands, the outcome remains the same. That is beautiful thinking.

Dragon Rouge

Dragon rouge is the creative fruit of the synergy between Pierre Cazaux, an advertising strategist and Patrick Veyssiere, a designer. When they pooled their talents in 1984, the two founders resolved that their new agency would build strong and sustainable brands to serve their clients' long term interests by having a truly entreneurial attitude. Today dragon rouge is the independent design group internationally. It's known for originality of approach, professional objectivity and uncompromising standards. As a result, within the span of a few years, the agency has expanded from its native Paris to host a solid and efficient network of offices in London, Warsaw, Hamburg and New York.

Eden Design & Communication

Eden Design & Communication is a strategic design and communications agency based in the heart of Amsterdam. It is one of the biggest and oldest agencies in the Netherlands, setting the standards for customer service, quality and design philosophy. They create brand identities and campaigns and specialize in website and tools development. They make complex documents accessible and understandable. Eden adds a creative and imaginative touch to brands, communication and interaction. Eden is an inspiring partner. Attentive and decisive, they never lose sight of the ultimate objective: forging strong partnerships. They have carried out projects for central and local authorities and government bodies, non-profit organizations, the business sector and service providers.

Erika Rennel Bjrkman Graphic Design

Seven years of working in London has given Erika Rennel Bjrkman a broader perspective on graphic design, through a number of close working relationships with international clients and a wide production network. Erika Rennel Bjrkman specially values simplicity and timeless design.
Her graphics expression often derives from typographic solutions. She pays detailed attention to the production process. After graduation, she joined Pentagram Design Limited in London, where she worked with John Rushworth and Justus Oehler. Her works there include projects for the Savoy Group and other major hotels, Disney Consumer Products and others that led to several British design awards. In 1997, Erika Rennel Bjrkman left Pentagram to set up her own business in London and worked with theatres, restaurants etc, until returning to STheyden and Stockholm in 1999, where she workes and lives. She specializes in graphic design, including logotypes, design programmes, brochures, posters, packaging, exhibitions and typography.

Formgivare Anna Larsson

Anna Larsson is Graphic Designer who got her Master of Fine Art in1995. Her studio is active and established since: 1996, with office locating in Gothenburg, Sweden. Her specialty and business areas includes: Typography, book design, profile programmes, logotypes, and posters.

Gary Fernández

Gary Fernández (1980) is a freelance illustrator and graphic artist based in Madrid, Spain. He's also the co-founder and creative head of the T-shirt brand VelvetBanana.

Gen Sadakane

Gen Sadakane was born in germany. His father is a sushi master and his mother a renowned concept artist. Gen started his career as an graffity artist. By day he studied philosphy and at night he coloured the trains. Worked for TBWA, McCann Erickson and Jung von Matt, now he is working as an senior art director for DDB Berlin. Gen's work has won gold, silver and bronze awards at Cannes Lions, New York Art Directors Club, the Clios, London International Awards, New York Festivals, Eurobest, D&AD, German Art Directors Club.

Ginette Caron Communication Design

Graduated in Graphic Design at Concordia University, Ginette Caron worked for a few years in different design agencies in Montréal, Bologna, Venice and finally in Milan where she opened in 1985 her own graphic design studio. She specializes in CI projects, branding, exhibit design and art books for clients like Barilla, Bulgari, Chase Manhattan Bank, Grand Thétre de Provence, Fondazione Prada, Knoll, Lualdiporte, Moleskine, Natuzzi, San Carlo, Swatch and TV5. She also worked as in house Design Director for Prada Group (Prada, Fondazione Prada, MiùMiù) and Benetton Group (United Colors of Benetton, Sisley, Playlife). From 1985 to 1997 for Gregotti Associati International, she is responsible for the corporate image for B&B Italia, Molteni&C, De Padova, Fontana Arte, iGuzzini, Zucchi and Unifor (Compasso d'Oro 1995). She is regularly invited to give seminars and lectures at Université du Québec à Montréal, Venice University, Libera Università di Bolzano and Grafika Day in Montréal.

Graciela Artiga

Graciela Artiga is a Madrid based graphic designer who loves art, typography, color, words, music, things that exist for a reason, and things that are there for no apparent reason at all, cutting and pasting, learning and teaching, white space and black space as black as can be, collecting and recollecting, appreciating the beauty of every little detail and merging little details into a whole that works from every angle. She loves to be a perfectionist, absolutely passionate about her work, to be challenged, and to experiment with new materials and media. She has designed for several Spanish magazines and studios and is currently working for the textile and cinema industries.

Grundform

"Grundform was established 2002, by Alexandra Németh - a Graphic Designer with 16 years of experience from advertising, web and media. The focus of Grundform has for the last few years been working with graphic profiles and all kinds of fun and challenging print/illustration/web tasks these companies have after the new/modified graphic profile has been set. Clients vary from small companies to big international ones; with branches of industry ranging from accessories, bags, cosmetics, telecom, and construction to movies and adventures.

GVA Studio

Founded in 2004, GVA Studio is a consulting agency in design and communications, helping its customers define their identity and make it visible, interactive and competitive. They supply services such as art direction, book and magazine design, as well as event and exhibition concepts, packaging, product promotion, corporate identity, and web site development.
Communities of journalists, photographers, musicians and designers throughout Europe often collaborate with GVA to come up with the most original concepts, logos or designs. It allows GVA to be capable of mastering as many tasks as art direction, brand naming and copy, graphic design, print advertising, book and magazine design, exhibition and event design, packaging, signage, motion and web design, production.

Hahmo Design Ltd

Hahmo is a Finland-based design agency founded in 2003. They offer a full range of services in graphic, spatial, product, and concept development. Hahmo is a Finnish word that best expresses the essence of the firm's focus: idea, outline, sketch, character, figure, shape and form. They are a group of established designers. They believe that good design takes into account both the needs and restrictions of the end-user. Teamwork with professionals delivers results that combine different fields of design in a more efficient and coherent way. They build corporate and organizational identities, create brandscapes and visuals for special events, and plan product launches. Their projects often involve international collaboration.

Hashka

Hashka is drawing since everytime starting to work during my first years of University of Arts, in an animation studio, after he worked in a web agency that permit to discover the computer world…
He works in freelance working in fields of Fly / Covers / Poster / websites / animations…
He love everything in graphics, and his works is a mix between all kind of arts inspired (Draw, Photos, Graffitis, Comics, Movies, Animation , cartoons, Caligraphy ,Graffiti,Tribals arts, Electronics,Toys, Music, Lyrics… and more Arts …)
He works with all tools that permit to do his ideas and is not define with one way…

Hesse Design

Year of foundation 1988. Established by the two chief executives Klaus and Christine Hesse in 1988, Hesse Design works in fields of Corporate Identity, Corporate Design, Branding, Naming, Logotypes, Literature Systems, Information Design, Theyb Design, Interface Design, PC-Forms, and Interior Design. It is also very well known through over a hundred awards in Germany and abroad as well as publications in specialist literature. Its founders, Klaus Hesse, is one of the leading graphic designers in Germany and holds a chair for Applied Design at the Academy of Art and Design in Offenbach, and Christine Hesse, is a well-known design manager and was lecturer at the University of Applied Art in Düsseldorf from 1993 – 2000. Hesse Design has contributed to the production of distinctive profiles for numerous companies and product brand names, including Audi, Bewag, the Bosch group and o.tel.o.

Hijack Your Life

Graduating form the Riedveldt Academy in July 2007, Kalle Mattsson rented the back of a gallery with some friends, making a living. The interest in lettering and typography might have started when he was 5. From there he drew superheroes, and later into drawing and painting in general. He is an illustrator, graphic designer and also an artist. His fellow designers that he shares a studio with would probably say that graphic designers work primarily with language, and typography. That seems strange to him. He is not very connected to the Amsterdam design scene in that sense. He is not a very editorial designer, and tries to be everything at once, which is really difficult, and interesting. Perhaps Obsessed God of a Private Universe is the best term.

Hörður Lárusson

Hörður Lárusson is a graphic designer working out of Reykjavík Iceland. After graduating from the Iceland Academy of the Arts in 2006, he started working at a small studio called Atelier Atli Hilmarsson. Along side the studio work he quite a bit of freelance work, teach at the Icelandic Academy of the Arts and he is the current president of the Icelandic Association of Graphic Designers.

Hypnoteis

Teis Albers is a freelance graphic and multimedia designer in Hertogenbosch.Educated at the Graphic Design School in Eindhoven, the Netherlands, he later started his own company under the name Graphik. Besides that he design free style work under the name Hypnoteis that most people known. His first commissions were for local companies designing websites, brochures, advertisements etc. In the evenings he experimented with free style work, without boundaries, and learned a lot that way. His first major opportunity came when he contacted Reload magazine. They let him design a cover and printed an interview with him, enabling him to present work to a larger public. That brought him lots of new clients.

Iconograpahic Magazine

Iconograpahic magazine is a new project, a magazine of graphic design and tipography, whose objective is to diffuse and to promote the discipline of the design. It is focused to all those that by affinity or by profession they sit down interested in this field. Each number is constituted like a monographic one, whose content itself structure in two parts differentiated: Theory and analysis: are invited theoreticians, cri Costa Rican, essayists, etc. to share their ideas. Practical: on a theme proposed by the publication, readers, designers and an invited school will be able to show of what are capable. Iconographic will be reinvented to itself in each number, changing typography and layout, in an exercise of constant renewal.

In Graphics We Trust

Born in Breslau, Poland on February 1st, 1978, Sebastian Onufszak is a German visual artist focusing on print, interactive media, and motion graphics. Since receiving his graphic design diploma in 2002, he has been working as an art director and freelancer for an international range of high-end clients including MTV, Mercedes, RedBull and Bacardi. Alongside he is reknowned for his experimental live visuals which supported Funkstoerung, Mouse on Mars, Michael Fakesch, Grandmaster Flash and many more. His work was featured in numerous publications and exhibitions worldwide. Currently he is living in Duesseldorf, Germany and working for Parasol Island, a film, animation and design studio, as Creative Director.

Ivo Valadares

Ivo Valadares is a graphic designer based in Spain working since 2002. He creates clean designs that express clients; company essence, and also illustrates their innovation. With 6 years experience as a designer, Ivo Valadares's expertise lies in logo design, brochure layout, print ads, corporate image, web design layout and many other tasks related. The essence of design is clear communication so as to best express their messages and distinct identities. Good customer service is his key, and no project is completed until his clients are satisfied.

Jelena Drobac

Borned in 1982, Jelena Drobac graduated at Department of Graphic Design , Faculty of Applied Arts, Belgrade in 2007, and then became fulltime member of ULUPUDS (Serbian applied arts guild) in 2008, and also a member of international jury for Identity: Best of the Best 2009. She has worked in various agencies and different freelance projects for: Zepter, Univerzal Bank, Banim, Dadov Theater, National Employment Agency- Government of Republic of Serbia, Atlantic travel & services, NIN magazine, advertising festival Golden Rooster, Decus company, Jannelli c Volpi. Most of her projects were predominantly visual and corporate identities, logotype, type design and packaging. These are the areas were my skills and talents are best shown.
She also worked with and published in many publications. Numerous awards home and abroad are gained, and countless international exhibitions are conducted under her name.

Josh Butcher

Country : Britain

Katrin Olina Ltd

Katrin Olina Petursdottir, born in Iceland, is a designer and artist whose work has been produced and published by the National Gallery in Oslo, Print Magazine, Die Gestalten Verlag, Rosenthal, Fornarina, Dupont Corian(R), Montreux Jazz Festival, 100% Design Tokyo, and among others. Graduated from product design at E.S.D.I., she worked for Philippe Starck's studio and Ross Lovegrove's studio. Alongside such design work, Katrin Olina has steadily cultivated a provocative two-dimensional graphic language that lies between art, illustration and graphic design. In 2007 Olina opened her own company, Katrin Olina Ltd, to accommodate her rapidly expanding client base. In recent years she has been responsible for projects from large-scale commissions by the Oslo National gallery (2005) and 100% Design Tokyo(2007), exclusive interior design projects such as SKIN clinic (Italy), limited edition designs for fashion house Fornarina(Italy) and porcelain specialist Rosenthal (Germany), and visual identity for the 2007 Montreux Jazz Festival (Switzerland).

Keja Donia

Keja Donia is an independently owned design and advertising agency with a rich history in creating successful brands and brand communications. Their strength lies in combining creativity with strategy. Solid ideas that build brands and steer communications to all stakeholders is brought internally and externally.

khdesign gmbh

khdesign has been specialized in brand and packaging design, more specifically, in the optimization and evolution of established brand images for over 25 years. They have a team of experts consists of marketing consultants, prototype makers, web designers, calligraphers, and sometimes even heraldists, guarantees work of the highest professional standard. Adhering closely to the strategic aims of the marketing campaign, khdesign carry out a methodical assessment of the brand from a holistic standpoint, while ensuring the perspective of the consumer remains the focus of all deliberations. Their personal service includes management, monitoring, and optimization of each phase in close consultation with clients – from prototype production through to the acceptance of print work.

Laboratorium

Laboratorium is a design studio, founded in 2001 by Ivana Vucic, an award-winning designer and photographer and Orsat Frankovic, an awarded designer - mainly engaged in all sorts of graphic design projects and photography (or in wider terms- visual communications). Laboratorium received numerous awards* and have been published continuously.

Laura Millán

1979, Sanlúcar de Barrameda. Spain
Laura Millán studied for her Technical Degree in Graphic Design at the Escuela de Arte de Sevilla and for Bachelor's Degree in Industrial Design at Escola Massana in Barcelona. After that she got the Young Designer National Prize Medalla ADI de Oro 2007, with her senior project "The Reversible Container.Actually she is working in the areas of graphic and product design also in art direction and audiovisual projects. She had won two national packaging awards Liderpack 2005 (Young Designer and a Special Prize) with 'Chopsticks for the Incompetents' with Belén Hermosa. Her projects has been published in magazines like Experimenta, Neo2, NDiseño Interior, Casa Viva (Spain), DDN and Disey 03. And they have been showed at Mlady Obal 2007 Young Package in Czech Republic, Hispack in Barcelona, FAD in Barcelona, Expohogar 07 in Barcelona and at Fuori Salone in Milan during the Design Theyek (2008).

Lava

Founded in 1990 Lava's experience is rich and widespread with clients ranging from the cultural to the corporate. Working throughout this vast spectrum of graphic design, Lava has a diverse portfolio with recurring work in the area of editorial design and identity development.
Lava's design philosophy has been found throughout its work experience. In editorial design Lava understood the paradox of creating consistency and change. A magazine needs to be recognized as the same magazine this month as last month and at the same time it needs to be different. Designers need to repeatedly manage this paradox of consistency and change. Lava applied this discovery to other areas in design specifically the area of identity design. By using consistency AND change identities become dynamic. These Dynamic Identities live, grow, and adapt over time. A Dynamic World = Dynamic Organizations = Dynamic Identities.

Lysergid

Loic Sattler is a French Art Director experienced in web, multimedia, print collateral, clothes styling, and corporate identity. Loic works with special emphasis on aesthetics, creative ideas and communication goals, with a very high attention to details. Inspired by everything, everywhere, interested and enthusiastic, he is in complete love with visual creation. Known as efficient, he's able to manage a creative crew and likes to have a global view on the projects he is

working-on. He has always been devoted in sharing his knowledge and views on graphic design, by making conferences, writing news and interviews for online communities, building-up design related events, teaching his views on graphic design. Loic's aim is to be understood as an individual who wishes to make things go further, by empowering his profession as best as he can.

Marc Taulé

Marc Taulé is a graphic designer from Barcelona founding of the design studio BEWEB DISSENY. The quality is our main goal. BEWEB is a study of young creators with ideas about the current conceived by one tomorrow of success. We are in favor of having a treatment completely personal and individualized with our customers to be able to offer the best solution to their needs, because of that, we surround ourselves of a group of professionals of the information like photographers, producers...

Mark Richardson Graphic Design

With a degree in Environmental Chemistry, Mark Richardson started his job at a newspaper agency, where he regained his passion for design. He then self-taught design became a soho designer two years later.
After two years and a half, he moved to College Design where his first brief was to re-brand the parent PR company College Hill. .Working with great senior designers there gave him competence and confidence to conduct permanent freelance.
Several years later, Mark set-up Mark Richardson Graphic Design. By utilizing the expertise and skills of his fellow independents, his studio provides a creative, dynamic and cost effective service. Their clients include The International Herld Tribune, Faber & Faber, Super Aguri F1, Spar & Eurospar (Parker Advertising Ireland), Rank Group and OMD winner of the Gunn Report 2006.
He believes that their job to creatively simplify the information so that the original intended massage is clear.

Modos Disseny Grafic S.L.

Why Modos? They just don't know it, but they like it. Just as they like Design and everything that surrounds it. For this reason they joined in order to design. They are Carolina, Dano and
Nere. Three entrepreneurs, three designers, three colleagues… three Modos. They form a multidisciplinary team with good academic formation, but also with great experience. Working in
Spain and China in fi elds related to the graphic design, web design and photography. Each one of they contributes to the group with his knowledge, experience and work, but above all, the desire and the illusion by forming part of this studio.

Moniteurs

Why Modos? They just don't know it, but they like it. Just as they like DESIGN and everything that surrounds it. For this reason they joined in order to design. They are Carolina, Dano and Nere. Three entrepreneurs, three designers, three colleagues… three Modos. They form a multidisciplinary team with good academic formation, but also with great experience. Working in Spain and China in fields related to graphic design, web design and photography. Each one of they contributes to the group with his knowledge, experience and work, but above all, the desire and the illusion by forming part of this studio. Meet them in www.modosdisseny.com

Maggie Ramadani Design Studio APS

An Interdisciplinary design studio, specialized in creating intelligent solutions for analog and digital media. Experienced in developing effective visual concepts and information hierarchiies to ensure clear communication of content, style and aesthetics.

Naroska Design

Marc Naroska studied visual communication at the University of Applied Sciences in Potsdam. He worked for five years at Thomas Manss and Company, responsible for customers such as the MeoClinic Berlin, the Oberhavel Holding, the Stern und Kreisschiffahrt shipping company, B&W Loudspeakers and Foster and Partners. In 2000, he founded his own design studio in Berlin, Naroska Design develops design for customers such as the M100 Sansoucci Colloqium, the Hartwig Piepenbrock Culture Foundation, HassoPlattnerVentures, Santaverde Naturkosmetik, and the Federal Foreign Office in Norway and Germany. Marc is also a co-founder and partner of C/O Berlin, a cultural forum with a special focus on photography. He is responsible for developing and managing the corporate identity and designing all the communication media and its exhibition projects for and with photographers like Rene Burri, Anton Corbijn, Annie Leibovitz, James NachtTheyy and Evelyn Hofer.

New Future Graphic

Ngdesign

Lines, blots, photos, press clipping, reminders, smiles, phrases, words, perfect clean up, caos. Nazario Graziano likes to play with these elements to create his art. No rules, no limits to communication, no keys, no alarms, no basement. His art is full of irony sense and spokes with a language of modern-day. Hybrid, nonconformist. Nazario Graziano absorbs and evolves styles and techniques of several backdrops to create his artworks and his personal style. Handmade forms, music, colors, hearts and clouds, press clipping like a dive in childhood. Nazario creates artworks for agency, events, bands, and every project that inspires himself. His clients include MTV, NewYork Magazine, Chicago Magazine, IdN, Vodafone, Grafuck, Firewater, Pasta, Toxic.fm Radio, Novum, Grab, etc.

Ohlsonsmith

Ohlsonsmith is a Stockholm-based design studio committed to emotional design. Emotional design is intuitive, curious, expressive, playful, and daring. It comes from both heart and mind and speaks to both heart and mind. They combine it with a keen sense of business and marketing to help clients to reach their objectives and create the right image to be seen, felt and remembered. Their clients range from small, emerging companies to very large ones. And they operate in different disciplines, from entertainment and culture to fashion. They also work in many media print, packaging, motion graphics and environments as well as create entire brand identities. Regardless of media, client or discipline, their work is always driven by ideas and results. And their approach is always the same. They collaborate closely with their clients to communicate the character and goals of their companies, products and ideas.

Peter Raczko

Picnic Oficina de creación

Creative Agency been founded on Madrid in 2006. Dedicated to the confrontation of the cultural theory and his practice with the policies of market, it chases the adequacy of the contemporary technologies to the new social, spatial and aesthetic needs. It develops his activity in the fields of the Architecture, the Landscape, the Territory, the Design, the Art and the Edition. In 2007 it starts the collection of books AAAAA for the diffusion of the global current culture from the impulse of creative young men of the graph, the narrative and the critique.

Proyecto Limon

Ragnar Freyr

Ragnar Freyr is a 27 year old freelance graphic designer from Reykjavik, Iceland. In 2000 he got a job as a graphic designer at a local design studio. Having worked at the studio for more than a year and established his love for graphic design, Ragnar then moved to Reykjavik, to attend the Irelandic Academy of Arts. Graduated with B.A. diploma in graphic design in 2005 he subsequently started a multidisciplinary design studio with Olafur Omarsson, a product designer graduate. In 2006 Ragnar got married and moved to Michigan, USA where Ragnheidur studies 3D design at Cranbrook Academy of Art. His studio is currently located at their home in Clawson. His design stretches across variety of media and formats but his approach to graphic design is based on simplicity, partial objectivity and the principles of modernism often featuring typography as the primary design element.

Rotbraun Informationsgestaltung

Two colors. Two women. Two locations. One signature. That is the quintessence of rotbraun information design. Founded early in 2003 by the qualified designers Pia Schneider (red-haired) and Nora Bilz (brunette), rotbraun meanwhile has offices in Berlin and Stuttgart. Rotbraun creates brand identities which go beyond purely visual aspects. High-quality design is the key to successful corporate identity strategies. Rotbraun is not interested in esthetics as an end it itself, but rather in the aim to process complex data in a user-friendly way and to create distinctive, unmistakable statements through competent design.

Sergio Calatroni Artroom srl

The studio Sergio Calatroni Art Room srl is the research facility who operates worldwide in various sectors: Architecture, Interior design, Product design, web design, Graphics, Coordinated Images, Packaging design, Cultural events, Teaching, Exhibit design, Art, Interdisciplinary research. The vision and the design approach of Sergio Calatroni Art Room srl consists in the interdisciplinary and the transversal research that focalize in the marriage between Art and Science. The mission of the study is the spirit of renovation in the signs of the different cultures. This attitude is described in his philosophy of "Step by Step" which means produce ideas in the harmony with the transformation and sustainable developments. The slogan of Sergio Calatroni Art Room srl is "MOST VITAL MORE EXACT"

Studio Annelys de Vet

As a graphic designer – educated at the Utrecht School for the Arts and the Sandberg Institute Amsterdam – Annelys de Vet (1974) explores the role of design in relation to the public and political discourse. Among others as teacher at the
Design Academy Eindhoven. Next to her work for cultural clients like Droog Design, Stedelijk Museum, TPG Post, Rijksgebouwendienst, de Appel art space, Thames&Hudson and Art Amsterdam she has published several books. In addition de Vet is the director and designer of the yearly '(Con)Temporary Museum Amsterdam'.

Studio Copyright

Studio Copyright is a young designers team from diferent areas that wants to offer different creative services, based in investigation and innovation on communicative languages. With a large experience on brand services, publishing, promotional design, multimedia, motion graphics and tipography.

Studio Dumbar

Gert Dumbar established Studio Dumbar in 1977. Right from the start, the Studio stood for top-notch design, employing the talents of individual designers to create powerful design solutions. Their work is known internationally. This has lead to many publications, awards, exhibitions, workshops, lectureships and even chairs at universities and design colleges all over the world. Another result of their international outlook is Dumbar Branding – their joint venture in China. Studio Dumbar's design approach is truly without borders. That shows in their hiring policy. Although clearly rooted in the Netherlands, they have on average, 5 different nationalities working in their staff of 30

Studio Kluif

Kluif reveals the essence without any unnecessary showboating. They believe that a core can impress without making a lot of noise. "Soul" is Kluif's password. It permeates everything Kluif creates: from graphic design to packaging and fashion; for every sector of industry and every target group. Kluif derives their authority in the field from their tenacity; they simply keep digging till they get to the heart of the matter, the essence. Styles can be like shackles. Kluif likes to break out. After all, diversity can only blossom in freedom. Still, Kluif's work does have some common threads. The most important ones are directness, playfulness, simplicity, a sense of humtheir and relativity. Kluif works digitally, but they also have scissors, color pencils and spray paint within reach at all times.

SUCE Estudio

Applied creativity. This is our main strength. We are just three Valencian designers who use the creativity as a tool to solve whichever design project: both product and graphic. This young workteam was born last January and we have already workerd with Air Nostrum airlines and the international NGO Intermon Oxfam. Feel free to have a look to our projects in www.sucestudio.com

Sweden Graphics

Sweden Graphics is founded by Nille Svensson (b. 1970) and Magnus strm (b. 1969)
They do Graphic design, Illustration, Animation, and Branding.
Both of them were educated at Konstfack University College of Arts Craft and Design in Stockholm.
Sweden Graphics has been around in different forms since 1998.

Tank Design

Tank Design was founded in 1999 and now has a total of 15 staff in its offices in Oslo and Tromso. Their objective is to be one of the most skilful agencies around when it comes to understanding and fulfilling their customers' needs for visual communication. They focus on quality, creativity and long-term working relationships. It is their priority to help customers to communicate their values in such a way that it increases their worth and reputation. Every day, they look forward to going to work.

Tridvajedan Market Communication Ltd.

TRIDVAJEDAN is the agency for creative management of integrated marketing communication founded on July 3rd 2000. Today it counts 12 employees and 10 external collaborators. Their mission is to plan and to implement the creative two-way communication actions that enhance sales results of their clients. TRIDVAJEDAN offers full services in the field of promotion. All campaigns verify on the market increasing sales and/or increasing promoted brands' notoriety and the greatest confirmation of all are the client's satisfaction and future collaboration on new projects. Further confirmation of the agency's team quality are numerous awards and recognitions (Red Dot, Eurobest, Worldstar, ED Award, BEDA, CroPak, Festo, HOW Award, D&AD, Cresta International, Magdalena), the publication of works in professional magazines (DesignTheyek, Print, HOW, I.D., Branded, KAK, Coltheir Management

Turner Duckworth

Founded in 1992, Turner Duckworth is an award-winning brand design consultancy with studios in San Francisco and London. David Turner is Head of Design in the USA, with Bruce Duckworth being Head of Design in the UK studio. Turner Duckworth help clients convey complex ideas with simple, emotive solutions. Consumers are bombarded by thousands of commercial messages every day. Turner Duckworth's brand identity and packaging design cuts through with clarity and wit. For sixteen years they've produced award-winning work serving cultural icons such as Coca-Cola, Amazon, Waitrose and Royal Mail, as well as entrepreneurial "brands on the rise" like Virgin Atlantic, Shaklee and Liz Earle.

Vladimir Scorcan

Fascination with images and visual language is continuous search for the expression, choosing elements and transforming them represents a sort of fusion. All parts of a work are organically attached to each other like it's a living creature. Every peace is evolving trough the working process until it becomes entity on its own. Personal enthusiasm for artistic/graphic work is followed by obsessive necessity to push the client as far as he is willing to go, and sometimes further to assure certain integrity/quality of the work. Making interesting (intending important) graphic design is quite a struggle since the work itself is always a sidekick for some product, service or else. Putting it in some kind of the centre of attention is very demanding thou amusement, especially if you have some sense for irony while trying to rise above the fluff. Effort to produce non mediocre work depends on the level of visual culture of the surrounding in which the visual communication is to be implemented. Criteria you consider are also very important. It all depends on your vision of a graphic design/art direction, of what you want it to be or how far you want to go, making pretty pictures or something else/more.

Warmrain

Warmrain is a bespoke communications company who create truly memorable events, installations, branding and graphics by engaging people's senses and emotions. They develop projects that get under the skin and into the heart of a client's message. Now in their seventh year Warmrain's strength lies in defining the essence of a project and bringing it to life by create visual stories of substance and wit.

Yonoh

YONOH is a study of creative development with a clear approach to the global design. Alex Selma and Clara del Portillo, both industrial designers, are the founders of YONOH, who after developing their careers separately decide to initiate a professional joint activity, a form of uniting capacities and developing combined projects that contribute a major quality to their work. www.yonoh.es

ZUU

ZUU comes from Zoology.
Rui Parada's characters are based in animal behaviors and in imaginary friends. The spirit of the cartoons and the BD is present to create a cool environment and relationships between the characters. Each one has his own name, personality and feelings. Sometimes they have strange behaviors... So if you wanna know about a new character world, always changing and growing, visit and enjoy Zuu".

123buero

123buero™ is a Berlin based Graphic Design Studio that consults, develops and realizes contemporary projects across a wide range of divers sectors. Believing that Design foremost is a discipline of analytic thinking, progressive attitude and professional craft, their work processes from content related idea into a conceptual visual language, which is often based on typographical solutions that also implicates production, material and the recipients all over experience into the final product—in addition, they develop Typefaces that results out of specific situations and necessities to apply as an extension to the projects. 123buero™ provides services in the classic field of Graphic Design: analizing, developing and designing all kinds of printed and digital matters, signage systems, typefaces, exhibitions and corporate appearances—including an overall project managment and consulting.